FAN
PHEN⬤MENA

BATMAN

EDITED BY
LIAM BURKE

Credits

First Published in the UK in 2013 by Intellect Books,
The Mill, Parnall Road, Fishponds, Bristol, BS16 3JG, UK

First Published in the USA in 2013 by Intellect Books,
The University of Chicago Press, 1427 E. 60th Street,
Chicago, IL 60637, USA

Editor: Liam Burke

Series Editor and Art Direction: Gabriel Solomons

Copy Editor: Michael Eckhardt

Inside front cover image: Dennis and Elijah Vasquez
Inside back cover image: Seamus Keane and Alison Brown

A Catalogue record for this book is available from
the British Library

Fan Phenomena Series
ISSN: 2051-4468
eISSN: 2051-4476

Fan Phenomena: Batman
ISBN: 978-1-78320-017-7
ePUB ISBN: 978-1-78320-094-8
ePDF ISBN: 978-1-78320-093-1

Printed and bound by
Bell & Bain Limited, Glasgow

🅐 intellect

Contents

5—6
Foreword
WILL BROOKER

7—9
Introduction
LIAM BURKE

10—21
A Fan's History
LIAM BURKE

FAN APPRECIATION (INTERVIEWS)

24—29
Paul Levitz

58—62
E. Paul Zehr

64—67
Josh Hook and Kendal Coombs

104—106
Dennis and Elijah Vasquez

108—111
Travis Langley

130—133
Seamus Keane

136—141
Kim Newman

166—171
Michael E. Uslan

172—175
Contributor Biographies

176—177
Image Credits

**PART 1:
BEING BATMAN**

30—39
Dark Hero Rising:
How Online Batman Fandom Helped Create a Cultural Archetype
JENNIFER DONDERO

40—47
Heroes with Issues: Fan identification with Batman
ANNA-MARIA COVICH

48—57
Being Batman: From Board Games to Computer Platforms
ROBERT DEAN

**PART 2:
EMBRACING THE KNIGHT**

68—77
The Passive Case: How Warner Bros. Employed Viral Marketing and Alternate Reality Gaming to Bring Fandom Back into the Culture Industry
MARGARET ROSSMAN

78—89
Canonizing *The Dark Knight*: A Digital Fandom Response
TIM POSADA

90—103
Mad, Bad, and Dangerous to Know:
The Nolan/Ledger Joker, Morality, and the Hetero-Fictional Fan Impulse
LESLIE MCMURTRY

**PART 3:
REPRESENTATIONS OF FANDOM**

112—119
Inspired, Obsessive and Nostalgic:
The Facets of Fandom in 'Beware the Gray Ghost'
JOSEPH DAROWSKI

120—129
Villainous Adoration:
The Role of Foe as Fan in Batman Narratives
TONY W. GARLAND

**PART 4:
INSPIRATIONS AND ADAPTATIONS**

142—153
"Elementary, My Dear Robin!":
Batman, Sherlock Holmes, and Detective Fiction Fandom
MARC NAPOLITANO

154—165
Dark Knight Triumphant:
Fandom, Hegemony and the Rebirth of Batman on Film
WILLIAM PROCTOR

Acknowledgements

The editor would like to thank the dozens of scholars who submitted proposals for this collection – the level of interest testifies to the enthusiasm that surrounds this topic. Particular acknowledgment should go to the final contributors, whose passion and expertise is evident in each chapter.

Special thanks must also be paid to Will Brooker for providing the collection's foreword. His many publications on pop culture audiences have been rightly celebrated, and his work on Batman has informed much of this collection. *Fan Phenomena: Batman* is also fortunate to feature interviews with a wide variety of fans from cosplay enthusiasts to the former president of DC Comics, and the editor would like to thank all those who shared their experiences.

The editor would also like to acknowledge Gar O'Brien for reviewing drafts; his many suggestions could fill another dozen collections. Without the careful guidance of series editor Gabriel Solomons this collection would not exist, and for that the editor is very grateful. A heartfelt thanks to Helen Walsh, who caught every misplaced Bat-prefix and incorrectly spelt 'Ra's al Ghul' over hours of careful proofreading.

Finally, this collection is indebted to the many fans who have kept Batman at the forefront of popular culture since 1939.

Liam Burke, Editor

Foreword
Will Brooker

→ From the legions of keyboard warriors who attacked Joel Schumacher's 1997 movie *Batman & Robin* until they sabotaged a major film franchise, to the armies of teenagers in Joker make-up who followed the viral marketing trail of Nolan's *The Dark Knight*, ten years later; from the fan-fic authors who write entire novellas about Rachel Dawes to the *Arkham Asylum* gamers who spend weekends controlling a Batman avatar… in addition to his wealth, his intelligence, martial artistry and gadgets, Bruce Wayne can count his millions of fans as one of his most powerful assets.

The heart of Batman's appeal has always been his humanity; his lack of any super-powers, and the fact that this cultural icon who walks with gods – a Kryptonian, an Amazon, a Martian Manhunter, the fastest man alive and the bearer of the most powerful weapon in the universe – is no more magical than the rest of us. Batman lets us believe David Bowie's promise that we could all be heroes – or at least, that we could all be Batman.

Or if not The Batman, then *a* Batman. That's the continuing attraction of Robin, despite those who protest that he lightens the mood and cheapens the tone; since 1940, he's been our route, as readers, into a life as Batman's companion and sidekick, with a strong possibility of promotion. As Nolan's *The Dark Knight Rises* (2012) shows, a Robin – Robin John Blake, to give his full name – can himself take on the mantle of the bat; and the cape and cowl had already been passed on temporarily to Dick Grayson in Grant Morrison's *Batman and Robin* series of 2009-2011.

And that, surely, is the attraction of Morrison's ongoing title *Batman Incorporated*, based on a 1955 story about Batman variants in nations across the world. Like the 1950s story, the modern *Batman Incorporated* is essentially about a fan-club – they even call themselves the Club of Heroes – whose dreams come true. The Legionary, The Musketeer, the Native American Man-of-Bats and the Australian Dark Ranger are all Batman fans, invited into the official brand through a ceremony that mixes the religious with the corporate. The concept of Batman as a global organisation, rather than a single figure, enables various spin-offs and side-kicks – Blackbat of Japan, Nightrunner of Paris, Batwing of Africa – to share the title. Wayne's capitalist ownership may insist that there's only one Batman at any one time – although even that isn't certain, and he encourages the ambiguity – but there's room, across the world, for various sub-brands and subsidiaries.

Batman Incorporated functions as a fantasy articulation of a real possibility: the long-standing promise that some fans, through a combination of luck and talent, can cross over into the mainstream and become producers of official, rather than amateur content. Several online critics and lettercolumn regulars have made that transition since the rise of fandom in the 1960s – their success stories encouraging others, even though few can survive the climb and make it big – and the viral marketing for *The Dark Knight* and *The Dark Knight Rises* holds out that invitation to a broader group. By photographing themselves in Joker make-up, fans could appear on the official movie website and become incorporated into the online simulation of Gotham City; by recording themselves reciting an enigmatic mantra, visitors to an early *The Dark Knight Rises* website had their voices added to the chant of Bane's soundtrack theme. Just prior to the film's release, online devotees were encouraged to photograph chalked-up Bat-graffiti around the world and submit it to the website, to reveal a new trailer. These fans may not be named and famous, but they have, in a small way, crossed over into Batman's fiction.

Why does the Dark Knight inspire such devotion? As with Batman's branding, one answer lies in the parallels between the real world and the textual mythos. *Batman Incor-*

Foreword
Will Brooker

porated, the comic, was launched at the same time that Bruce Wayne launched 'Batman Incorporated', his global enterprise, within the comic. Every time a new Robin strikes out on his own, he earns a new monthly title. As Batwing, the first Black Batman, was initiated into the group, *Batwing* #1 hit the comic stands. Just as Coca-Cola can encourage distinctions within its empire such as Diet and Cherry Coke, so Wayne Enterprises can finance sub-franchises such as Red Robin and Batgirl, and the *Batman* line of comic book titles can embrace a whole 'family' of related titles. Developments in our world are echoed and confirmed, in stylised form, within Batman's parallel universe.

So the army of Jokers who followed viral marketing clues are a real-world equivalent of the Batman look-alikes in *The Dark Knight*, the Sons of the Batman in *The Dark Knight Returns* and the Jokerz gang from *Batman Beyond*. The chorus of voices chanting Bane's theme were visualised in *The Dark Knight Rises* as the league of thugs and mercenaries facing the Gotham City Police Department. The fans who tracked down chalk traces of the Bat-symbol in London, New York and Sydney found their own activity echoed in *The Dark Knight Rises*, as the same markings decorated the walls and benches of Batman's imaginary city.

But the parallels go deeper, and perhaps darker. Joker is Batman's greatest antagonist, but also his most adoring fan – 'you complete me', as Heath Ledger quips, recalling the decades of comic book continuity in which Joker fashioned utility belts, customised cars and even helicopters in a loving parody of Batman's style. Joker has his own fan-girl in Harley Quinn, just as Batman has his followers. Batman, we learn in one episode of *The Animated Series*, modelled his career on an earlier icon, the Gray Ghost (voiced, in the show, by 1960s Batman Adam West); we know, too, that he idolises Sherlock Holmes.

And finally, Batman would not have been created without fandom – in our world, of course, but also in his. Why did Bruce Wayne pester his parents to go to the cinema that fateful night? Because he was a fan of Tyrone Power, the actor in *The Mark of Zorro*. 'You loved it so much,' he reminds himself in *The Dark Knight Returns*. 'You jumped and danced like a fool'. Thomas and Martha Wayne died, and Batman was born, because of fandom; and in celebrating him, we echo his own childish enthusiasm and energy that evening, and we keep the adult Batman, the dark icon, alive. ●

Contributor Bio
Will Brooker is the foremost academic expert on Batman. His PhD was on Batman's cultural history from 1939-99 – published as *Batman Unmasked* (2000) and his most recent monograph is *Hunting the Dark Knight: 21st Century Batman*. He has written on Batman for various publications including *The Guardian*, *The Independent*, *Times Higher Education* and *Newsweek*, and been interviewed on television with 1960s Batman icon Adam West. Brooker is currently Director of Research in Film and Television at Kingston University, London.

Introduction
Liam Burke, Editor

→ For many, Beatlemania was the zenith of pop culture adulation, a brief moment where mere enthusiasm bubbled over into an all encompassing frenzy; but the Liverpool quartet have nothing on Gotham's guardian, Batman. Whether swinging across a canary yellow sky on his startling first comic cover, holding court in a carnivalesque 1960s' television series, headlining big screen adaptations, or his current role as the transmedia anchor of the world's largest entertainment conglomerate, the Dark Knight has prompted more periods of 'Batmania' than John, Paul, George and Ringo combined. However, it has not been all lunchboxes, Batdances and box office records across the caped crusader's seventy year-plus career.

In between the crazes there have been times when Batman has shrunk back into the shadows ignored by the world at large. Throughout these fallow periods Batman's most important ally has kept him from slipping into the same dim recesses of pop culture that claimed The Shadow, Doc Savage and so many of his antecedents and imitators. While Batman's exploits in the form of a popular series, landmark graphic novel or blockbusting film will often raise wider interest, it is the fans who, with the patience of Alfred, the loyalty of Commissioner Gordon and the unbridled enthusiasm of Robin, have sustained Batman through his darkest nights.

This collection by Batman experts and scholars will explore why, despite occasional creative missteps, poor adaptations and opportunistic tie-ins, Batman compels such devotion. It also includes interviews with a wide variety of fans, including Paul Levitz, who rose through the ranks of fandom to become the president of DC Comics, and Michael E. Uslan, who has executive produced every Batman adaptation since Tim Burton's film in 1989.

After a history of Batman from the perspective of those who know him best – the fans – the first section will consider the caped crusader's unique appeal. At the climax of *Batman Begins* (Nolan, 2005) Ra's al Ghul taunts Batman: 'You are just an ordinary man in a cape!' This is meant as an insult, but for Batman's legion of fans the hero's mortal status is his most admirable trait, with Paul Levitz explaining that in research DC Comics found that Batman was 'the most aspirational of the superheroes, people would say, I could be Batman'. This first section, which Levitz's interview opens, explores this aspect of Batman's archetype, and how reader identification has fuelled much of the character's merchandise.

In her chapter 'Dark Hero Rising: How Online Batman Fandom Helped Create A Cultural Archetype' Jennifer Dondero indentifies those elements that have come to epitomize Batman for fans, such as 'his fortitude in dispensing justice while grappling with his own humanity'. Like Dondero, Anna-Maria Covich finds many examples of readers gravitating towards Batman because of his 'humanness' in her fan study 'Heroes with Issues: Fan Identification with Batman'. As Levitz notes, part of the appeal of Batman's mortal status is that it allows fans to fantasize about becoming Batman. In 'Being Batman: From Board Games to Computer Platforms', Robert Dean explores how Batman merchandise runs the gamut from opportunistic tie-ins to more inventive entertainment that allow fans to experience a tiny semblance of what is it like to become Batman. While many fans harbour a pipe dream that they could replicate Bruce Wayne's skill and training, the reality is much more difficult as professor of neuroscience and kinesiology E. Paul Zehr notes in his book *Becoming Batman*. Zehr discusses his research in the interview that closes this section.

In *The Power of Comics*, Duncan and Smith describe traditional comic book fandom

Introduction
Liam Burke

as a 'good example of an "imagined" or virtual community where people are joined by bonds of mutual interest rather than geographic proximity'. However, every so often fans have the opportunity to interact with each other in real world locations such as comic stores, conventions or movie screenings. The second section, which considers the participatory activities of fans, is bookended by interviews with fans that have donned costumes to interact with their fellow enthusiasts.

It is not only through cosplay that fans display their enthusiasm for Batman, comic book fandom has long been a participatory culture with publishers providing spaces for reader interaction. Although initially adopting more prohibitionist policies, mainstream film-makers have begun to recognize the advantage of utilizing these media-savvy enthusiasts. In her chapter 'The Passive Case: How Warner Bros. Employed Viral Marketing and Alternate Reality Gaming to Bring Fandom Back Into the Culture Industry', Maggie Rossman identifies how the studio adapting Batman channelled fan activity in a way that furthered their marketing initiatives. Tim Posada notes how online fan communities elevated *The Dark Knight* (Nolan, 2008) as the high watermark by which other superhero films and blockbusters would be judged in his contribution 'Canonizing The Dark Knight: A Digital Fandom Response'. In the first section Dondero describes how fans will often use fan fiction to 'redeem canonically unredeemable characters'. Leslie McMurtry also identifies this practice in her analysis of the Joker fanfiction, 'Mad, Bad and Dangerous to Know: The Nolan/Ledger Joker, Morality, and the Hetero-Fictional Fan Impulse'.

The third section considers how fandom is portrayed in Batman comics and other texts. By focusing on a fan favourite episode of *Batman: The Animated Series* (1992–95), 'Beware the Gray Ghost' (1992), Joseph Darowski indentifies a number of ways in which fandom can be represented in his chapter, 'Inspired, Obsessive and Nostalgic: The Facets of Fandom In "Beware the Gray Ghost"'. In 'Villainous Adoration: The Role of Foe as Fan in Batman Narratives' Tony W. Garland explores the mutually dependent relationship between Batman and many of his villains. Garland argues that some of these relationships can be seen as a variation on the characteristics of fandom.

While 'Beware the Gray Ghost' includes some positive representations of fandom, the episode's antagonist is still a fan who has taken his interest to villainous extremes. Many entertainments, including ones with large fan followings, tend to heighten those aspects of fan culture that most greatly transgress social norms. Like 'Beware the Gray Ghost', feature films *Unbreakable* (Shyamalan, 2000) and *The Incredibles* (Bird, 2004), as well as the *Smallville* episode 'Action' (2007), feature superhero fans as villains. Such representations often ignore the positives of fandom, including how many fans have, as Duncan and Smith note, turned their 'avocation into their vocation'. For instance, *Convergence Culture* author Henry Jenkins has coined the term 'aca-fan' to describe the increasing number of media scholars that have emerged from fandom. Professor of psychology Travis Langley is one such 'aca-fan'. Langley's research includes studies

of aggressive behaviour and mass media, particularly the psychology of media fans. An interview in which Langley discusses Batman and fandom opens this section. Closing this section is an interview with Irish artist and comic store clerk Seamus Keane: like Langley, Keane's career stemmed from an early interest in comics.

Batman is at the centre of a spider's web of intertextual relations, which includes those antecedents that inspired his creation, as well as the many texts that have stemmed from his original conception. The fourth and final section considers the inspirations for Batman, as well as the character's film adaptations. While 'Beware the Gray Ghost' acknowledges Batman's debt to The Shadow, Marc Napolitano's contribution '"Elementary, My Dear Robin!": Batman, Sherlock Holmes and Detective Fiction Fandom' explores the hero's debt to another literary antecedent. Turning to adaptations, William Proctor crystallizes the moment that the increasing power of fans felled the 1990s' film franchise in 'Dark Knight Triumphant: Fandom, Hegemony and the Rebirth of Batman on Film'.

Celebrated journalist and novelist Kim Newman was reviewing films back when Michael Keaton was still *Mr. Mom* (Dragoti, 1983). Newman discusses his enthusiasm for Batman, as well as the varying fortunes of cinema's Batmen in the interview that opens this section. It is possible that without the tireless efforts of superfan Michael E. Uslan to produce a faithful adaptation of 'The Batman' this collection would not exist. That Uslan succeeded in his Herculean task is a testament to the ingenuity and determination of fandom, and so it is appropriate that an interview with Uslan, The Boy Who Loved Batman, closes this section and the book. ●

Chapter
1

Batman:
A Fan's History

Liam Burke

→ It is difficult to remember a time when the world was not in a perpetual state of Batmania. Today, Batman is the basis of a blockbuster film series, a universally-adored video game and a host of other media and entertainments. However, like the penniless Wayne in *The Dark Knight Rises* (Nolan, 2012), the character has experienced many hard times, including the post-World War II decline in superhero popularity, the camp hangover from the television series that prevented mainstream audiences from recognizing the renewed complexity of the comics, and the mid-1990s' film adaptations that pushed the Dark Knight back into the neon mire he had spent decades clambering out from. Yet, throughout, Batman fans have kept their hero at the forefront of popular culture. What follows is a history of Batman from the point of view of those who know him best – the fans.

It is appropriate, given the important role that fans have played over Batman's undulating career that the creation of the hero was, in itself, an act of fandom. Bob Kane was already an established cartoonist in 1939 when editor Vin Sullivan tasked him with creating a character to complement DC Comics' already soaring star, Superman. Kane's first attempt was the red unitard and domino mask-wearing 'Bird-Man', but fortunately for Kane (and legions of future Bat-fans), the cartoonist had enlisted the services of his frequent collaborator Bill Finger. On Finger's advice Bird-Man's colour scheme shifted to black, his mechanical wings became a scalloped cape and his domino mask morphed into a cowl with pointed ears – Batman was born.

Kane shrewdly ensured that his was the only name that would appear on Batman comics, even if he was not directly involved in the particular issue's creation. This saw many of the early innovators of Batman, including Finger, go unrecognized during the first decades of the hero's comic book career. Kane was equally as astute when it came to developing Batman, with the cartoonist, and his growing roster of ghost artists, cherry picking from the best of pulp magazines, novels and the movies. Before Batman, Zorro featured a nobleman who emerged from a subterranean lair to right wrongs, while another darkly-clad pulp hero, The Shadow, was one of the first to use theatricality and deception 'to cloud men's minds'. Stretching back before pulp magazines, Batman's analytical mind is indebted to the world's first 'greatest detective', Sherlock Holmes, while the hero's style draws on cinematic representations of Dracula and the caped killer of the 1930 mystery film, *The Bat Whispers* (dir. Roland West). This defanged Dracula with The Shadow's style and Zorro's toys may have 'borrowed' from pulp, film and literary precursors, but Batman blossomed in the superhero genre. By serving as the golden halo around the darker figure of the bat, Superman's example lifted the nocturnal vigilante out of the gutter and placed him into a new genre populated by modern mythological icons.

Batman mirrored Superman's success, and quickly annexed anthology series *Detective Comics* following his introduction in issue 27 (cover date May 1939). By Spring of 1940, Batman was rewarded with his own, eponymous title. Like *Detective Comics #27*, the cover found the hero swinging across a canary yellow sky, but now Batman was not alone, and he even seemed to be smiling. Premiering one month earlier, Batman's sidekick was introduced as 'The Sensational Character Find of 1940... Robin the Boy Wonder'. Since his addition, Robin has divided fans, with many suggesting that his Technicolour presence diminished the gritty realism of the Dark Knight, while others argue that he introduced necessary warmth to Batman's brooding austerity. However, in this era before letters pages, fanzines and the Internet, approval was registered through sales, and as

Batman: A Fan's History
Liam Burke

_Fig. 1: The first Batman
story was in Detective
Comics #27 (May 1939). By
May 1940, he was rewarded
with his own title, Batman.
Robin the Boy Wonder
first appeared in Detective
Comics #38 (April 1940)._

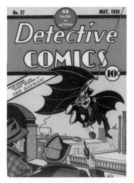 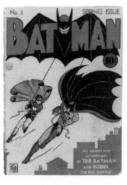 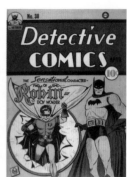

Bill Boichel notes, Robin 'was an immediate success and so widely imitated that the junior sidekick emerged as one of the most important terms in the superhero lexicon'.

In the same month Robin was introduced, Nazis troops invaded Denmark and Norway on their march across Europe. Soon comic books, many of which were produced by first generation European immigrants, joined the war effort; Duncan and Smith identify 61 patriotic comic book heroes that appeared between 1940 and 1944 including The Shield, The Patriot and most famously Captain America. The covers of _Batman_ and _Detective Comics_ during this time found the dynamic duo also doing their part. For instance, in _Batman #15_ (February–March 1943) the hero waived his 'no guns' policy by taking hold of a smoking machine gun as a caption reminded readers to 'Keep Those Bullets Flying! Keep On Buying War Bonds & Stamps!' However, Batman did not engage as fully in the conflict as those heroes created in direct response to the war effort. In _Batman Unmasked_, Will Brooker identifies only four stories during this period that can be described as 'war-related'. Nonetheless, the war effort had a massive impact on Batman fandom, as many servicemen who missed home comforts and sought escape became avid comic book readers.

While the comic book Batman may not have fully engaged in the jingoism of the time, the hero's first foray into cinema certainly did. _Batman_ (dir. Lambert Hillyer) was a low-budget serial produced by Columbia in 1943. With hyperbolic chapter titles like 'Slaves of the Rising Sun', the 15-part adventure saw the dynamic duo tackling Axis criminal Dr. Daka. Although posters promised that _Batman_ would be '[a] hundred times more thrilling on the screen!' the serial's paltry budget, with its ill-fitting costumes, cheap effects and basic sets, could not have met reader expectations. However, as Brooker explains, the serial was designed 'to reach a wider viewing public than the established Batman fan-base'. This desire to target a larger market at the expense of fan interests would be a continual source of contention across Batman's cinematic career.

A return to peacetime saw a massive lull in superhero popularity. Fortunately, as Batman was not as fully entwined with the war effort, he persevered while his Timely (today Marvel) Comics' equivalents like Captain America were cancelled. Nonetheless, Batman still had to compete for fans with the variety of genres that filled the shelves, including Westerns, romance, horror and crime books. However, soon Batman would face a greater threat than Archie or the Rawhide Kid.

In 1954 psychiatrist Dr. Fredric Wertham published _Seduction of the Innocent_ in which a post-World War II rise in juvenile delinquency was linked to comic books. Despite his later vilification, many acknowledge that Wertham, however misguided, was well intentioned, with former Spider-Man editor Danny Fingeroth describing Wertham as a 'reform-minded progressive who was responsible for many positive changes in the psychiatric care system'. Nonetheless, the doctor made a number of assumptive leaps.

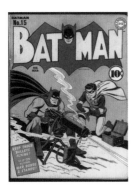
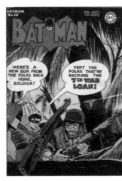
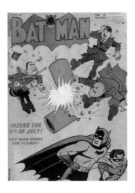

Fig. 2: On the covers of Batman and Detective Comics, Batman and Robin joined the war effort, but inside the covers the stories rarely focused on the war.

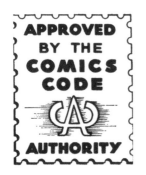

Fig. 3: The comics industry implemented the self-censoring Comics Code Authority (CCA) to pre-empt outside censorship. Only comics bearing the CCA seal would be sold through mainstream outlets.

Chiefly, he concluded that comic book fandom was a harmful activity after noticing that many of the troubled children he interviewed read comics. The focus of Wertham's campaign was the now popular horror and crime comics. Nonetheless, superheroes did not escape the good doctor's scorn with Wertham describing Batman and Robin's relationship as 'the wish dream of two homosexuals living together'.

Despite the outlandishness of Wertham's conclusions, Americans were eager to challenge any threats to their hard won peace. Ultimately, a Senate subcommittee convened to discuss the comic 'problem', prompting the comic book industry to implement the self-censoring Comics Code Authority (CCA). All comics fulfilling the Wertham-inspired criteria would receive the 'Approved by the Comics Code Authority' stamp required for comics to be sold through mainstream outlets. Consequently, comics began moving away from crime and horror stories and back to the more widely acceptable action fantasies of superheroes.

Unfortunately for fans, the restrictions of the CCA meant that only the most anaemic stories made it onto the shelf. For instance, to avoid any further questions regarding the appropriateness of Batman and Robin's relationship, Batman was repositioned as the head of a 'Batman Family' with the addition of Batwoman (1956), Batgirl (1961) and Ace The Bat-Hound (1955). However, even before the CCA, Batman comics had been in a creative tailspin, with the 1950s stories becoming an increasingly surreal mix of garish covers, sci-fi clichés and imaginary tales, which reached its apotheosis with the 1959 introduction of Bat-Mite, an imp-like extra-dimensional Batman fan. If fans ever wanted to see a return to the Dark Knight they would need to get organized, gain industry recognition, and demand change – they needed to become a community.

Comic book fandom began in earnest in the 1960s, with many of its developments predicated on narrowing the boundaries between creator and fan. At DC Comics legendary editor Julius Schwartz began printing reader letters, thereby enabling fans to communicate their desires to the creators. It was through these letter pages that the uncredited writers and artists would finally get the recognition they deserved, as devoted readers would make educated deductions as to which writers and artists were responsible for the stories still credited to Bob Kane. Demonstrating the influence fans were beginning to wield, by 1968 DC Comics were including the bylines for all artists and writers.

Letter pages not only fostered dialogue between fan and creator, but also fan and fan, as like-minded readers began to contact each other. These newly-formed networks fostered the wider circulation of fanzines as well as the emergence of dedicated comic book conventions. Mainstream media began to take notice with a 1965 *Newsweek* article, 'Superfans and Batmaniacs' describing 'comic cultists' who 'have the enthusiasm of rare stamp collectors'. Soon this newly consolidated fanbase began to enjoy a 'New

Batman: A Fan's History
Liam Burke

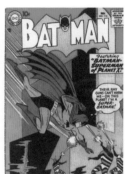

Look' Batman, which was really a return to the hero's dark detective origins. However, this revival was to be short-lived.

In the mid-1960s American network ABC was eager to attract a family audience to its lucrative 7:30pm slot. With high production values, committed leads (Adam West and Burt Ward) and A-list guest villains (Frank Gorshin, Cesar Romero, Vincent Price etc.), *Batman* the television series was a smash hit when it premiered on 12 January 1966. The series managed to engage adults and children alike by blending self-aware moments with sound effect-punctuated action sequences. Soon, West's Batman was appearing on the cover of *Life* magazine, starring in a spin-off feature film and adorning an endless array of merchandise.

Nonetheless, with its canted angles, endless puns and knowing allusions to the ridiculousness of the concept, the *Batman* series disappointed, if not outright antagonized, comic book fans, particularly as the 'New Look' Batman comics began to emulate the show in an effort to entice new readers. However, unlike earlier unfaithful adaptations, fans now had forums where they could voice their discontent. Brooker quotes a letter from *Detective Comics #353* (October 1966) which was typical of reader criticism:

'Camp' has only been around for one or two years, and already every article on the subject predicts that the fad will vanish in a couple of months. Batman will still be around long after 'camp' is gone, unless he starts trying to be so bad he's good – and winds up so bad he's gone.

Despite initial success, the joke soon wore thin and *Batman* was cancelled after three seasons. In predicting the faddish nature of camp, the above letter seems incredibly prescient, but what strident comic book fans will often fail to recognize is that despite the innovations of Batman's 'New Look' comics, the books struggled to compete for readers with Spider-Man and the other more grounded superheroes being introduced at Marvel. Without the interest generated by the series there is a chance that Batman would not be the potent pop culture force he is today.

In his autobiography *Back to the Batcave*, Adam West describes his relationship with the series' many followers: 'Batman touched the child in viewers, and that has always made for a very special bond with the people I meet'. As the interviews in this collection attest, many of today's fans' earliest recollection of Batman is not the comics, but rather Neil Hefti's mantra-like theme song, Burt Ward's spirited puns, and Adam West's unshakable delivery. In this regard *Batman* the series was unique; it was the first time that the character had successfully ventured beyond his native medium and gathered groups of fans that had never read comics. For a brief moment in 1966 it seemed as if the entire world became Batman fans. While this 'Batmania' was over almost as soon as

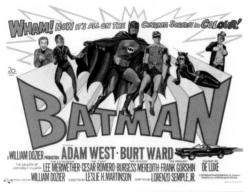

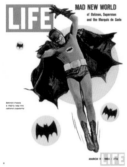

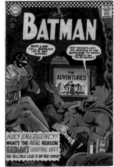

Fig. 5: The success of the Batman television series gave rise to a spin-off feature film, as well as a Life magazine cover. However comic book readers were unhappy with this camp approach, which the comic creators articulated on the cover of Batman #183 (August 1966), wherein the caped crusader appeared more interested in watching himself on TV than fighting crime.

it begun, it would return.

The quick cancellation of Batman left the comics in a difficult position, with Denny O'Neil noting, 'when the camp fad was over the comic books weren't'. As writer, and later editor, O'Neil helped Batman reclaim his mantle as a dark detective. Typical of O'Neil's approach was, 'The Joker's Five Way Revenge' in Batman #251 (September 1973). During the 1950s, Batman's villains had been attenuated to colourful pranksters who would occasionally rob banks. O'Neil's story, with photorealist, full-figure art by Neal Adams, returned the violent, chalk-faced gangster of the Kane-Finger era, and set a template for future interpretations, including the 1989 film.

The 1970s saw further consolidation of comic book fandom as direct distribution through newly-established comic stores meant that older readers could now buy comics without facing derision from supermarket cashiers. Consequently, the average age of readers increased and collecting became commonplace. These bastions of comic book fandom, however, were uninviting to outsiders. Thus, the greater depth and complexity of the 1970s' comics went unacknowledged by a wider world that still associated Batman with Adam West's Technicolour pratfalls. By 1985, sales in Batman comics had reached an all-time low. Into that malaise, the landmark graphic novel The Dark Knight Returns would hit like the lightning bolt that crackled across its cover.

In the 1980s, the fan interest in creators had developed into a fully-fledged star system. One of the most popular creators was the noir-influenced writer/artist Frank Miller. Released in 1986, Miller's The Dark Knight Returns was a genre redefining four-part limited series that extrapolated from 1980s America a bleak, near-future Gotham mired by unchecked crime and political corruption. Out of this maelstrom rose a 55-year-old Batman who believed that 'the world only makes sense when you force it to'. Written with a Clint Eastwood drawl, and drawn like a bare-knuckle boxer, this vivid reinterpretation, repackaged as a bookstore-friendly graphic novel, garnered widespread media attention and a darker knight started to supplant the caped crusader in public perceptions.

To motivate further interest, DC embarked on an initiative that took fan participation to a new level. By the 1980s, Dick Grayson (the original Robin) had matured into Nightwing, leader of the Teen Titans. To take over from the grown-up Grayson the publisher introduced streetwise orphan, Jason Todd. However, while some fans never fully embraced Grayson, there was widespread hatred of Todd. In this era of greater reader involvement, Denny O'Neil opted to let the readers decide via a phone poll whether Robin would live following a vicious beating from the Joker. By a narrow majority fans

Batman: A Fan's History
Liam Burke

*Fig. 6: Batman #251
(September 1973) saw the
reintroduction of the Joker
as a homicidal gangster.
The Dark Knight Returns
(February 1986) and 'A Death
in the Family' in Batman #428
(December 1988) helped
further reposition Batman as
a nocturnal vigilante.*

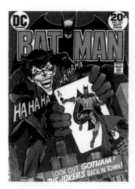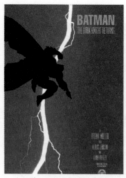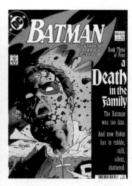

decided that Robin should die in *Batman #428* (December 1988). The stunt garnered widespread attention, with *USA Today* proclaiming 'The Boy Wonder is dead, and the readers of DC Comics' Batman want it that way', as well as much criticism, with Frank Miller suggesting that it was 'the most cynical thing that particular publisher has ever done'. Cynical or not, Robin's death further repositioned Batman as a 'dark' character, a process that would be completed the following year, the character's 50th, with the release of *Batman* (Burton, 1989).

Since the 1980s, entertainment lawyer and comic collector Michael E. Uslan had been trying to produce a faithful adaptation of 'The Batman'. As a fan, Uslan understood the importance of getting the readers on board, and in 1980, flanked by DC Comics publisher Jenette Kahn and creator Bob Kane, he announced the project at the New York ComicCon. This unusual step, which is commonplace today, was designed to galvanize reader support, but as the film moved towards production at Warner Bros. there was growing discontent among the fanbase as some creative decisions, such as the casting of comedic actor Michael Keaton as Batman, seemed to contradict Uslan's promised faithful adaptation.

The film's 30-year-old director, Tim Burton, seemed unfazed by reader dissatisfaction, stating, 'This is too big a budget movie to worry about what a fan of a comic would say'. Burton may not have worried about what 'a fan' would say, but Warner Bros. were very concerned about what 50,000 of them would. During production, fans began a letter-writing campaign to protest the humorous direction the adaptation was perceived to be taking. It was not long before the negative reader response roused wider interest, including a *Wall Street Journal* front-page article, 'Batman Fans Fear The Joke's on Them in Hollywood Epic'. Commentators soon began linking reader discontent to the studio's declining share price. In response, Warner Bros. hastily cut together a suitably 'dark' trailer, which successfully allayed readers' concerns. Elevated by Jack Nicholson's turn as the Joker and Burton's distinctive gothic style, *Batman* broke box office records and ushered in a new era of Batmania, with everything from T-shirts to candy branded with the distinctive Bat-logo.

In addition to its financial success, *Batman* managed to finally banish the image of the camp crusader and bring mainstream audiences back to the comics, with Paul Levitz noting, 'We spent that summer sitting around the conference table literally figuring out how we could get more paper to print more books'. In an ultimately futile effort to maintain these high sales, the publishers increasingly relied on fans. Comic book collecting reached its saturation point in the early 1990s with the creation of a speculation market. Exploiting this trend, publishers began to produce comics that catered to collectors, as well as epic storylines like *Knightfall* that required readers to buy multiple

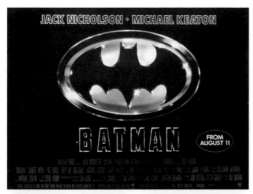

Fig. 7: Batman (Burton, 1989) reintroduced a darker hero to mass audiences and was a major success, but by 1997 the release of the more tongue-in-cheek Batman & Robin (dir. Joel Schumacher) sent the series into hibernation until Christopher Nolan's more faithful Batman Begins (2005) revived the franchise.

issues. Inevitably the speculation market crashed sending the industry into a steep decline. Compounding dwindling sales, Batman's cinematic career was about to come to an abrupt halt with the film that writer Grant Morrison credited with 'turning a money-spinning film franchise into a radioactive turkey cat dinner'.

Following the superior sequel *Batman Returns* (1992), Tim Burton left the franchise to be replaced by *The Lost Boys* (1987) director Joel Schumacher. His first franchise entry, 1995's *Batman Forever* maintained enough of Burton's influence to stifle the director's penchant for day-glo spectacle, but his 1997 follow-up, *Batman & Robin*, was an unbridled return to the camp crusader of the 1960s' series. The film ultimately underperformed at the box office, and reviewers and fans vilified Schumacher.

Across the history of Batman, fans challenged infidelities using the forums available to them. Nonetheless they were often ignored as, despite their enthusiasm, they were only a small subset of a blockbuster audience. However, in the late 1990s, the already networked fans were uniquely positioned to take advantage of the Internet. When making *Batman* for Warner Bros. Burton dismissed the opinions of 'a fan', but a mere eight years later Warner Bros. marketing chief Chris Pula saw one fan as a major threat, saying 'one guy on the Internet could start enough of a stir that causes a reactionary shift in the whole marketing program'. Like Burton before him, Schumacher dismissed fans as a 'cult', with *Entertainment Weekly* reporting that he blamed negative pre-release buzz on 'an unpoliced Internet'. Schumacher may have been attempting to deflect personal criticism, but his argument has some veracity; from letters pages to websites, fans are more inclined to listen to their peers than publicity material. Furthermore, mainstream publications will often pick up on fan debate, positive or negative, thereby enabling it to proliferate beyond fan forums. Whereas in pre-digital times *Batman & Robin* may have been forgotten by the wider world, fans ensured that the film's infamy would echo through cyberspace.

To avoid a similar debacle, Warner Bros. showed unprecedented reverence to the source material and the fans when they rebooted Batman in 2005, with director Christopher Nolan and his co-writer David S. Goyer referencing many fan-favourite comic books – such as *Batman: Year One* – when promoting the adaptation. This comic book continuity clearly chimed with online fans, with Ben Fritz noting in a prescient 2004 *Variety* article: 'On fan sites across the Internet, users are giving rave reviews to images of the new Batmobile and casting decisions like Christian Bale'. Ultimately, *Batman Begins* (Nolan, 2005) rehabilitated Batman's big-screen image before the universally adored sequel, *The Dark Knight* (Nolan, 2008), ushered in a new era of Batmania. As Batman

Batman: A Fan's History
Liam Burke

Fig. 8: The many deaths of Batman. Batman R.I.P. (May–November 2008) and The Dark Knight Rises (Nolan, 2012) conclude with the hero's apparent death, while in Whatever Happened to the Caped Crusader? (2009) writer Neil Gaiman suggests a number of potential ends for Batman.

neared his 75th anniversary, his prospects had never seemed brighter. And then he died.

Writing in 1972, novelist Umberto Eco observed that Superman stories were told in an 'oneiric climate', which stemmed from the publisher's efforts to avoid character development, as any progression 'would have taken [Superman] a step toward death'. Uricchio and Pearson make a similar assessment of Batman, describing him as a 'Gotham Sisyphus who can never reach the crime-free summit of the mountain'. However, over the last few years Batman has experienced a number of status quo changing shifts. In the comics he became a father, adopting the third Robin, Tim Drake, and accepting into the fold his wayward son Damian, while *The Dark Knight Rises* introduced a Howard Hughes-like Wayne whose body is failing him. As Eco predicted, with this progression came death.

Appropriately for a character that enjoyed many lives, he also faced a number of deaths. In the comics Grant Morrison seemed to end Bruce Wayne's career in a helicopter explosion over Gotham Bay at the climax of multi-part story arc *Batman*

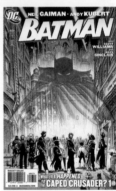

R.I.P. Echoing this comic, *The Dark Knight Rises* sees Batman saving Gotham by towing a nuclear bomb away from the city in a final self-sacrificing action. Although the film, like *Batman R.I.P*, reveals that Bruce Wayne survived the explosion, Christopher Nolan's trilogy-closer offered a degree of closure unmatched by any superhero franchise when Bruce is seen relaxing in a Florence café having finally hung up the cape and cowl. Rather than settle on one death, fantasy writer Neil Gaiman suggested several in the continuity-blending comic *Whatever Happened to the Caped Crusader?*, which finds a collection of Batman's supporting characters offering conflicting, yet no less fitting eulogies for the Dark Knight. However, with each death Batman returns, rises and begins again. Despite a brief 'Rot In Purgatory' (the true meaning of the acronym *Batman R.I.P.*), Bruce Wayne was back in the comics to reclaim his mantle, while *The Dark Knight Rises* made good on *Batman Begins*' promise for the hero to become an 'everlasting' symbol with the series' final moment finding a new vigilante, former-Gotham police detective John Blake, literally rising.

As the gatekeepers of Gotham, fans have stood vigil over a seventy-year mythos, ensuring their icon has become more than a comic book character, cartoon hero or big-screen star. As this collection will attest, through the patronage of fans Batman has become what Ra's al Ghul predicted in a dank cell at the start of *Batman Begins*: a legend. ●

~~~~~~~~~~~

## GO FURTHER
*Books*

*Batman and Psychology: A Dark and Stormy Knight*
Travis Langley (Hoboken, NJ: John Wiley & Sons, 2012)

*Hunting the Dark Knight: Twenty-first Century Batman*
Will Brooker (London: IB Tauris, 2012)

*The Boy Who Loved Batman: A Memoir : The True Story of How a Comics-obsessed Kid
Conquered Hollywood to Bring the Dark Knight to the Silver Screen*
Michael E. Uslan (San Francisco: Chronicle, 2011)

*75 Years of DC Comics: The Art of Modern Mythmaking*
Paul Levitz (Köln: Taschen, 2010)

*The Power of Comics: History, Form and Culture*
Randy Duncan and Matthew J. Smith (New York: Continuum International Group, 2009)

*Becoming Batman: The Possibility of a Superhero*
E. Paul Zehr (Baltimore: Johns Hopkins University Press, 2008)

*Superhero Movies*
Liam Burke (Harpenden: Pocket Essentials, 2008)

*The DC Vault: A Museum-in-a-book Featuring Rare Collectibles from the DC Universe*
Martin Pasko (Philadelphia: Running, 2008)

*Burton on Burton*
Tim Burton and Mark Salisbury (London: Faber & Faber, 2006)

*Superhero: The Secret Origin of a Genre*
Peter M. Coogan (Austin: MonkeyBrain, 2006)

*Convergence Culture: Where Old and New Media Collide*
Henry Jenkins (New York: New York University Press, 2006)

*Fans, Bloggers, and Gamers: Exploring Participatory Culture*
Henry Jenkins (New York: New York University Press, 2006)

*Superman on the Couch: What Superheroes Really Tell Us about Ourselves and Our Society*
Danny Fingeroth (New York: Continuum, 2005)

*Comic Book Encyclopedia: The Ultimate Guide to Characters, Graphic Novels, Writers,
and Artists in the Comic Book Universe*
Ron Goulart (New York: HarperEntertainment, 2004)

**Batman: A Fan's History**
Liam Burke

*Comic Book Movies*
David Hughes (London: Virgin, 2003)

*Comic Book Nation: The Transformation of Youth Culture in America*
Bradford W. Wright (Baltimore: Johns Hopkins University Press, 2003)

*The Great Comic Book Heroes*
Jules Feiffer (Seattle: Fantagraphics, 2003)

*Fan Cultures*
Matthew Hills (New York: Routledge, 2002)

*Batman Unmasked Analyzing a Cultural Icon*
Will Brooker (New York: Continuum, 2000)

*Batman: Animated*
Paul Dini and Chip Kidd (New York: HarperCollins, 1998)

*Comic Strips and Consumer Culture, 1890–1945*
Ian Gordon (Washington, D.C.: Smithsonian Institution, 1998)

*The Dark Knight Returns*
Frank Miller, Klaus Janson and Lynn Varley (London: Titan, 1997)

*The Art of the Comic Book: An Aesthetic History*
Robert C. Harvey (Jackson: University of Mississippi Press, 1996)

*Back to the Batcave*
Adam West and Jeff Rovin (New York: Berkley, 1994)

*The Many Lives of the Batman: Critical Approaches to a Superhero and His Media*
Roberta E. Pearson and William Uricchio (New York: Routledge, 1991)

*Batman & Me: An Autobiography*
Bob Kane and Tom Andrae (Forestville, CA: Eclipse, 1989)

*Comics & Sequential Art*
Will Eisner (Tamarac, FL: Poorhouse, 1985)

*The World of Fanzines: A Special Form of Communication*
Fredric Wertham (Carbondale: Southern Illinois University Press, 1973)

*Seduction of the Innocent*
Fredric Wertham (New York: Rinehart, 1954)

### Essays/Extracts/Articles

'Net heads finally get some respect' by Ben Fritz
In *Variety*, 11 April 2004, Available at: http://www.variety.com/article/VR1117903071.ht
ml?categoryid=1009&cs=1&query=%27Net+heads+finally+get+some+respect.

'Batman: one life, many faces' by Will Brooker
In Deborah Cartmell and Imelda Whelehan (eds). *Adaptations: From Text to Screen,
Screen to Text* (London: Routledge, 1999), pp. 185–98.

'Comic book fandom and cultural capital' by Jeffrey A. Brown
In *The Journal of Popular Culture* (30.4), 1997, pp. 13–31.

'WWW.H'W'D.TICKED' by Rex Weiner
In *Variety*, 29 July 1997, Available at: http://www.variety.com/article/VR1116675713.
html?categoryid=1009&cs=1.

'Reshooting down the rumors' by Pat E. Broeske
At *EW.com*, 6 June 1997, Available at: http://www.ew.com/ew/article/0,,288247,00.html.

'Batman: commodity as myth' by Bill Boichel
In Roberta E. Pearson and William Uricchio (eds). *The Many Lives of the Batman:
Critical Approaches to a Superhero and His Media* (New York: Routledge, 1991), pp. 4–17.

'Batman, deviance and camp' by Andy Medhurst
In Roberta E. Pearson and William Uricchio (eds). *The Many Lives of the Batman:
Critical Approaches to a Superhero and His Media* (New York: Routledge, 1991), pp. 149–163.

'"Holy commodity fetish, Batman!": The political economy of a commercial intertext'
by Eileen Meehan
In Roberta E. Pearson and William Uricchio (eds). *The Many Lives of the Batman:
Critical Approaches to a Superhero and His Media* (New York: Routledge, 1991), pp. 47–65.

'Notes from the Batcave: an interview with Dennis O'Neil' by Roberta E. Pearson and
William Uricchio
In Roberta E. Pearson and William Uricchio (eds). *The Many Lives of the Batman:
Critical Approaches to a Superhero and His Media* (New York: Routledge, 1991), pp. 18–32.

'The myth of Superman' by Umberto Eco
In *Diacritics* (2.1), 1972, pp. 14–22.

'Superfans and Batmaniacs'
In *Newsweek*, 15 February 1965, p. 89.

# **Part 1**
# Being Batman

# Fan Appreciation no.1
## Paul Levitz

Like many of today's comic book professionals, Paul Levitz rose up through the ranks of fandom. Levitz started out as the publisher and co-writer of the fanzine *The Comic Reader*. Building on his connections in the industry, Levitz gained freelance work writing DC Comics in the early 1970s before becoming an assistant editor to Joe Orlando on *Adventure Comics* at the age of 20. Over his 35 year-plus career at DC Comics, Levitz has held many roles, including serving as the editor of a number of Batman comics. In 2002 Levitz became the president of DC Comics, a position he held until 2009. Today Levitz continues to write comics such as *World's Finest*. He also lectures on transmedia at Columbia University and is the author of the epic history of DC Comics, *75 Years Of DC Comics: The Art Of Modern Mythmaking*, which was published in 2010.

**Liam Burke:** *Why do you think Batman compels such devotion among fans?*
**Paul Levitz:** I think there are a couple of driving forces on Batman. One, over the years we consistently hear in research that he was in many ways the most aspirational of the superheroes; people would say, 'I could be Batman, If something terrible happened to my parents I could do that, I could find the way'. It is not necessarily the most realistic response, but there is an emotional connection made on that level.

The other factor, certainly in the last forty years, is that you can make a pretty good argument that the peaks of quality of execution on Batman were higher and more frequent than other major DC heroes. I won't draw comparisons to Marvel or other publishers, but within their own pack, if you stack up what are generally acclaimed to be the best Superman stories, that's a nice stack out of the last forty years. Your stack of Wonder Woman is a lot thinner, your stack of Green Lantern has some very long gaps in it, but Batman is a pretty thick stack and pretty recurrent.

**LB:** *Across the decades there have been many different interpretations of Batman. Do you have a preferred version?*
**PL:** No, I think part of what's wonderful about him is there are so many different versions. I mean I'm old enough that I fell in love with the Dick Sprang Batmobile as a kid in the reprint editions that were coming out. I loved the Gardner Fox and Carmine Infantino stories that were coming out fresh when I was eight or nine. When Denny [O'Neil] and Neal [Adams] took over and were at their peak, some of that stuff blew me away. The other great moments I had some kind of professional involvement with, and therefore comes from another corner of the brain.

**Fan Appreciation no.1**
Paul Levitz

**LB:** *Comic books seem to facilitate the transition from fan to creator more easily than other entertainments – why do you think that is?*
**PL:** I think comics have several things going for them that make them appear more attainable, particularly to young people. First of all they are a medium that historically, at least in the US, has a disproportionate appeal to young people, and that's the age at which people begin to think about what they can do creatively.

Until the last five years or so, the means of production of film or television were way beyond the average young person's reach, so that tends to be a barrier to experimentation in that direction. The attention span required to create a book of prose, even badly, is significant. Comics on the other hand, historically, have often been presented in fairly short forms with a wide variety of visual styles, often very simple in their drawing, so the apparent barriers to entry are not as high. I think that is part of why you had the big level of experimentation, particularly in the last fifteen or twenty years, with mini-comics, self-publishing and micropublishing.

**LB:** *Do you have a favourite Batman villain?*
**PL:** I was always a great fan of Catwoman: as an editor I did the first stories where we began to look at Catwoman as a romantic partner for Batman, and as an anti-hero with a fairly heroic dimension. As a writer I wrote the first story that prophesied what would happen if they married, so I always found her fascinating. I got to write a few more panels of the current 'Earth-2' version of Catwoman in the last couple of months for [comic book] *World's Finest*, and I've just had enormous fun with her.

**LB:** *Where do you think Robin fits into the mythos?*
**PL:** Most literary analysts will make the argument that young people want to read about protagonists who are slightly older than they are, at the next stage of whatever's going on. I think when Robin was created in 1940, the perception of comics was that a massive proportion of the readership was very, very young and so Robin was the right age and it connected, setting a trend for a lot of things. Flash forward to the beginning of the direct sales/comic shop era in the early 1980s when we were doing *New Teen Titans* with Marv [Wolfman] and George [Pérez]. At that point most of our readers were 16 to 18 years old, and Robin felt very young. So I think that's a lot of what drove the recreation of Dick Grayson as Nightwing. I think that was a success, but there was still a need to have a Robin in the DC mythology for merchandising and movies and all those things. Some of those replacements succeeded, some were a bit more problematic, but I

think that remains the challenge.

**LB:** *Since* X-Men *in 2000 [dir. Bryan Singer] there seems to have been an unprecedented number of comic book film adaptations. Why do you think that is?*
**PL:** First of all you reached a point with the technology where it permitted you to make a beautiful, visually imaginative superhero. That was a very, very challenging thing to do at the time of the Christopher Reeve movies [Donner, 1978]. If you spent a humongous amount of money, and you physically tortured your actors enough, you could pull it off, but it was very difficult. By the year 2000, the technology existed to do it in a much more flexible manner and demonstrate a wider variety of superpowers, with the special effects that were financially prudent and visually satisfying.

Second, and equally important, by and large the generation of directors who have done the wonderful comic book movies, maybe from Tim [Burton]'s time on, were people who read comics, loved them and wanted to recreate the joy they had as readers in the medium that they were the masters. I don't think that group of people was as large before that, and I don't think that the ones who were there had memories of comics that were as sophisticated, or, to put that another way, as suitable in terms of being raw material to translate to film.

**LB:** *Why do you think there is such fan insistence on fidelity to the source in adaptations?*
**PL:** I think fans insist on fidelity to the *essence* of the character because, while it is a very hard thing to put into words, it is something that is peculiarly easy to get a consistent opinion on. The hive mind recognizes what is good in a character and they want that to come through. One of my early mentors, Joe Orlando, made the argument that in comics the reader knows sincerity in creative work: they would rather enjoy a piece of creative work that is done imperfectly, but sincerely, than a piece of work that's very polished and full of craft, but somehow doesn't have the sincerity. I think that's generally true in most media, and that sense of fidelity is one of those forms of sincerity. This person really loved the character, loved the stories and is trying to recreate the experience that he and we all had, and bring that to life.

**LB:** *Do you think the wider status of fans has changed over the years?*
**PL:** When I was doing *The Comic Reader*, which was basically a TV guide for comics in the early 1970s, there was a period where, for a fairly brief

## Fan Appreciation no.1
Paul Levitz

time, Marvel decided they shouldn't release any material to the fanzines because it wasn't fair for the fans to know any more than the readers did. So the only way you would find out what was going on in the books was from the books themselves. Now you have the whole world, not just the comic book publishers, but all forms of entertainment, and marketing traipsing down to places like Comic-Con in San Diego to tell people that 'these are the toys that are coming out next year', 'these are the costumes that are coming out next year' and 'meet the actors in the movie that'll be coming out next year'. That's a massive shift in the attitudes toward fan culture. The world has come to recognize the power of opinion leaders in pretty much every category, including entertainment.

I think the other shift that's critically powerful is embodied in Bill Gates. I think the generation I grew up in, the kid who was a science buff playing with his science fair project was not extraordinarily well regarded in society. The stars remained the kid who played football really well, and if you had the choice between being the football kid and the valedictorian, most kids would have taken the football star. I think that we're living in a time where geeks have made a powerful cultural shift that says: being a book worm, being a geek, being a science kid with your nose in the book, maybe that's a good thing. You may not end up a billionaire, but you are a cool part rather than an awkward part of the equation, and that's a wonderful shift.

We celebrate the geeks. Today a banker could have a Dilbert statue sitting on his desk, a librarian might have a librarian action figure, someone else might have a Star Trek Enterprise model sitting on their desk or mirror. A generation ago, nobody would have done any of those things, except maybe the craziest and bravest of fans. One young woman made the remark to me, 'what I really like I tattoo onto me'. She was saying that metaphorically rather than literally – although there certainly are people walking around sporting Batman tattoos and the work of specific comic book artists – but what she really meant was: 'If I like something, I'm really happy to have the world know it and see it in everything I do', and that was only an acceptable behaviour a generation ago with regard to your sports teams and maybe your religion. ●

# YOU EITHER DIE A HERO OR YOU LIVE LONG ENOUGH TO SEE YOURSELF BECOME THE VILLAIN.

**HARVEY DENT**
THE DARK KNIGHT

Chapter
2

# Dark Hero Rising: How Online Batman Fandom Helped Create A Cultural Archetype

Jennifer Dondero

→ 'Starting today, we fight ideas with better ideas. The idea of crime with the idea of Batman'.
  - *Batman: The Return of Bruce Wayne*

### From popularity to myth

Congratulations, Batman fandom; you have created a legend. With the exception of Superman, no other comic book character has achieved the epic status currently enjoyed by Batman in terms of popularity or societal relevance. More than a mere character, Batman has become a cultural juggernaut and an immediately recognizable beacon of justice worldwide. While comic creators, television producers, and film-makers share the credit, Batman owes perhaps the greatest debt to fandom, which has been remarkably instrumental in shaping Batman as an archetypal icon.

In the last 25 to 30 years, Batman has dramatically risen in popularity and undergone a major character overhaul. Historically, Batman was portrayed as a crime-fighter avenging his parents' death and a hero defeating campy villains with gadgets and sidekicks. In the 1980s, however, Batman graphic novels such as Frank Miller's 1986 comic mini-series *The Dark Knight Returns*, and Tim Burton's 1989 *Batman* film, began an era of portraying the darker side of Batman by revisiting the pulp roots of the character. However, Batman's resurgence in the 1980s marked the first character exploration of Batman in terms of psychological depth and purpose as a superhero. As Frank Miller states in his introduction to the 2006 edition of *The Dark Knight Returns*, 'Much of what I was after was to use the crime-ridden world around me that needed an obsessive, half-maniac genius to bring order'. What Miller gave Batman fans was authorial intent about the nature of Bruce Wayne as a character, and we can thank Miller for the idea that Batman is the kind of hero who responds to the needs of the people, even if it means walking a darker path.

Comic book fans and mainstream media embraced this new version of Batman. Tim Burton's *Batman* was one of the highest grossing films of 1989. Batman merchandise flew off the shelves, the colour palette for Batman comics became bleaker as the Bat Symbol became an icon of vigilante justice. Fans began to replace Adam West and brightly coloured comic panels with a darker hero. By the early 1990s, old and new fans embraced Batman as a hero for a new era, a champion who – more so than his comic book contemporaries – could represent justice in a corrupt, post-Vietnam world. Subsequently, Batman has transcended canonical material to become an enduring cultural archetype. To put it another way, Batman is no longer just a fictional character we see in fictional stories. He is a cultural icon that fans and creators have turned into an archetypal hero who represents mortal justice and humanity.

Archetypes, according to Swiss psychologist Carl Jung, are meaningful figures and symbols in our culture that represent our collective ideas of the best and worst parts of humanity. We see these figures in our own lives and celebrate them in our stories. For instance, the Wise Old Man figure is a Jungian archetype that emerges time and again in traditional storytelling to offer wisdom and guidance to the main characters. Obi-Wan Kenobi from *Star Wars* and Gandalf from *The Lord of the Rings* are two basic examples. In real life, many people consider elder family members or professional men-

**Dark Hero Rising:**
**How Online Batman Fandom Helped Create A Cultural Archetype**
Jennifer Dondero

*Fig. 1: Batman's inner and outer world is much darker than that of his superhero counterparts.*

tors Wise Old Man figures. In addition to traditional Jungian archetypal figures, highly celebrated popular culture characters can sometimes be thought of as modern Jungian archetypes in that they oftentimes represent what we value as a society. The 'All-American Hero' is an example of a modern cultural archetype. Pop culture, media and especially fans might build up characters such as Superman or real-life sports heroes to embody this archetype. As a collective, we create these archetypes because we like the idea of them; we want to invest in what this archetype represents for us. For a fictional character to become a permanent archetypal fixture in culture, you need more than canon material and authorial intent about that character. You need fans, and you need those fans to celebrate and spread the ideas they love about their character until these ideas seep into our cultural consciousness.

Which brings us to Batman. From a traditional Jungian perspective, Batman most readily fits in with The Shadow archetype, which can be defined as an archetypal figure who represents the things we want to keep hidden from our conscious selves, such as immoral tendencies or things that we find emotionally painful. As comic creators and film-makers devote more attention to Bruce Wayne's tragic childhood and moral struggles, the more fandom and scholarly literature understands Batman as a modern 'Dark Knight' who faces and even utilizes the darker side of his nature to fight crime. As noted by Batman scholar Will Brooker in his 2000 book *Batman Unmasked*, Batman is so prevalent in our cultural imagination he has become a mythic figure who embodies what we want to see in a modern heroic archetype: a champion who grapples with the dark, emotionally troubling side of his humanity to rise as a hero next to godlike, morally upstanding figures such as Superman.

Of course, none of this would be part of the cultural landscape without Batman gaining popularity as a character. Since his conception, Batman's presence in pop culture is staggering. From the 'Batmania' in the 1960s that surrounded the Adam West television show to the present-day, Batman is, in terms of numbers, the most popular superhero. This is evident in how completely the Batman brand has leaked into mainstream culture. With the advent of the Internet, fan culture has become even more immediate and participatory. As of this writing, a quick Google search of Batman currently yields around 322,000,000 results, which easily outnumbers Superman (164,000,000), the X-Men (162,000,000), and the recently popular Marvel Avengers (262,000,000). Batman also continually generates high volumes of fan-driven content on websites like fanfiction. net and Tumblr, where memes, fanfiction and fanart are present for nearly every incarnation of Batman.

The rise of Batman in popular culture is noteworthy in that fandom is largely responsible for the popularity of the current, darker version of Batman. The last three decades have seen a symbiotic relationship between fans and creators of Batman comics,

television and film. With the advent of geek culture and digital media, the opportunity for Batman fans to celebrate and generate content related to Batman has dramatically increased, and the results are telling. Internet fan videos, memes, and other such media collectively demonstrate what Batman represents to his fans, and it is easy to see some of those concepts reflected in current canon material. This type of back-and-forth relationship between fans and creators is common enough in any fandom, but Batman seems to be a special case where authorial intent and fan response have evolved together. Beginning with Frank Miller's influence in the 1980s, Batman has been built up as a paragon of justice in a corrupt world. The overwhelmingly positive fan response to this aspect of Batman has led to canonical material that almost exclusively explores Batman through this lens to the point where the themes about Batman as a character often take precedence over the narrative of the story being told. From a cultural standpoint, this puts Batman among the ranks of the few iconic pop culture creations that transcend existence as individual characters. To fans, Batman is a cipher, a modern mythic figure, where the brand and idea of Batman are just as powerful as the character himself.

### How memes and fandom help make cultural icons

An exploration of the significant influence of the Batman fandom must begin with a brief overview of how fandom can influence culture. The word 'meme' almost immediately brings to mind the popular macro images and videos that are virally passed around the Internet, but memes are also an area of study in the social sciences. People who study memes are interested in seeing what ideas groups of people replicate and pass around to one another. In essence, memes indicate what ideas we, as a culture, want to evolve and survive. The same concept holds true in fandom. The ideas we have about stories or characters are inspired by canonical material and given life through fan participation. Some ideas in fandom deviate so far from canonical material, they have to exist on in the 'mind canon' or 'head canon' of fans. This could include supporting a relationship between two characters that want nothing to do with each other in canonical material, producing fan material that brings dead characters back to life, or fan material that redeems a canonically unredeemed villain. Batman fans are lucky in that some of the main ideas celebrated in popular fandom material – ideas having to do with Batman dominating his teammates and enemies while having very human struggles – are reflected in canon.

If we agree to loosely define memes as ideas and images that are replicated and widely spread, an examination of some of the more prevalent Batman memes and pictorial representations will reveal the ideas fandom has about Batman as an archetypal character. Specifically, Batman memes and videos seem to call attention to the idea that Batman is a harbinger of justice and that Batman is fundamentally mortal. Most superheroes explore these themes in one way or another, but Batman is the only one who has leaked into our collective unconscious as a cultural representative of these

# Dark Hero Rising:
## How Online Batman Fandom Helped Create A Cultural Archetype
Jennifer Dondero

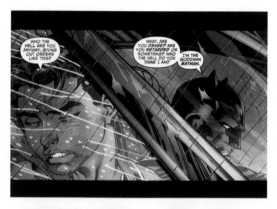

*Fig. 2: The original comic panel that introduced 'The Goddamn Batman' into the cultural lexicon.*

themes. While Superman, for example, is a moral beacon who famously represents 'Truth, Justice, and the American Way', Batman is celebrated in fandom for his fortitude in dispensing justice while grappling with his own humanity.

## The legend of Batman in fandom:
## justice and (super-)humanity

Superheroes by definition exist to defeat villains. Crime, after all, isn't going to fight itself, especially when one is dealing with criminals as colourful and dangerous as the Joker or Two-Face. From a storytelling perspective, Batman is no exception to this rule. Like all his cape and spandex counterparts, Batman primarily exits to take down the bad guys. However, Batman is clearly more than this to his fans. In looking at Internet fan creations, it seems Batman fandom wants to highlight that not only is Batman great at fighting crime, he is the coolest, toughest crime-fighting hero out there. Once again, if we think of this through the lens of what ideas Batman fandom wants to spread about their favourite superhero, the answer is this: the most popular Batman memes currently circulating on the Internet focus on a larger-than-life Batman who can take down any villain in the name of justice.

*Fig. 3: Law and Order Batman.*

For instance, one prevalent meme is 'The Goddamn Batman'. This meme is inspired by Frank Miller's *All-Star Batman and Robin the Boy Wonder*, an Alternate Universe comic published between 2005 and 2008 that retells the origin story of Dick Grayson's Robin. In Miller's comic, Batman is attending the infamous acrobatic show where Dick Grayson's parents are killed. He rescues Robin by removing him from the scene and fleeing in the Batmobile. As they are driving to Wayne Manor, an understandably upset Dick Grayson asks Batman who he is, which prompts a dramatic response from Bruce Wayne that culminates with, 'I'm the Goddamn Batman'. While most fans and critics agree Miller's incarnation of Batman is a bit over the top, the original comic panel was almost immediately spread around the Internet and the phrase 'The Goddamn Batman' has become popularized within Batman fandom.

The 'Goddamn Batman' portrayal of Batman is often included in memes or macro images that highlight his role as a justice personified. For example, a popular illustration by artist Brandon Bird that has been popping up on the web since February 2008 depicts Batman walking with the actors from NBC's *Law and Order* television series. Although the illustration began as a T-shirt design, Batman fans like to circulate the drawing as a macro image with text underneath explaining that police, attorneys and 'the Goddamn

Batman' represent the people of Gotham City. So not only do we have fan celebration and propagation of the idea of Batman as Miller's gritty and aggressive agent of justice, we see fandom promoting the idea of Batman as a literal representative of law and order.

In addition to being a representative of justice, Batman fandom likes to promote the idea that Batman can do anything, despite being a mere mortal. He may not be superhuman, but his raw ability is almost treated as its own superpower. He speaks every language, is capable of completing nearly any impossible task set before him, and is often portrayed as the best detective, martial artist and tactician on the planet. There are literally hundreds of YouTube video compilations dedicated to Batman's portrayal in *Batman: The Animated Series* and the animated *Justice League* television series. Most user comments express sentiments such as, 'They should rename "The Justice League" to "Batman and his superpowered sidekicks"' and 'Knows everything, sees everything, and can beat everyone… because he's Batman'. This type of fan enthusiasm is typically generated in response to Batman displaying his superior intelligence or combat skills, particularly if either of these were done in a way that upstages a major villain or other members of the Justice League.

Part of the glee of Batman fandom seems to come from watching him defeat people who have underestimated him based on his mortal status. Batman's humanity is as big a part of his character as his detective work or fighting tactics. We identify with him because, unlike most superheroes, Batman has to overcome his own limitations to utilize his 'powers'. Superman can shoot lasers out of his eyes without even trying and Green Lantern's power ring lets him do just about whatever he wants, but Bruce Wayne is a man who became as strong and tough as his fellow crime-fighters with no particular power at all. Canonical material and fandom seem to let Batman be the coolest member of the Justice League, perhaps because there is a need to justify a mortal keeping up with the likes of Wonder Woman and Martian Manhunter, but also because Batman's mortal status means he has to earn his victories. A recent image circling the web is the 2010 painting by artist Andrew Zubko, which depicts Batman riding a shark while holding a lightsaber. Obviously, this is conceptually ridiculous, but the fan response to the image was and is incredibly positive. Most fans agree that not only could Batman ride a shark while wielding a lightsaber if he felt like it, but it is almost inevitable that he do so. What is interesting about these sorts of images being culturally promoted by fandom is the unspoken idea Batman fans want to show that Bruce Wayne, as a mortal, has the ability to achieve superior human feats. In a way, this makes Batman's incredible displays of intelligence and strength much more impressive than the efforts of his superheroic counterparts.

Everybody knows Bruce Wayne is mortal, but more importantly he is *human*. What is especially compelling about Batman is that his humanity is rarely portrayed as a weakness even if he is behaving immorally. Rather, Batman is celebrated for being almost preternaturally talented while remaining fundamentally human in his emotional

### Dark Hero Rising:
### How Online Batman Fandom Helped Create A Cultural Archetype
Jennifer Dondero

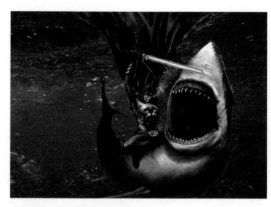

*Fig. 4: Batman riding a shark while wielding a lightsaber.*

and interpersonal struggles. This is suggestive of another theme that has triggered positive fan response and is culturally spread, namely the idea that Bruce Wayne still has recognizable vestiges of humanity inside him that he willingly puts aside to be able to become the impressive Batman figure we see fighting crime. As often as Batman is shown outsmarting incredibly powerful villains and members of the Justice League, he always has more difficulty maintaining stable relationships. One of the many memes that highlight this particular aspect of Batman's character is a macro image of a panel from *World's Finest #153* (November 1965). The image is Batman slapping Robin, and the original text has been replaced with Robin starting to ask Batman what he got his parents for Christmas and Batman yelling, 'My Parents are Deeaaaaaaad!' While this meme certainly pokes fun at the art of older comics and Batman's ever-present angst over his parents' murder, it is also a sign that Batman fans recognize that, at his core, Batman is motivated by understandable human grief. Canonical material and fans like to revisit the idea of Batman as a hero with a tragic past because it is a human motivation we can all recognize. The fact that Batman perpetually grieves for his family is especially poignant in light of how stoic and detached he forces himself to be in order to be a hero. Consequently, Batman allows himself to be dark, mistrustful, cold, and sometimes highly immoral with regard to his personal relationships. Essentially, he sacrifices the things that make him human so he can be more than human as Batman. This resonates more with fandom than a hero motivated by his own intrinsic goodness. Even if the images that fans promote are amusing in nature, they are still indicative of the cultural recognition of Batman's relatable human struggles.

So what are fans to make out of the cultural examples of Batman's personality in canon material and in fandom? Fandom is about more than making things popular. A new meme, YouTube video, or fansite is an example of what fandom wants to convey to others. A meme, even ones that approach Bruce Wayne's heightened angst and attitude with levity, are also indicative of the themes Batman fans gravitate towards: his grief, his determination, and his ability to impressively rise above the limitations of his status as a mortal. Fandom embraces, celebrates, and most importantly shares that information about Batman as a character. The more Batman becomes a viral presence on the Internet or the more a few traits are highlighted over the character at an individual level, the more an archetypal figure begins to emerge in our collective minds. We are at the point where the idea of Batman the merciless vigilante, Batman the troubled human, and Batman the symbolic representative of a modern 'Dark Knight' mean more to creators and fans than Batman's identity under the cape and cowl.

### Batman beyond Bruce Wayne, and the lasting impact of fandom
The zeitgeist behind Batman has inevitably overlapped with an interesting trend in re-

Fig. 5: Batman inc.

cent canonical material: what Batman represents is bigger and much more powerful than Bruce Wayne could ever be. This concept is not exactly new territory for Batman fans, but it is telling that this particular theme has become so richly explored in Batman canon alongside Batman's growing popularity and cultural presence. Although the Batman persona has always eclipsed Bruce Wayne in comics, the democratization of Batman as a symbol was not fully explored until the 1980s and was most recently telegraphed in Christopher Nolan's 2012 film *The Dark Knight Rises* when Bruce Wayne comments, 'A hero can be anyone' just before he departs Gotham forever, leaving the Batman legacy in the hands of former Gotham police officer and protégé John Blake.

DC Comics has also recently introduced a number of storylines that examine the impact of Batman as a symbol rather than a person. Writer Grant Morrison, for instance, has masterminded several recent comic arcs such as the 2010 series *The Return of Bruce Wayne* and the ongoing series *Batman Inc.* that explore the impact of Batman as a cultural symbol within the DC Universe. The set-up for both of these titles is that Bruce Wayne is presumed dead and the world has to decide what to do without a Batman. The answer they come to is significant: they make another one because the idea of Batman as a beacon of justice exists beyond Bruce Wayne as an individual. A battle for Batman's cowl ensues with heroes and villains alike competing to become the new Batman. Of course, in typical comic book fashion, Bruce Wayne isn't dead after all, but upon his return decides to create an international organization called Batman Inc., in which heroes all over the world will take on the Batman 'brand' so mortal men can use the 'idea of Batman' to fight crime worldwide. These types of storylines directly explore ideas fans have been promoting for nearly three decades: Batman is a cultural symbol of justice, created by a man, but used by all people who need a certain kind of superhero.

In recent years, traditional archetypal heroes have not represented us as they once did. The age of elevating wholesome figures like Superman or Captain America is not past us, but these types of heroes are no longer sufficient on their own. We have made new heroes for new times. To put a twist on the oft-quoted line from the end of Christopher Nolan's 2008 film *The Dark Knight*, Batman is the hero we deserve *and* the hero we need right now. Since the mid to late 1980s, what society and fandom have embraced in Batman is the idea that the mantle of 'hero' is not who you are but who you choose to be. Batman sacrifices his humanity while remaining fundamentally human in his flaws and weaknesses. He struggles daily with the loss of love and warmth because he chooses the

**Dark Hero Rising:**
**How Online Batman Fandom Helped Create A Cultural Archetype**
Jennifer Dondero

harder path of fighting for justice. He chooses to be a 'Dark Knight' who represents an idea instead of one man fighting crime.

Just as Bruce Wayne creates Batman as a symbolic hero that meets the needs of the people within the DC Universe, fandom elevates Batman as a representative of what fulfils our ideas of a hero in the real world. We let Batman serve as this kind of cultural icon because the idea of his character has become so open and willing – both in and out of canon – to take on the mantle of justice and humanity. The 'idea of Batman' would have never have caught on without the participation of fandom, particularly the spread of memes and enthusiastic online response to the character. So keep sharing, Batman fandom, and once again, congratulations, your participation has transformed the character of Batman into his own modern heroic archetype. ●

## GO FURTHER

### Books
*Batman: The Return*
Grant Morrison (New York: DC Comics, 2011)

*The Return of Bruce Wayne*
Grant Morrison (New York: DC Comics, 2010)

*All-Star Batman and Robin, The Boy Wonder*
Frank Miller (New York: DC Comics, 2008)

*Absolute Dark Knight*
Frank Miller (New York: DC Comics, 2006)

*Batman Unmasked: Analyzing a Cultural Icon*
Will Brooker (New York: Continuum, 2001)

### Extracts/Essays/Articles

'Memes through (social) minds' by Rosaria Conte
In Robert Aunger (ed.). *Darwinizing Culture* (New York: Oxford University Press, 2000), pp. 83–119.

'Part I – the clash of cape and cowl' by Edmond Hamilton
In *World's Finest Comics* (vol. 1:153), (New York: DC Comics, 1965)

**Films**

*The Dark Knight Rises*, Christopher Nolan, dir. (USA: Warner Brothers, 2012)
*The Dark Knight*, Christopher Nolan, dir. (USA: Warner Brothers, 2008)
*Batman*, Tim Burton, dir. (USA: Warner Brothers, 1989)

**Websites**

Brandon Bird's Brandon Bird-O-Rama!', http://www.brandonbird.com/
'Know your meme', http://knowyourmeme.com/
'Zubko Illustrations', http://zubko.com/

Chapter
3

# Heroes With Issues:
# Fan Identification With
# Batman

## Anna-Maria Covich

→ For nearly three quarters of a century Batman, one of the oldest comic book superheroes, has captivated his audience in comics, live action and animated television series, movies, toys and games. He has been through many incarnations, from the camp and cheerful television version played by Adam West to Frank Miller's brooding and cynical Dark Knight. He is a cultural phenomenon recognizable the world over.

What is it about Batman that makes this character, in all of his manifestations, so popular and enduring? My research with adult fans of superhero comics suggests that Batman's lack of superpowers and his troubled emotional life make it easier for fans to identify with him. As a superhero without superpowers, Batman challenges fans to reconsider what they are capable of as human beings, and to imagine how they too can overcome their own physical, mental and emotional limitations. In my investigations of the relationships fans have with comic book superheroes I found that fans of Batman engaged with him in a number of ways, both identifying with him as a human being, and using aspects of the stories and character in their own lives.

My research was a small-scale project in which I interviewed 38 adult fans of super-hero comic books from all around Aotearoa/New Zealand. We discussed their reader-ship in groups and individually, both online and face-to-face. These discussions covered a number of topics relating to comics and their experiences of fandom, with a particular focus on their comic book readership and what they enjoy about it. Batman's human-ness was a common theme through many of the conversations, both as a point of pleas-ure and of tension for the readers. I noticed that the fans who identified Batman as their favourite superhero (or as one of their favourites) enjoyed the same few characteristics. The fans I spoke to enjoyed Batman because they could recognize themselves in his emotional life, and because they saw the potential to be like him themselves. Batman's humanness and psychological flaws made it easier for them to identify with him than with other superheroes.

The superhero, by definition, has extraordinary abilities that set him apart from ordi-nary people. Inherently-powered superheroes, such as Superman, possess traits that no human being could aspire to have, no matter how hard they pushed themselves or how naturally gifted they were. However, Batman is not an ordinary superhero as he has no superpowers. His abilities stem from years of training and focus, from his unmatched creative abilities and almost limitless resources. Batman's investigative mind is so pow-erful that he has earned the title of the 'world's greatest detective'. He invents devices for every possible eventuality, and has a contingency plan for almost every situation (for example, in his utility belt he carries a piece of Kryptonite, the one thing that can harm Superman, to use if the Man of Steel ever turns evil). Batman's mind, training and his utility belt are his superpowers. He is otherwise entirely human. Batman's humanness affects the way fans identify with him and how they use his stories.

Most superheroes have a human secret identity that allows them to participate in day-to-day activities as non-heroes. The alter-ego is always a weaker version of the hero. Matthew Pustz suggests in *Comic Book Culture: Fanboys and True Believers* that the alter-ego's weaker (and often feminized) nature contrasts with the exagger-ated masculinity of the heroic aspect, making the superhero appear stronger and more masculine by comparison. At the same time, the alter-ego's ordinariness means that he is also an entry point for readers, allowing them to feel that they may have something

## Heroes With Issues: Fan Identification With Batman
Anna-Maria Covich

in common with the superhero. In his book *Black Superheroes, Milestone Comics, and their Fans*, Jeffrey Brown argues that the reader's relationship with the alter-ego is am- bivalent; they deride him for being weak, while at the same time, they have sympathy for that same weakness. He argues that while they do not want to be like the clumsy alter-ego, because fans can recognize similarities between themselves and that side of the hero, they are able to extend this identification to see themselves *as* the hero. The readers of this study did identify with Batman's alter-ego, Bruce Wayne, but it was not through a focus on any failure-prone characteristics. Rather it was through the recog- nition that he is a mere human like them, and that he has a complex personal life, and emotional pain to overcome just like they do.

Like his fans, Batman has personal problems and difficult relationships to negoti- ate. His emotional pain stems from scenarios that, while extreme, are recognizable and familiar to his fans and similar to experiences in their own lives. Most participants de- scribed Batman's emotional 'issues' as a point of identification, something that they can relate to and with which they could empathize. In the following interview extract, a 40-year-old male fan describes why Batman is his favourite superhero:

Thomas: He's credible. OK, he has issues, but there is something easier to relate to in what he is and what he does. He is real, and in a way it's easier to identify with who and why he is what he is.

Also, for a big part of it, his stories are crime stories set in a modern city. Once again, it's easier to relate to than the idea of a superhero team fighting off an alien armada.

Anna-Maria: Because he's just a well-honed human?

Thomas: No, because if I had the resources, drive and mental ability, I could be like that. [...]

I think it is something we look for in stories as humans. How would I react to this situ- ation? If there is no character in the story that you can relate to, it makes it harder to immerse yourself in the story.

It is not only the setting and storyline choices that make the Batman stories believ- able and enjoyable for Thomas. The characterization of the hero also contributes to this. Thomas alludes to Batman's past with his comment that he 'has issues', that he has had difficulties in his life that have left him with emotional scars. While many superheroes have lost their parents, Batman's backstory is darker than most. In Batman's origin, the young Bruce Wayne witnesses the murder of his parents during a mugging. This trauma left him with emotional scars and no close family. Seeing his parents' murdered led the young man to seek revenge against the criminals of Gotham City as Batman. While there is often a love interest in the stories, the secrecy necessary to maintain the Bat- man identity, and the emotional scarring caused by the loss of his parents, culminate in Bruce Wayne struggling to maintain these romantic relationships. Bruce Wayne's main

close relationships are with his butler, Alfred, who raised him after his parents died, the orphaned Dick Grayson (the first Robin) and Superman. However, even these relationships suffer at times from Bruce Wayne's deep distrust of others, and the emotional distance he puts between himself and his supporting cast.

By focusing on Batman's psychological instability as being somehow *like* the (non-super) reader, readers such as Thomas can find a way of seeing Batman as being like themselves. Batman's responses to his emotional challenges are as important to many fans as his engagement with the villains that threaten Gotham. They give the reader a point of similarity to Batman, which they can use to immerse themselves in the story. These personal battles give Batman and his supporting cast extra depth while justifying the story in a way that is easily recognized and understood. Batman's psychological 'issues' make him an exaggerated version of other, ordinary people. He has been through real trials in life, lost loved ones and found a way to cope with that.

While being able to relate to the superheroes on a human level is important, too much emphasis on mortality seemed to be a bad thing. While readers may want the hero to be available on a human level, there are limits to the humanity of superheroes. Emotional reality is acceptable in comics to a small extent, but too much means losing the 'superness' of the hero, which then defeats the purpose of reading the comics. The constant reminders of Batman's tragic past were a significant point of criticism for the fans in this study. Many joked about Bruce Wayne/Batman 'whining' about being an orphan, when all of his friends are orphans too (Superman has been twice orphaned). One group discussion included repeated references to things that Bruce Wayne does not like because he associates them with the death of his parents (rock and roll music, for example). To highlight the excessiveness of Batman's obsession with the death of his parents, they even role-played a fantasy scenario where Bruce Wayne attempted to compete with Superman to be considered the most tragic. While the fans enjoy being able to identify with Bruce Wayne's childhood tragedy and Batman's resulting psychological flaws, they found that it became tiresome when the character seemed to be reminding everyone at every opportunity.

In the earlier quote, Thomas also suggests that because Batman does not have superpowers, it is therefore possible for him to imagine a scenario where he too could become like Batman. The ability of ordinary people to do what Batman does and achieve similarly super feats was important to many participants when they discussed their pleasure in reading Batman comics. Most fans know that they will never even consider trying to become a superhero, so the question of whether or not it is possible to do so (as discussed in *Becoming Batman: The Possibility of a Superhero* by Paul Zehr) is not as significant to them as is the idea that *it is not impossible*. This was a common theme in the discussions about Batman in both face-to-face and online interactions. Readers saw Batman as the epitome of what a human body and mind can achieve, and used this to inspire thoughts about their own potential and abilities, and of their place in the world.

### Heroes With Issues: Fan Identification With Batman
Anna-Maria Covich

When 28-year-old participant Cody described why Batman is his favourite comic book superhero, his reasons focused on the idea that even though Batman is 'only' human, his humanness did not hinder him as a superhero. His enjoyment arises from the idea that the human body (and mind) has the potential to match (or overcome) even the most powerful super-bodies:

I think I liked Batman before I realized that he was a 'superhero' or what superheroes actually were. Nowadays the appeal is just that he is the pinnacle of human conditioning. Some of my favourite Batman stories are the ones where he appears in context with the JLA [Justice League of America]: He is just a man walking among gods, but he can take every single one of them out *and they all know it.*

The Justice League of America is a superhero team made up of a varying cast of DC superheroes. Of the core cast, Batman is the only team member who has no special powers (Green Lantern is also human but his alien ring gives him superpowers). Cody's initial attraction to Batman was not based on his superhero status; rather his enjoyment of that character comes from his humanness. Despite his lack of superpowers, Batman is so powerful that even when working with a team of almost omnipotent superheroes, he is not outmatched. Cody enjoys the idea that the 'merely human' Batman can match and potentially beat a 'god' (or a superhero like Superman).

Batman's lack of superpowers makes him more like the comic book reader, while still being powerful enough to fight alongside the most gifted superheroes. This idea allows the fan reader to imagine themselves, or someone around them, as having the potential to do that too. The ability to imagine that comic book scenarios could come to fruition gave an extra level of enjoyment to many. Jade (female, 40) said:

I think I prefer those sorts of characters [skilled humans like Batman] because of the fact that they're a bit more true to life. We don't have any superpowers yet, in the real world. I know there are people that do super human feats occasionally.

Despite enjoying the fantasy of superheroes with superpowers, the potential that events in the comic book stories could also relate to a real-life scenario was pleasurable for Jade. She enjoyed the 'Batman-type' superhero because of the way that the narrative could relate to ordinary people doing extraordinary things. The similarity between Batman and real-life heroes blurs the boundary between the comic book fantasy universe and our own. Her statement that 'We don't have superpowers *yet*' suggests that she can imagine a future when humans (maybe even herself) will potentially have superpowers, or superpower-like attributes, which would then break down the distinction between human and superhuman. She notes that the human body is already capable of achieving superhero-like tasks, so she has no trouble accepting the possibility of a

character that has deliberately trained himself to be able to achieve these things.

Throughout the discussions it became clear that participants appreciate the idea that any person with the drive and the resources could (potentially) push themselves to become like Batman. Many readers found this notion inspirational, because they imagined that they too could, with work, achieve something similar. In an online conversation, Christopher (28 years old) described the motivational quality of Batman:

[My favourite hero is] different from the books I buy or read [...]. I'd say Batman simply because he represents something inspiring: That strength of will and intellect can be enough for you to go toe-to-toe with the worst the world has to offer. That one man can change the world from a nightmare into a paradise (even if the nature of monthly comics means he never gets there).

To Christopher, Batman's humanness places his superpowers within anyone's reach. Any person with the (intellectual) resources and the drive could, according to Christopher and Batman, overcome anything. He sees Batman as a symbol of what one person might achieve. Batman shows how any person can make a difference in the world. Through strength of spirit and mind, and by fighting their own supervillains, any person has the capacity to shape the world into something they want it to be. For fans like Christopher, Batman is a reminder that they too can make a difference in the world.

Other participants explicitly stated that they like to read stories with scenarios that they could recognize and solutions that they could apply to their own lives. As a human character, Batman gave them more opportunity than most to do this. By recognizing the potential 'life lesson' that the superheroes can teach them, fans of Batman can use his stories to test responses to imagined scenarios. When asked why Batman (and Batman like characters) appealed to her, Jade said:

Often we're reading for enjoyment, but also we're reading to emulate what we...if we were in a stressful situation, what would we do? If we were Superman, or if we got superpowers, it just doesn't work, but people with strengths that they have adapted or developed, the same as everybody else, then we can all be superheroes in our own right.

Super-powered superheroes have limited use as role models as their powers give them strategies beyond those of ordinary people. Jade suggests that, as a human, Batman allows readers to see ways of being a hero themselves by using their own focused and developed strengths and skills. This implies that readers are not limited to mimicking Batman; they may also be inspired by him to see themselves as having the tools and skills required to defeat the villains in their own lives.

In *Super Heroes: A Modern Mythology*, Richard Reynolds argues that superheroes are a new version of traditional mythology replacing the likes of Gilgamesh, King Arthur

## Heroes With Issues: Fan Identification With Batman
Anna-Maria Covich

and Zeus. In 2003, Hal Colebatch's book, *Return of the Heroes: The Lord of the Rings, Star Wars, Harry Potter, and Social Conflict*, described the cultural purpose of the hero as one of a guide or teacher, a reference to draw on in times of stress and danger. When stress is high and time is short, there may not be sufficient time to consider all of the options before making decisions on how to act, so heroes provide templates and models in the form of stories, behaviour and the consequences of actions in a variety of situations. Drawing on the work of Joseph Campbell, Reynolds and Colebatch theorize that through these stories, heroes give people a pattern to work from; an outline for 'good behaviour' that they can apply to their own lives. As superheroes often have to make decisions, both ordinary and extraordinary, in contemporary situations, they could be seen as filling this role in contemporary society. Reynolds and Colebatch both suggest that by identifying with the characters in this way, instead of imagining themselves to be physically like the hero, the fans can imagine themselves as having the potential (if the need arose) to behave in a heroic manner. As suggested above, this is one of the ways that fans use and identify with Batman.

The fans' enjoyment of Batman comics and films was linked to the connection they could form with him on an emotional or human level, as opposed to the fantasy of the super-powered hero. Batman has human flaws and vulnerabilities, which fans recognize in themselves. Rather than seeing these traits as inferior and limiting, the fans understand that they are part of what makes Batman who he is, and that they can be overcome. This allows them access to the character as an inspirational model, showing them that they too, if they put their minds to it, can be heroes in their own lives. To his fans, Batman's 'issues' and lack of inherent superpowers are what make him powerful. While they did not always enjoy his emotional reaction to his circumstances, the fans appreciated Batman's potential to serve as a model and teacher, letting them ask (often in a humorous fashion): 'What would Batman do?' ●

## GO FURTHER

### Books

*Caped Crusaders 101: Composition Through Comic Books*
Jeffrey Kahan and Stanley Stewart (Jefferson, N.C: McFarland & Co., 2006)

*Superman on the Couch:*
*What Superheroes Really Tell Us About Ourselves and Our Society*
Danny Fingeroth (New York: Continuum, 2004)

*Return of the Heroes: The Lord of the Rings, Star Wars, Harry Potter, and Social Con-flict*
Hal Colebatch (Christchurch, NZ: Cybereditions Corporation, 2003)

*Black Superheroes, Milestone Comics, and their Fans*
Jeffrey A. Brown (Jackson: University Press of Mississippi, 2001)

*Super Heroes: A Modern Mythology*
Richard Reynolds (Jackson: University Press of Mississippi, 1994)

*The Hero with a Thousand Faces*
Joseph Campbell (London: Fontana, 1993)

*Little Big Men: Bodybuilding Subculture and Gender Construction*
Alan M. Klein (New York: State University of New York Press, 1993)

### Extracts/Essays/Articles

'Alter/Ego: superhero comic book readers, gender and identity' (master's thesis)
Anna-Maria Covich
(Christchurch: University of Canterbury, 2012)
Available from: 'University of Canterbury Research Repository', http://ir.canterbury.ac.nz/

'"Draped crusaders": Disrobing Gender in *The Mark of Zorro*' by Catherine Williamson
In *Cinema Journal* (vol. 36), 1997, pp. 3–16.

# Being Batman: From Board Games to Computer Platforms

## Robert Dean

→ In 2009 Warner Bros. released the critically acclaimed and extremely popular computer game *Batman: Arkham Asylum* (Rocksteady, 2009). However, the superhero game genre pre-dates digital technology. Beginning with the 1966 board game *Batman Swoops Down*, this chapter will chart the evolution of Batman games and identify the ways in which these products have interpreted and adapted elements of the superhero's mythos. This analysis will reveal the underlying principles of interactivity and branding that have informed the development of these games, and increasingly allowed fans to become Batman.

Fig. 1 (above): Batman and flipper, Batman Swoops Down (Spear's Games, 1966).

Fig. 2: Board, Batman Swoops Down (Spear's Games, 1966).

*Batman Swoops Down*, released by Spear's Games in 1966, was one of the first Batman board game spin-offs, and although it may not be the 'official' game of the 1960s' television series, both were released in the same year. The box even featured drawings of the dynamic duo wearing Adam West and Burt Ward-style costumes. This early example of branded board game merchandising was essentially a combination of tiddlywinks and noughts and crosses. The colours of the pieces, the number of 'winks', and the launching of plastic projectiles towards a pot are all elements taken from a traditional tiddlywinks game. However, in a conventional game the players propel their winks into the air by pressing down on them with a larger plastic disc known as a 'squidger'. In this version the winks and squidger are replaced with a more complicated method of propulsion. Each player receives their own plastic Batman effigy that resembles a *Subbuteo* piece with its static action pose and weighted spherical base (Fig. 1). They also each receive a 'flipper.' This is a short plastic see saw device which the player uses to catapult their Batman figure into one of nine plastic 'cavities' built into the box. An incarcerated Robin is pictured in the centre of the box while the eight spaces that surround him contain comic book style drawings of Batman tackling his arch-enemies (Fig. 2). Like tiddlywinks, the player is required to fire their counter into a pot; however, in this variation there is not a single central receptacle. Instead, each time Batman 'swoops down' and lands in one of the villain's spaces they leave a 'wink' in the compartment and the first to get three-in-a-row wins.

Despite the assurance on the box that the game is suitable for players of any age, the combination of aiming and operating the flipper is tricky. With practice the player can become quite proficient at launching Batman in the direction of the board, although ensuring he lands in the intended cavity is often more a question of luck than skill. It is

**Being Batman: From Board Games to Computer Platforms**
Robert Dean

*Fig. 3: Board, Batman: Shoot
'n' Score Springboard (New
World Toys, circa 2008)*

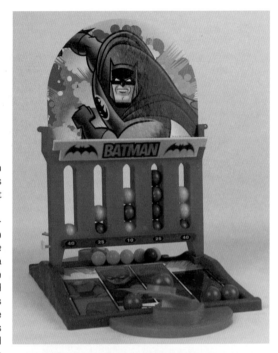

this frenetic and somewhat haphazard gameplay through which most of the fun is derived. Misfires, overzealous launches and landings that knock other player's winks out of the box are part of the game's appeal.

The same formula was applied in more recently produced tabletop games such as New World Toys' Batman themed *Shoot 'n' Score Springboard* (Fig. 3) and *Rapid Fire* (Fig. 4). In the first of these, the flipper is replaced with a revolving catapult that looks like a short ruler with a cup on one end. Its frame resembles Mattel's *Connect Four*, and the aim of the game is similar, but in this version players fire their pieces into the frame to get four-in-a-row. The *Rapid Fire* game is equally frenetic. In essence it is a cross between Milton Bradley's *Crossfire* and the traditional Indian game *Carrom*. As the name suggests, this is not a turn-based game. Instead opponents must fire their counters as rapidly as possible and whoever pots the most wins.

*Batman Swoops Down*, *Shoot 'n' Score Springboard* and *Rapid Fire* are adaptations of existing games that have been branded with Batman iconography. Another characteristic these games share is that wining them depends on the players proficiency with a novelty Bat-gadget. However, while these games are similar, the type of imaginative engagement they prompt from the player is a little different. With regards to *Shoot 'n' Score Springboard* and *Rapid Fire* the evocation of the Batman mythos is purely perfunctory. Indeed, the company also manufactures versions of these games which feature images from the animated series *SpongeBob SquarePants* (1999) instead of Batman.

Games with interchangeable façades such as these allow manufacturers to release the same game with different branding in order to exploit current trends. To enable this, the basic framework of a game remains as neutral as possible, thereby reducing production costs and facilitating an efficient rebranding process. Beyond their branding the games have no other links to the mythos they reference than the iconography they bear. Any further connections rely entirely on the players' imagination.

*Fig. 4: Board, Batman: Rapid
Fire (New World Toys, circa
2008).*

In contrast, although *Batman Swoops Down* bears many similarities to the other two games, the Batman mythos is more fully integrated. There is a nominal storyline that links gameplay to branding and imagery:

Robin the Boy Wonder has been captured by Batman's enemies. It is impossible for

Fig. 5: Board, Batman Forever
(Parker Brothers, 1995).

Fig. 6: Batarang Launcher,
Batman Forever (Parker
Brothers, 1995).

Fig. 7: 'Riddler's Side Game',
Batman Forever (Parker
Brothers, 1995).

him to escape without assistance. Only Batman can set Robin free and to do so he must overpower three of the villains, who are on guard in adjoining positions. (*Batman Swoops Down*, Game Instructions, Spear's Games, 1966)

Each time a player successfully lands in one of the cavities they are prompted to imaginatively participate in the action scene depicted. It is their shot that enables Batman to 'overcome' that particular enemy (or enemies) and move ever closer to saving Robin. The players also participate in the game with their own Batman effigy, which provides a physical link between the player, the game and the mythos. From this perspective, the game has the potential to be more immersive than its counterparts as it encourages an element of imaginative interplay in which the player's skills and the success of Batman's mission are linked.

A similar approach was adopted in the design of Parker Brothers' board game *Batman Forever* (1995), which was released to coincide with the third Batman film (dir. Joel Schumacher, 1995) from the 1989–97 Warner Bros.' quadrilogy. Like the games previously discussed, *Batman Forever* incorporates moving parts, gadgetry and elements of chance; however, the player's counters, the villains, the scenario and board are all drawn directly from the film. The game is played on a cardboard and plastic interpretation of Gotham Charity Circus (Fig. 5). The 'Big Top 3-D Board' referred to on the box is an A-frame which rises vertically from the baseboard. This means that the player's journey around the board takes them up a ladder via two platforms, across a holey plastic beam (referred to in the instructions as a tightrope), down another ladder and back across the baseboard to the finish. Along the route are four Two-Face cut-outs. When a player's progress is obstructed by Two-Face, a game of chance ensues and the outcome of the encounter is decided by the flip of a cardboard coin. However, rather than simply flipping the coin in the traditional manner, the game contains a 'Batarang Launcher' (Fig. 6) which is used to fire the coin through the air.

The 'Batarang Launcher' has two other functions players can utilize to overcome Two-Face and the Riddler. Rather than rolling the dice, the player can 'shoot the hoop'. This option gives them three attempts to fire a small black ball, embossed either side with the Bat symbol, through a cardboard ring of fire suspended from the 'tightrope'. If the player succeeds, they can move their piece one step in front of whoever is in the lead. As an added bonus, they also get to contribute to a connected side game (Fig. 7). At the beginning of the game, six cards that connect together to form a dual-sided picture of the circus audience are arranged to show the crowd enjoying themselves. However, each time a player throws the eight-sided dice and it lands on a green sticker, one of the segments is turned over to reveal screaming audience members coloured with a green hue. If at any point all six cards are turned over, the Riddler succeeds in stealing the audiences' brains and the game is over. This adds a time sensitive aspect

**Being Batman: From Board Games to Computer Platforms**
Robert Dean

Fig. 8: 'Elephant feet',
Batman (Ocean, 1986).

to the game as the longer it goes on the more greens will be rolled. It also necessitates a certain level of teamwork as when only one segment remains, players must combine their efforts to get the Batarang through the loop or everyone will lose. Similarly, if the player rolls the Bat symbol on the dice, they get to take three shots at whichever Two-Face figure is causing the most immediate obstruction.

In comparison to *Batman Swoops Down* this game enables the player to engage with the Batman mythos in a more detailed, directed and specified manner. While the player's imaginative navigation of *Batman Swoops Down* is prompted and informed by still images, *Batman Forever* is a board game adaptation of a scene that takes place in a Hollywood action movie. Therefore, the game allows the initiated players to revisit the filmic fantasy world, albeit within the constraints of a board game. However, in this re-enactment, only one player can assume the role of Batman as the game contains a single counter bearing the hero's image. The other participants have to make do with Robin, Alfred or Dr. Chase Meridian.

*Fig. 9: Comic book panels,
Batman: The Caped Crusader
(Ocean, 1988).*

In the 1970s, a new type of home gaming experience began to develop in the form of computer games. By the 1980s, Spectrum, Amstrad and Commodore's range of home computing systems supported a rapidly expanding portfolio of games. In 1986, *Batman* (Ocean) joined other titles drawn from popular culture such as *Ghostbusters* (Activision, 1985), *Alien* (Amsoft, 1984) and *Superman: The Game* (First Star Software, 1985). In one of the opening screenshots, the player is shown the seven pieces of a dismembered 'Batcraft' they need to collect. As the short chubby Batman avatar makes his way through isometrically-rendered rooms of the Batcave, his hideaway appears to be infested with lethal objects that move around the room in various fixed patterns. These range from deadly plant-pots and killer cue balls, to a chomping head and a monster with an oversized skull. A fan well-versed in the Batman mythos might suppose the plant-pots to be a horticultural hazard created by Poison Ivy, while the head could be a device left by Penguin. However, the limited graphics of the time make visual interpretations subjective. Nonetheless, the giant cue balls emblazoned with a question mark are a clear reference to the Riddler, so when a character pops up alongside them part way through the game the player will no doubt make that connection.

Whilst moving from room to room Batman must avoid these hazards by climbing onto platforms, standing behind furniture or blocking them with one of the numerous elephant feet lying around the Batcave (Fig. 8). The player must also collect Bat-gadgets, including special Bat-boots that allow him to jump higher and a jet pack (somewhat defeating the purpose of the boots). In addition, there are mini Batmen scattered

Fig. 10: 'Rouges' Gallery',
Batman: The Caped Crusader
(Ocean, 1988).

Fig. 11: 'Inventory', Batman:
The Caped Crusader
(Ocean, 1988).

throughout the levels that enable Batman to move faster (in much the same way that mushrooms affect Mario). To collect each section of the Batcraft, the player must solve an access problem. The solutions include: utilizing the jumping boots, activating a switch by standing on top of a dismembered elephant's foot, and balancing an S-shaped platform on a dog's head.

Two years after Ocean released their first Batman game, they produced the follow-up, *Batman: The Caped Crusader* (1988). Visually the game is very different. The Batman avatar is a little taller, less rotund and more muscular. Instead of navigating three-dimensional rooms, Batman moves through two-dimensional passages that resemble comic book panels (Fig. 9), which light up and are layered over each other as the player proceeds through the game. The game also features a more varied colour palette in comparison to its predecessor, which was limited to a single colour per room. While this improved the recognisability of characters Fig. 10 illustrates that even in an enlarged cut-away shot,–only two of the villains depicted are identifiable. Similarly, while some of the hazards Batman must avoid or destroy relate to a particular villain (such as bouncing Jack in the boxes most players would associate with the Joker) many others are more general (i.e. mini trains, tanks and helicopters).

The different objects Batman needs to find are an equally strange combination. In addition to a Batarang for combat situations and wire cutters to diffuse bombs, Batman must also locate a toilet roll, sunglasses, false teeth, a coconut and a can of cola (Fig. 11). Working out the purpose of these objects is an integral part of the gameplay; a fitting, though somewhat ridiculous, pursuit for a character also known as 'the world's greatest detective'.

The third instalment of the Ocean trilogy *Batman: The Movie* was produced the following year as the official game of Warner Bros.' *Batman* (Burton, 1989). Such recognition and validation from the entertainment industry only three years after Ocean released their first Batman game is indicative of the incredible growth the computer game industry experienced during the 1980s. This expansion was matched with continued advances in technology that led to improved graphics, as well as more responsive avatars and varied forms of gameplay. The game Ocean created drew on all these factors.

Its Hollywood credentials were made clear with direct quotations and scenarios taken from the film. For instance, Batman's first mission is to prevent Jack Napier from blowing up the 'Axis Chemical Plant'. To complete the level, Batman tackles Napier and in the process knocks him into a vat of acid thereby creating the Joker. These and all other tasks are derived from the film's plot devices, characters, imagery and structure. Batman's stature and physique have improved greatly since his two previous incarnations. In addition, on this outing the seemingly arbitrary hazards the player had to tackle

## Being Batman: From Board Games to Computer Platforms
Robert Dean

*Fig. 12: Level 2, Batman: The Movie (Ocean, 1989).*

*Fig. 13: Level 3, Batman: The Movie (Ocean, 1989).*

in *Batman* and *Batman: The Caped Crusader* have been replaced with threats that are taken directly from the film. For instance, in the chemical plant, Batman must avoid dripping acid, swing across platforms with a grappling hook, and knockout criminals with his Batarang. Another important difference between this game and the previous releases was that it featured different types of gameplay. Levels 1 and 5 were platform games, Levels 2 and 4 were driving games, and Level 3 was a puzzle game (Figs. 12-14).

While all the games in Ocean's Batman trilogy allowed the player to assume the role of Batman, their effectiveness at providing an experience, which enabled the player to 'become Batman' in this virtual environment, developed alongside advances in technology and the computer-gaming industry. As such, the first two games could be described as the computer game equivalent of *Shoot 'n' Score Springboard* and *Rapid Fire* in that the basic structure and format of the games are transferable, and with a little reprogramming and repackaging the game could be reoriented towards an alternative fanbase. Ocean's last release is far more specific in terms of how it ties in with a particular Batman text and the range of challenges the player must complete. Like the *Batman Forever* board game, *Batman: The Movie* allows the player to enter and experience an alternative rendering of a filmic story-world. However, the computer game format provides a richer and more immersive experience as the player takes direct control over the movement and action of the Batman avatar; a connection which induces the sense of becoming Batman far more than moving a cardboard cut-out around a board.

*Fig. 14: Level 5, Batman: The Movie (Ocean, 1989).*

Batman was repeatedly rebooted into a range of different guises and scenarios over the twenty years that followed Ocean's trilogy. During this period, computer games evolved rapidly. Of these numerous developments, three key areas are of particular relevance to this chapter: perspective, control and game-world. The 2009 release, *Batman: Arkham Asylum* is a game that exemplifies the impact of these elements and the extent to which they enable the player to interact with their Batman avatar. The player experiences the game from a third-person perspective. Therefore, they see most of the action as if they were continually peeping over Batman's shoulder (Fig. 15). An alternative option that could have enhanced the player's sense of immersion in the game would have been to adopt a first-person perspective. However, erasing the animated representation

Fig. 15: Over-the-shoulder perspective, Arkham Asylum (Rocksteady, 2009).

of the Batman avatar would remove the main attraction of the game. When following in Batman's footsteps the player sees detail: the texture of the suit, the metallic finish of a Batarang, the figure's muscular physique, and other facets which hold a fetishistic fascination for fans.

Players control Batman with a gamepad that features two analogue directional controls, which are used to move the avatar 360-degrees in any direction; and unlike the earlier incarnations discussed, this Batman can also run, jump, crouch, slide, climb and glide. The player also collects a range of Bat-gadgets that enable Batman to access out of reach areas. These include an explosive gel to destroy weak walls, floors and ceilings; a code sequencer to override security systems; and a zip-line launcher to avoid hazards between platforms. Should Batman encounter any henchmen that need to be dispatched, the player manipulates two buttons to 'attack' and 'counter' their opponent, and in doing so builds up to spectacular combination moves which are shown in short cut-away movie sequences. In some scenarios it is also necessary to adopt a stealthier approach by sneaking up behind enemies to perform 'silent takedowns', or string them up from the nearest gargoyle. Players may also experience strangely intimate moments where they lead Batman to a quiet part of Arkham to practice using a new Bat-gadget.

With this level of control the player has a tremendous scope of choice regarding how the Batman they control behaves in the game-world. There are limitations as certain routes have been are cut off to ensure that the game progresses in accordance with its prepared narrative. Similarly, Batman cannot interact with all the objects shown on-screen. However, although the player's route and what they do along the way is somewhat predetermined, for the most part they are free to roam the virtual world and deal with the obstacles they face in whatever way they choose. Another important factor to consider is that (like all the games previously mentioned) the ability to successfully control this central 'piece' of the game requires practice, skill, dexterity and luck. Therefore, while a perfectly coordinated superhero could flawlessly navigate the game-world, it is unlikely that the average player would be able to achieve this on the first few attempts. Regardless of how big a fan the player is, the avatar is ultimately as flawed as its operator. Batarangs will be thrown both in error and annoyance, punches will fail to make contact, and the hero will have to make hasty retreats when the player's clumsy fingers spoil a stealthy attack. These mishaps are as important to the game as the successes. If it is our fallibility that makes us human, when mistakes manifest themselves in the iconic form of a superhero, the avatar is increasingly humanized and more closely aligned with the individual controlling it.

Like the other computer games discussed, progressing from stage to stage requires

## Being Batman: From Board Games to Computer Platforms
Robert Dean

*Fig. 16: 'Flashback', Arkham Asylum (Rocksteady, 2009).*

the completion of tasks (locating items, engaging in combat, solving problems, etc.). However, in *Arkham Asylum* this progression is closely integrated with a complex narrative that unfolds as the different stages are completed. Rocksteady commissioned the script from Paul Dini, a writer whose many credits include the Emmy Award-winning *Batman: The Animated Series* (1992–95). With these credentials it is perhaps unsurprising that the author's knowledge and understanding of the Batman mythos is apparent throughout the game. Indeed, the link between the game and the series extends to the voice actors as both feature Kevin Conroy as Batman and Mark Hamill as the Joker. Another similarity is that the game doesn't focus purely on action. The dialogue, gameplay and imagery also offer an insight into the psychological make-up of the main character. This is most apparent in stages that follow Batman being drugged by Scarecrow's hallucinogenic gas. At one point the avatar even transforms into Bruce Wayne as a child, and as the player progresses they witness the death of Bruce's parents followed by the appearance of a silhouette that literally foreshadows the young boy's later transformation into Batman (Fig. 16).

Whether playing a game involves a board and counters or a screen and avatars such pursuits are often more than trivial. Alongside the all-important 'fun factor', playing games imparts important lessons about patience, cooperation and concentration, as well as helping to develop the player's strategic and imaginative skills. However, certain games also carry an added value by virtue of their alignment with an existing cultural product. Games that refer to Batman in their title are clearly aimed at fans of the character. Like most merchandise tie-ins these products could be regarded as little more than attempts to cash in on the existing popularity of an iconic figure. From this perspective, the fan's penchant for Batman is exploited in order to make money. The formula is straightforward: take an existing game format, brand it with Batman iconography, and sell at an inflated price. It is easy to see how this criticism could be levied at games like New World Toys' *Rapid Fire* and *Shoot 'n' Score Springboard*.

However, can the popularity of these games simply be put down to branding compelling brainwashed consumers to reach for the familiar? Or do these games prove so popular because they allow the player to operate within the framework of a mythology? From this contrasting perspective, the appeal is found in the extent to which the game converges with other representations of the Batman universe and the characters that inhabit it. In 1966, *Batman Swoops Down* was produced and designed to align with the TV series. The players were provided with their own Batman figure, a Bat-gadget and uncaptioned images of confrontations and combat. Although the arrival of computer games in the 1980s enabled players to operate a more animated figure, utilize an increased range of gadgets and navigate a virtual environment, the technology of the time restricted what could be achieved. To tackle this problem game designers applied a good deal of artistic licence regarding the avatar's appearance, the hazards encountered

and the connections (or lack of them) with Batman mythology. By the time *Arkham Asylum* was released these shortcomings had been overcome. The avatar's appearance drew on the contemporary incarnation of Batman popularized in Christopher Nolan's trilogy (2005–12). Moreover, the storyline, the virtual world, and the characterization brought the Batman universe to life in a level of detail that surpassed what had previously been achieved in all other computer game adaptations of the franchise. As technology evolves and the computer games industry matures, the level to which players can experience, navigate and interact with virtual worlds through an avatar of their choice will inevitably expand. While it is impossible to predict exactly how computer games and their associated hardware will develop during the twenty-first century, it seems certain that the desire to become Batman (or indeed any superhero) will be facilitated by ever more immersive gaming experiences. ●

**GO FURTHER**

**Ludography**

*Arkham Asylum* (Rocksteady, 2009)
*Batman: Rapid Fire* (New World Toys, circa 2008)
*Batman: Shoot 'n' Score Springboard* (New World Toys, circa 2008)
*Sponge Bob Squarepants: Shoot 'n' Score Springboard* (New World Toys, circa 2001)
*Sponge Bob Squarepants: Shoot 'n' Score Disc Launcher* (New World Toys, circa 2001)
*Batman Forever* (Parker Brothers, 1995)
*Batman: The Movie* (Ocean, 1989)
*Batman: The Caped Crusader* (Ocean, 1988)
*Batman* (Ocean, 1986)
*Batman Swoops Down* (Spear's Games, 1966)

# Fan Appreciation no.2
## E. Paul Zehr

Professor of Kinesiology and Neuroscience E. Paul Zehr's career developed from his early interest in the marital arts. Zehr's research focuses on the neural control of movement and rehabilitation of walking after stroke and spinal cord injury. Recently Zehr has gained widespread acclaim for his book *Becoming Batman: The Possibility of a Superhero*, which explored if there really is science behind the superhero. Zehr continued this approach for his latest book *Inventing Iron Man: The Possibility of a Human Machine*. Zehr was interviewed at the 2012 WonderCon where he presented the paper 'Batman vs. Iron Man: Can Biology Best Technology?' as part of the Comics Arts Conference.

**Liam Burke:** *What was your first experience or encounter with Batman?*
**E. Paul Zehr:** The first thing I can remember is actually watching the original Adam West show – the re-runs of it. And as a kid I liked it, but to me that wasn't really Batman. It was just some kind of entertainment show that I was watching. It was only when I started to read Batman comic books that I really got interested in Batman the character. So even though Adam West was the first thing I remember seeing, I definitely, even at the age of ten, was drawing distinctions between whatever that was and the comic books, which were drawn at that point by Neal Adams. They really influenced me and I was drawn into the complex character. That is what I really remember as Batman.

**LB:** *So would you consider Batman, as drawn by Neal Adams, your preferred version of Batman?*
**EZ:** Yeah, it is actually. In fact, I didn't set out to come to this conclusion but when I wrote *Becoming Batman*, the process of researching and thinking about the scientific perspective, I did come back to that. The characteristics of that kind of mid-1970s Batman, the Neal Adams/Denny O'Neil Batman, when they were teamed up as writer and artist, that's actually really close to the realistic portrayal of Batman, what he would look like, what he could do, his athleticism, that kind of thing. Later on, once you get to the 1990s, he basically becomes a steroid monster. He's not supposed to be taking steroids in the storylines, but he's way too muscular, and he's not really athletic anymore. That guy from the 1970s was a real athlete. So, to me, that's the real Batman archetype.

**LB:** *Why do you think Batman compels such devotion among fans?*
**EZ:** I think it's the human element. The idea that you've got a human being; you don't have somebody born on another planet or who needs extra-

terrestrials or anything like that – not that those stories aren't fun to read. Batman's the guy who is pitched as wanting to do something, setting out a path to achieve that and doing all the work. And I think, even though nowadays we don't want to do that much work, people still admire the work ethic and the idea that if you try to do something, if you're willing to put in the time and the effort, you can achieve things. I think that's what really draws people to the character, even though, as you read in my book, the likelihood of that happening is so small because of all the factors that would need to come together. Despite that, it's really illuminating that pieces of what Batman achieves – or Bruce Wayne achieves – are realized. There are pieces of it that a person can do. I think that just highlights our own potential, the abilities we all have, if we were to put the effort and sweat in to doing them. I think that Batman highlights that as an option.

**LB:** *Would you still consider yourself a Batman fan?*
**EZ:** I wouldn't say I'm a Batman fan actually. I appreciate Batman's athleticism and have a lot of respect for what the character represents, in particular the training end of things. In my own experience in martial arts, I realise how hard you have to train to do even a piece of what Batman achieves as a character. So I wouldn't call myself a fan of any of the characters I've written about, but rather a respectful sort of nod to what they've achieved is how I'd look at it.

**LB:** *So, do you think the desire to become Batman fuels cosplay?*
**EZ:** I think in some ways it probably is behind that. I think it's a game that's a bit misplaced though. People respect the character and admire the fact that you can do that, but they want to skip the work and think that there's a costume that actually produces the character, when in fact that is just the last possible thing. The costume could be used in Batman's case to scare people, but it's got to be on top of everything else. The metaphor that I used in *Becoming Batman* and *Inventing Iron Man* is that technology only enhances your own ability; it doesn't create something that doesn't exist.

The costume can give a nod towards your wish fulfilment, which can be fun, but I think you see real people now who try and act as vigilante crime-fighters, and one of the things they're always doing is dressing up in outfits. I don't get that. But that's different from the cosplay question, which is misplaced again, because nobody wants to do the training. You know if I told someone they had to train for fifteen to eighteen years, nobody wants to put in the work, but they want to get the outcome and I think that's where we're misplaced in society now, and I think that's where

the disconnect comes out.

**LB:** *It's like that sequence in The Dark Knight where Batman scolds the amateur vigilante saying, 'I'm not wearing hockey pads!'*
**EZ:** Yeah, it seems a bit harsh, but it's a very serious point in the movie: he's actually got the training and he's just created the gear that goes with the application of the training. You cannot create some gear and then just use it and think you're going to be a player, whether it's a sport or Batman. You know the idea in sports where you buy Phil Nicholson's or Tiger Woods' golf club. It doesn't make you the player by using it; it's only going to add to what you've already done through training and hard work.

**LB:** *So would you consider that vigilante aspect as possibly a negative aspect of this fandom?*
**EZ:** Yeah, I think it is a negative aspect. What I really encourage people to do when I talk about *Becoming Batman* is to find the little bit of Batman you have inside yourself, and put it to work in your daily life. Use the concept of what you see in the metaphor to improve yourself. If you see somebody in line at the bank belittling the cashier or whoever, intervene and say something. Don't intervene physically, but show with your actions in daily life that you are actually trying to make the world a better place by trying to be kind to people. It's what Batman's about, but he takes it to the extreme of armed vigilantism. How do we use that in real life? It isn't by dressing up and going out on the streets and finding people at night.

**LB:** *In your own personal experience, can you think of a particular moment where your engagement with Batman has informed something you've done?*
**EZ:** Yes. One of the things that I think I took away from the process of writing *Becoming Batman* was to emphasize a more generalist attitude. In other words, I think as humans we always want to take everything all the way to the extreme: if I'm a marathon runner, all I do is run marathons, or if I'm a strength trainer, then all I'll do is lift weights. The reality of the Batman concept is that you have to be good at many things and I think that's a big take-home message. For me, in my own martial arts training, I'm always emphasizing all kinds of things, not just one thing in particular, because you have to have a palette of abilities, not just be super, super good at only one thing. Even though our society allows us to do that, we don't have to hunt and gather food, run long distances and spear things. We can be specialists now, but it's not healthy and I think the ironic part of thinking about the extreme training that Batman requires is to back it up

**Fan Appreciation no.2**
E. Paul Zehr

and say, 'don't put all your eggs in one basket'. I think that's a really important take-home message that I've tried to apply to my own life.

# **Part 2**
# Embracing the Knight

# Fan Appreciation no.3
## Josh Hook and Kendal Coombs

Fans want to be first. They line up for hours, even days, so they can be the first to buy the ticket, read the book, get into the stadium. Such enthusiasm surrounded the release of Christopher Nolan's trilogy-closer *The Dark Knight Rises* in the summer of 2012. Fortunately for Australian Bat-fans the film was released on 19 July, one day earlier than most of the world. Factoring in the time difference, these fans were able to experience the film almost two days before their Stateside equivalents. Nonetheless, for 23-year-old artist Josh Hook and 22-year-old writer Kendal Coombs this wasn't early enough. To ensure they were amongst the first to see the blockbuster, they attended a marathon of Nolan's Batman films that culminated in a midnight screening of *The Dark Knight Rises* at Melbourne's IMAX cinema, and of course, they were dressed as Batman and Catwoman.

**Liam Burke:** *What was your first experience or encounter with Batman?*
**Josh Hook:** My dad was really big into the 1960s' Adam West *Batman*, so through that. When I was about three or four my grandma made me a costume; this cowl [pictured] is actually from the original costume. So that's pretty much where I started. I got into comic books when I was in high school. There was a comic book store near the train station so I said I'd check it out.
**Kendal Coombs:** My parents bought *Batman Forever* on DVD when we first got a DVD player. It's like the worst movie ever, but I always liked Batman. I never really embraced being a proper comic book nerd until I started going out with Josh. I've embraced it since. I love dressing up and going to movies.

**LB:** *Across the decades there have been many different interpretations of Batman. Do you have a preferred version?*
**JH:** I always loved the original animated series from the early 1990s with Kevin Conroy and Mark Hamill doing the voices of Batman and the Joker. In terms of the current Batman writers, Scott Snyder is doing really, really good stuff with the Batman comics at the moment. I would always have arguments with my Dad because he would never budge on Adam West being the ultimate Batman, and as much as I tried I could never get through to him. It's been forty years; it's time to move on.
**KC:** Not Batman so much, but I really love the villains in the 1960s TV series. I loved it when Eartha Kitt was Catwoman

**LB:** *Do you have a favourite Batman villain?*
**JH:** I always sort of loved Two-Face the most, and then the Scarecrow and

the Joker. With Two-Face there's a graphic novel called *The Long Hallow-een*. I love Tim Sale, he's one of my favourite artists, and when I read it I went, 'OK, Two-Face is the best'.

**LB:** *As Batman fans, can you recall any extreme moments in your own fandom?*
**JH:** Considering I'm the only one here tonight dressed up as Batman, I think I've gone above and beyond. There are many times when I've been drunk where I attempted to be Batman and climb buildings, but it's never been very successful.
**KC:** I always try and get him down, because I know he's going to hurt him-self! Look at him – he's spindly; he's nowhere near built up as much as the current Batman. However, I do love Christopher Nolan, and love that he's made this series so good!

**LB:** *You haven't seen the third one yet.*
**KC:** Well, can you have much doubt; seriously, the man is a genius.

**LB:** *Why do you think Batman compels such devotion among fans?*
**JH:** It's just that he's so damn cool. When it comes down to it, it's just a guy standing on rooftops looking really, really bad ass, as opposed to the guy that swings around in red and blue. It's that sort of dark side that ap-peals to everyone, I think.
**KC:** I think it's like the legend, maybe. Everyone knows the Batman story. Whereas when the *Amazing Spider-Man* came out, everyone was like, 'Well that's not the real Spider-Man story', when actually if you read the comic books, yes it is. There are too many interpretations of other su-perheroes, whereas the Batman ones will always be the same. So I think it resonates with people. It translates from generation to generation, you know a guy who loses his parents when he's a kid and then grows up and decides 'I'm going to stand up and do something about it'. I think every-one wishes they were a little bit like that.

## THE POST-SCREENING VERDICT

**JH**: The film was good when you considered it on its own, but as a trilogy it was amazing and the best comic book narrative on-screen.
**KC:** It was awesome! It was great to see a comic book movie that wasn't just an adaptation of comics, but looked and felt like a real film.

# THE TRUE CRIMEFIGHTER ALWAYS CARRIES EVERYTHING HE NEEDS IN HIS UTILITY BELT, ROBIN.

**BATMAN**
BATMAN (THE TV SERIES) 'THE DUO DEFY'

Chapter
5

# The Passive Case: How Warner Bros. Employed Viral Marketing and Alternate Reality Gaming to Bring Fandom Back Into the Culture Industry

Margaret Rossman

→ Men and women of all ages, faces caked in white make-up, hair covered in green dye, all costumed as some manifestation of the Joker, invade the city. What might seem like a comic convention gone awry was, instead, part of an extensive marketing campaign for *The Dark Knight* (2008), the second film in Christopher Nolan's Batman trilogy. On Halloween night 2007, visitors to www.rorysdeathkiss.com were instructed to dress up, visit their local landmarks, snap a picture in support of the Joker and upload it online. While the many pictures taken show the depth of the Batman fandom, this also marked a major moment for producers seizing control back from potentially resistant fan practices.

The 'culture industry', as coined by Theodor Adorno and Max Horkheimer in 1944, suggests that culture creates a world of conformity through mass media, as a passive audience simply receives what is presented to them. However, the fan, as often constructed today, perhaps is the best counter to this argument. Self-proclaimed 'aca-fan' (part academic, part fan) Henry Jenkins writes in his seminal work, *Textual Poachers*, of 'five levels of activity' in fandom. Jenkins acknowledges that '[f]andom does not prove that all audiences are active; it does, however, prove that not all audiences are passive'. Indeed, comic book fans, though highly devoted to the source material, are one of the biggest dangers to the buzz generated for a new film adaptation, easy to anger at production choices that conflict with their perception of the characters. But fans are also in a position to be appeased, as marketing caters to their desire for knowledge, giving them the images and trailers they crave in anticipation of a film. As Adorno and Horkheimer point out in *Dialectic of Enlightenment*, 'Advertising is [culture's] elixir of life,' and it is ultimately advertising which makes the audience into an unknowing apparatus of the 'culture industry'. While this push and pull has always been central in the fan/producer relationship, viral marketing takes it to the next level, appropriating fan practices to suppress the once active audience.

The concept of viral marketing is ambiguous in its various usage, but the defining trait is an advertisement's ability to 'go viral' – to spread like a virus through the potential audience until everyone is 'infected' with its message. Viral marketing took on another connotation with the success of the marketing for the horror film *The Blair Witch Project* (Myrick, 1999), with the creation of a website presenting the mythical history of the Blair Witch as if it, and the resulting movie documenting it, were real. In this sense, viral marketing attempts to morph the film world into reality through a variety of interactive events.

Critics of the culture industry suggest that the audience resists mass media even as they embrace it and, increasingly in a globalized world, such standardization of culture is no longer applicable. Indeed, Adorno and Horkheimer were writing in exile, influenced by the images of the rise of the Nazi regime in their native Germany, when state control and ideological influence permeated culture substantially. Yet, the culture industry still serves as a critique of capitalism and the words of Adorno/Horkheimer continue to indict the modern Hollywood system. It is hard to miss the parallels when considering their ideas in light of current marketing practices. Scott Lash and Celia Lury attempt to update the culture industry concept in *Global Culture Industry: The Mediation of Things*. They note that cultural objects are no longer identical as Adorno and Horkheimer posit, but instead 'cultural entities spin out of the control of their makers'. This idea is certainly true, but even these transformations can be contained. Adorno clarified his term in 'The Culture Industry Reconsidered' (1967): 'Thus, the ex-

### The Passive Case: How Warner Bros. Employed Viral Marketing and
### Alternate Reality Gaming to Bring Fandom Back Into the Culture Industry
Margaret Rossman

*Fig. 1: The first viral website
for The Dark Knight, www.
ibelieveinharveydent.com.*

*Fig. 2: 'Joker's' response to Harvey
Dent's campaign site, www.
ibelieveinharveydenttoo.com.*

pression "industry" is not to be taken too literally. It refers to the standardization of the thing itself [...] and to the rationalization of distribution techniques, but not strictly to the production process'. With viral marketing, the resistant fan practices that refute the culture industry concept are likewise homogenized and standardized.

Adorno and Horkheimer were well aware of how contests and games could keep the audience conformed to mass culture ideals. In discussing an earlier media form, they write, 'Any trace of spontaneity in the audience of the official radio is steered and absorbed into a selection of specializations by talent-spotters, performance competitions, and sponsored events of every kind'. Anticipating that some in the audience will desire to interact, the media creates limited possibilities within which this is allowed. In his book, *Show Sold Separately*, Jonathan Gray describes the idea of online 'policed playgrounds', which provide for permissible fan-created content while still 'imposing a set of rules and limitations'. Viral marketing similarly lures fans into a real-life protected space for such activity. Yet while fanfiction bares the risk of copyright infringement, viral marketing attempts to control fan practices, such as dissent, which were never in jeopardy.

The marketing for *The Dark Knight* stretched further into the new world of 'alternate reality gaming'. Alternate reality gaming (ARG) uses the real world as its game space, not a video game console. According to Chris Lee, writing for the *Los Angeles Times*, the film's early promotion worked by 'mashing up advertising, scavenger-hunting and role-playing [...] all in the name of galvanizing a community of fans to bond (with the new Batman and each other) over the course of a wild goose chase'. In May 2007, the official Warner Bros. website for the film went online with nothing but a bat symbol that, when clicked, redirected the user to www.ibelieveinharveydent.com (Figure 1), a political campaign website for Harvey Dent, one of the main characters in the narrative. This discovery was followed by www.ibelieveinharveydenttoo.com (Figure 2), which invited people to sign up with their e-mail addresses, eventually revealing Heath Ledger as the Joker.

At this point, the creation of the campaign was situated primarily in a casual fan community. The only effort needed to discover the first website was to visit the obviously corporate-endorsed official website. The direction to give an e-mail address to achieve a reward – the first view of the new Joker – is quite similar to an official fan network. It is important to note here that the fan's hyper-awareness of the official cam-

Fig. 3 'Jokerized' dollar
bills handed out to fans
at the San Diego Comic
Convention, 2007.

paign's involvement may make it less susceptible to the view of passivity. However, the official capacity became increasingly hidden as the campaign continued.

The various stages of this viral campaign serve to show how marketing brings the fan back under the control of the producer. This marketing targets the most active fans, but also the ones most willing to give in to the system. These fans then become enforcers of the system, refusing to acknowledge the advertising aspect inherent in the campaign. Ultimately, the fans lose their will to resist. Even though it seems as if they are taking more action than ever before by participating wholeheartedly in the ARG, the ARG presents pseudo-freedom, a mode of action within the system.

The next event transitioned the campaign to targeting the more active fandom Jenkins describes. At the San Diego Comic Convention, 'jokerized' dollar bills (Figure 3) were given to attendees, which advertised the website www.whysoserious.com. As Lee writes, the website carried instructions from the Joker to potential participants to 'become his henchmen with special prizes tempting those willing to carry out his off-line demands'. Lee continues: 'These players gathered at a physical location to obtain a phone number that was written in the sky by a plane, and from there, they embarked on an elaborate scavenger hunt around the city'. The hunt ended with instructions to the online followers: 'When your friends on the ground go back to the vans, they will need to submit one of their own to complete the application process'. At this point, one fan, dressed in Joker face paint, was chosen and escorted into a black Cadillac Escalade. The last message of the game suggested that this 'henchman' had been 'murdered' for the sake of the Joker's plan: 'A new clown has stepped up to represent me in some sensitive negotiations with old pals of mine from uptown. The lucky candidate will be starting his new career at the county morgue within the hour'. With this move, the viral marketing of *The Dark Knight* transformed. The attendees of a comic convention are high-level fans – willing to make a pilgrimage for their fandom. Furthermore, the new website was obtained through a prop – not a typical advertising leaflet. Thus, the campaign distanced itself from the official status of Warner Bros. Most importantly, the campaign would be targeting those fans willing to go to extremes to be a part of the experience – even 'sacrificing' themselves for the cause.

The website www.whysoserious.com was not the only site to become a focal point of fan energy during the next few months, with over twenty websites created representing all of Gotham, Batman's mythical city, including the newspaper (www.thegothamtimes. com), the police department (www.gothampolice.com), citizen's organizations and even Gotham delicatessens. Often, these sites would find their counterpart in a 'jokerized' version, as in thehahahatimes.com, which graffittied the news of *The Gotham Times* (Figure 4). Discovery of the existence of these websites came from hints provided in previous sites and the fans' diligent searching for these alternate realities. Beyond simple promotion, the studio was giving the fans what they craved –more information.

### The Passive Case: How Warner Bros. Employed Viral Marketing and
### Alternate Reality Gaming to Bring Fandom Back Into the Culture Industry
Margaret Rossman

*Fig. 4: 'Jokerized' version of The Gotham Times, created for the fictional Gotham City.*

Yet the meticulous maintenance of official and unofficial sites demonstrates who really is in charge. Fan boards on SuperHeroHype.com devoted a forum to identifying real websites (those sanctioned by Warner Bros.) and fake websites (those created by other internet users) by finding out who registered the domain name. Even here, Warner Bros. attempted to conceal its involvement, as it was not shown as the domain registrant. Instead, these real websites are addressed to Domains by Proxy, Inc., a registration service that creates privacy for the domain owner. While keeping track of official websites is helpful for gaining clues to games and determining information about the film, the suppression of fake websites by the fan community itself contradicts Jenkins' notion. The creation of new material – fake websites – targeted the active fan that Jenkins discusses. Yet these fan sites are apparently not to be trusted and, as such, the fan community promotes the corporate websites over those of their fellow fans. As Gray suggests, the company sets up sanctioned playgrounds, but here the fans themselves act as the 'police'. In this way, the activity fulfils what Gray writes: 'media firms can still subtly reinforce their own preferred meanings by privileging certain fan products whose meanings wholly conform to those of the firm'.

An examination of the creative force behind many ARGs, 42 Entertainment, reveals the strategy for engaging the fan. In an article for *Wired*, Frank Rose describes the methods of Jordan Weisman, 42 Entertainment's principal creative executive, to 'reach people who are so media-saturated they block all attempts to get through'. Rose phrases Weisman's philosophy: 'Instead of shouting the message, hide it'. 42 Entertainment's website separates its audience into three categories: Casual, Active and Enthusiastic (those with a high level of interaction who create their own 'content' —Jenkins' idea of productive fans). The website actually uses quotation marks around the word content — a nod to the idea that fan-created content is not fully creative, but controlled content, similar to the 'performance competitions' and 'sponsored event,' cited by Adorno/ Horkheimer.

The website for Harvey Dent's campaign certainly allows followers to get involved — the 'You in Action' section enables fans to upload videos and photos in support, a virtual grassroots effort. However, the creators have dictated the place to upload, and the type of support - only positive. If a fan wants to oppose Dent they must do so within these

Fig. 5: 'Sitting Ducks game that fans deciphered as a binary message, rewarding them with a new website.

Fig. 6: 'The 'reward' for solving the Sitting Ducks game — a placeholder for a new trailer for The Dark Knight (2008).

constraints, by following the Joker's viral mayhem. Even when the 'Joker' himself does not dictate fan behaviour, it follows the proper paradigm. For instance, during the Harvey Dent campaign rallies that occurred around America, some groups showed up in clown make-up as a form of protest. Just as Adorno/Horkheimer point out that the individuality in the media is a pseudo-individuality, so is this creation is a pseudo-creation. The dichotomy of Dent and the Joker had already been set up from the beginning of the campaign and the style of clown make-up was set in place by the Joker's earlier tasks.

These marketing initiatives do allow for an awareness of the medium — as fans are asked to not only think of answers, but to think of how the game is run. To find new parts of www.whysoserious.com, fans needed to discover specific phrases and insert them into the URL:—for instance, www.whysoserious.com/itsallpartoftheplan. These are not simple clickable links. At the conclusion of one online game, a number of upper and lower case 'J's were discovered in online safes. Per a key discovered at the San Francisco viral event, the 'J's were deciphered as letters of the alphabet, which were then revealed to be an anagram of sitting ducks. Going to www.whysoserious.com/sittingducks revealed a shooting game with blue and yellow ducks. Upon converting these to binary code, the message was revealed to shoot a certain order of blue and yellow ducks only in the second row (Figure 5). This allowed the participant to 'win' but the reward was simply another website (www.whysoserious.com/happytrails) (Figure 6), hinting that the new trailer would be released there the following Sunday. These mechanisms appeal to the highly specialized knowledge of the computer-literate super-fan who would think to convert ducks to binary code. Of course, once one or two super-fans figure out these codes, they are expected to pass on the knowledge virally, democratizing their gains. In this sense, there is still an escape from the conversion into passivity. However, though the fans remain active, they are still allowing their disruptive fan behaviour to be converted to industrial, focused, fan labour in service of the marketing cause.

Another escape is in the ability to voice dissent, as Jenkins points out. During the game, 'It's All Part of the Plan', participants in major cities across the country were sent on a scavenger hunt to discover clues and ultimately be one of 300 admitted to see a new trailer. In order to learn each new clue, the on-site participants needed online counterparts, known as 'oracles'. So when the 300 on the ground were rewarded with the theatre screening of the trailer, the online oracles were stuck at their computers

The Passive Case: How Warner Bros. Employed Viral Marketing and
Alternate Reality Gaming to Bring Fandom Back Into the Culture Industry
Margaret Rossman

with nothing. Immediately, fans popped up on message boards to express anger at this treatment. As the oracles were also forced to give up an hour of their time, many of the oracles expected to be rewarded with a version of the trailer online. This demonstrates their willingness to have their experiences reinforced within the official system, rather than turn against it. While some of these fans may have complained directly to Warner Bros., it seems most complaints were to each other in the realm of fan message boards and websites – a protest that the studio would likely not hear.

The fans most involved in the viral marketing were aware of who was in control – even if Warner Bros. tried to hide it. When complaints arose, they were directed at the studio or the director, not at the alternate reality of Batman and the Joker. Yet fans have brought this industry courtship upon themselves through their desire to exalt advertising materials – posters, pins, and other promotional 'swag' – as the ultimate goal for participating in a live event. The fans may be aware that a movie poster is an advertisement, but they do not recognize it as such when coveting it. Instead, they see it as art they can keep for posterity. A souvenir of the film will help them prolong the experience.

Fans have always expressed this duality: to gain some 'insider-ness' while also bad-mouthing the industry among themselves. Discussions and discord have been part of the Batman comic community in the form of letter columns and fanzines long before the adaptation to film, as Will Brooker describes in *Batman Unmasked*. As he notes, these forums elide the separation between producer and audience, and the transition to comic boards on the Internet 'have eroded more completely than any other format the boundaries between "reader" and "writer," amateur and pro, fan and author'. But this closeness reverts to distance when the role of creator is replaced by a Hollywood studio catering to a mass audience.

When discussing Tim Burton's *Batman* (1989), Brooker notes this dismissal of fans by the industry. He writes of the paradox where,

'[T]he movie will be tailored for those who care least about the character, while those with the greatest emotional investment become a powerless elite, a vocal minority whose voice is rarely loud enough, and who are fated to watch helplessly as "their' treasured possession is given over to the whims of the majority'.

In the twenty years since the release of *Batman*, fandom's position in the mainstream has changed drastically enough that the fan voice did matter to executives in the marketing of *The Dark Knight*. But in what way? Clearly, the viral marketing was not just to quash dissent – though it may be seen as re-engaging fans that were loudly dismissing the casting of Heath Ledger as the Joker. Instead, the notion of the fanboy has gone from outsider, to an insider icon – something Warner Bros. can co-opt for their own symbolic use.

The fannish desire to make life indistinguishable from film merges with the narra-

Fig. 7: A fan in Joker make-up at Walt Disney World, submitted to www. rorysdeathkiss.com.

tive of *The Dark Knight* itself. Nolan's gritty portrayal of Batman – already the least superhero of superheroes with no real superpowers – seems to naturally play into realist marketing. Beyond the many websites creating the world of Gotham, viral videos included a press conference by Rachel Dawes (played by Maggie Gyllenhaal) supporting Harvey Dent, alongside several audio statements from Harvey Dent (as played by Aaron Eckhart) himself. To hold campaign rallies with supporter pins and bumper stickers during an actual election year merges the film into the events of contemporary society.

However, this merge towards reality may actually be what keeps the fan aware of the filmic medium and not simply a passive consumer. No longer can the audience members be simply content to watch the film and immerse themselves in the filmic reality, because some of them (the reality gamers) have already tried to transition this reality. Suddenly, there is a disconnect between film and audience when sitting in front of the screen. The presence of the screen itself and the seats in the theatre make the new viral audience members hyper-aware of their situation as spectator. Thus, they no longer see the actual film as real in the same way. This potentially provides a partial escape from the bounds of the culture industry. It offers a chance to be aware of your position as viewer; and without passive immersion, the culture industry cannot succeed.

Additionally, the lack of control over who participates in these campaigns may be one other method of resistance to the marketing techniques. On www.rorysdeathkiss. com, (Figure 7) the variety of uploads show many interpretations of how to show yourself as the Joker. While the structure prevents too much creativity (and one would guess a censor is in place for any photos that try to push certain boundaries), the lack of homogeneity allows these fans to merge their personal creations of the Joker into some sort of canon. Also, the control of fans is centred during times of marketing – during the interim between movies, active fan discussion and creativity emerges.

Centring the viral marketing campaign for *The Dark Knight* on the Joker is ironic as the Joker is most representative of rebel chaotic appeal. Though this is exactly why the Joker is the best choice. Being a 'goon' for the Joker in the ARGs of the campaign allows the fan to feel renegade and free – even if every move in the game is dictated before the players even start. This marketing specifically targets the active fan in an attempt to reclaim corporate authority. The culture industry may no longer be as Adorno/Horkheimer imagined it, but studios can still use these techniques to homogenize, standardize, and mass-produce fan behaviour.

Jenkins writes of fans that develop an active viewing experience, which allows them, not the mass culture, to create the interpretation of art. Yet, it is not just a need to suppress that makes this fanbase ideal for targeting by the studios. Through their superfandom, these people have the most cultural capital – the most clout to influence other fans, and to affirm the authenticity of the film for mass audiences. This is capital Warner

### The Passive Case: How Warner Bros. Employed Viral Marketing and
### Alternate Reality Gaming to Bring Fandom Back Into the Culture Industry
Margaret Rossman

Bros. and other studios are eager to spend. The rising power of fans presents a threat to a streamlined and accepted brand. By understanding what fans desire and how they operate, the studios, along with ARG companies like 42 Entertainment, have found a way to bring fandom back into the fold. Though these fans still present an awareness of their situation, they knowingly refuse it in order to benefit from the fantasy world. Adorno/ Horkheimer conclude 'That is the triumph of advertising in the culture industry: the compulsive imitation by consumers of cultural commodities which, at the same time, they recognize as false'. This is also the triumph of viral advertising — to seduce an active fandom into fantasy and allow them once again to be controlled. ●

## GO FURTHER

### Books

*Show Sold Separately: Promos, Spoilers, and Other Media Paratexts*
Jonathan Gray (New York: New York University Press, 2010)

*Batman Unmasked Analyzing a Cultural Icon*
Will Brooker (New York: Continuum, 2000)

*Textual Poachers: Television Fans & Participatory Culture*
Henry Jenkins (New York: Routledge, 1992)

### Extracts/Essays/Articles

'Bat Infiltration; Raising their Internet Game, '*Dark Knight*' Promoters use Genre-bending, Viral Ways to Pull in Viewers.'
Chris Lee. The Los Angeles Times, March 24, 2008.

'Secret Websites, Coded Messages: The New World of Immersive Games.'
Frank Rose. *Wired Magazine*, Issue 16.01, http://www.wired.com/entertainment/music/magazine/16-01/ff_args, December 20, 2007

'The Culture Industry Reconsidered.' Theodor Adorno.
In *The Culture Industry: Selected Essays on Mass Culture* (London: Routledge, 1991).

'The Culture Industry: Enlightenment as Mass Deception.' Theodor Adorno and Max Horkheimer. In *Dialectic of Enlightenment* (London: Verso, 1997) pp. 120-167.

### Films

*The Dark Knight*, Christopher Nolan, dir. (USA: Warner Bros. 2008)

### Websites

42 Entertainment, www.42entertainment.com
Rory's Death Kiss Website, www.rorysdeathkiss.com
Why So Serious Website, www.whysoserious.com

Chapter
6

# Canonizing *The Dark Knight:* A Digital Fandom Response

Tim Posada

→ 'And here we...go'

Find any superhero message board and a 'Top 10' of superhero films is sure to follow, with appearances from familiar films like *Spider-Man* (Raimi, 2002), *Superman* (Donner, 1978) and *Iron Man* (Favreau, 2008). But one film often soars above the rest: *The Dark Knight* (Nolan, 2008). While Matthew J. Pustz in *Comic Book Culture* considers nostalgia a primary motivation for collecting comics, new fans who became interested in superhero films over the past decade brought with them different expectations. While superheroes made brief appearances on the big screen prior to the new millennium, comics no longer hold a monopoly on superhero stories as their cinematic *doppelgängers* increase in popularity and numbers. In the midst of this, fan news websites like SuperHeroHype.com contain digital conversations that define the aesthetic calibre of these new superhero films and the open-forum process of determining their ranking. For this study the forums of six superhero films on SuperHeroHype.com were examined, revealing *The Dark Knight's* (*TDK*) rules the roost. For users, *TDK* marked the shift from fun to serious superhero cinema in a changing mediascape. This research highlights the shifting expectations and rules created by fans that turned *TDK* into the ideal motion picture adaptation that functioned as both a quality film and an accurate reflection of beloved characters.

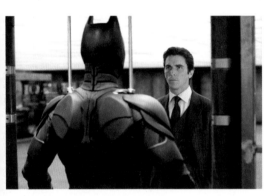

Fig. 1: 'Bruce Wayne (Christian Bale) contemplates his role as Batman, the dark saviour of Gotham City, in The Dark Knight (Nolan, 2008).

**The origin story (or the method and results)**
This research began as an analysis of the way one particular fan community responded to a superhero film based on previous knowledge of superhero comics. To this end, John Fiske's term 'active audience' helps counter often unfounded accusations that fans indiscriminately praise popular culture texts with little critical thought. In other cases, fans are even blamed for something clearly made for mass audiences. For example, sci-fi news website GiantFreakinRobot.com reporter JT countered Roger Ebert's assumption that *Transformers: Revenge of the Fallen* (Bay, 2009) catered too much to 'fanboys'. Ebert claimed *Transformers: Revenge of the Fallen* would not reach substantial box office heights due to its narrow audience appeal:

I don't believe 'Titanic' and 'The Dark Knight' have much to fear, however, because (1) [*Transformers:Revenge of the Fallen*] has little to no appeal for non-fanboy or female audiences, and (2) many of those who do see it will find they simply cannot endure it.

But with a global gross of $836,303,693 (and $1,123,746,996 for the third film in the franchise), 'non-fanboy' and 'female audiences' seem to have found a way to 'endure it'. Even with their powers combined, fan communities can't break $100 million let alone $800 million. For example, *Variety* magazine reporter Brian Lowry warns film producers against what he calls the 'Comic-Con false positive'. While fans might be vocal about their support, especially at cons (conventions), 'plenty of projects that produce infectious excitement within the convention hall don't spill over much beyond it'. In short, approximately 100,000 fans cheering in one place remains a substantial but niche market. Fans are often marginalized and fragmented groups, thus Ebert's assertion feels

## Canonizing *The Dark Knight*: A digital fandom response
Tim Posada

more like an attack on what he considers lowbrow taste than a genuine demographic analysis. Fan groups are usually not large enough to fill seats at theatres, and this study shows an example of fan taste that differs from popular and critical tastes. Tallying with JT's assessment, many threaded conversations focused on *TDK*'s new role as the super-hero film standard – a far cry from the fannish support supposedly behind *Transformers: Revenge of the Fallen.*

In his article 'Comic Book Fandom and Cultural Capital', Jeffrey A. Brown contends that comic stores provide 'a place for fans to accumulate and demonstrate their cultural knowledge of comics'. Similarly, the focus of this study, SuperHeroHype.com, facilitates an archivable comic shop-like dialogue. Media scholar Henry Jenkins argues that with the advent of media convergence, digital environments '[enable] communal, rather than individualistic, modes of reception', allowing users to build upon other users' posted conversations. Six superhero films were chosen based on their higher box office grosses, proximity in premiere dates (2008–09), and previous comics-storied form:

1) *Iron Man* – $585,174,222

2) *The Incredible Hulk* (Leterrier, 2008) – $263,427,551

3) *The Dark Knight* – $1,001,921,825

4) *Watchmen* (Snyder, 2009) – $185,258,983

5) *X-Men Origins: Wolverine* (Hood, 2009) – $373,062,864

6) *Transformers: Revenge of the Fallen* – $836,303,693

For each film, the first 200 forum responses from the Saturday posting of each film's opening weekend (usually a post titled 'What did you think?') were collected and categorized. The 1,200 user comments were placed into the categories positive, neutral and negative to create an estimated film grade (neutral comments were divided in half for this approximate grade):

| Films | Positive | Neutral | Negative | Grade |
|---|---|---|---|---|
| The Dark Knight | 177 | 21 | 2 | A/A- |
| Iron Man | 160 | 35 | 5 | A-/B+ |
| The Incredible Hulk | 170 | 23 | 7 | A-/B+ |
| Watchmen | 128 | 41 | 31 | C |
| Transformers: Revenge of the Fallen | 100 | 38 | 62 | D/D- |
| X-Men Origins: Wolverine | 74 | 36 | 90 | F |

*The Dark Knight* clearly earned the most fan adulation, with the film's dramatic con-

clusion, intelligent story and Heath Ledger's performance as the Joker frequently cited. Many other topics discussed included the film's chances of beating *Spider-Man 3*'s (Raimi, 2007) opening weekend record at the box office (which it did), overall box office performance, the likelihood of a third Batman film, and if another sequel should occur out of respect to Ledger's incomparable performance. As for the other five films, the following conclusions prove helpful in understanding how they influence the formation of a canon that finds its apotheosis in *TDK*:

1.  *Iron Man*: Excitement for the possibility of crossover films like *The Avengers* (Whedon, 2012) and enthusiasm about the film as a whole due to Robert Downey, Jr'.s performance and the casting of Samuel L. Jackson as Nick Fury (which is unique considering he only appeared briefly in a post-credits scene).

2.  *The Incredible Hulk*: Support of the film, especially its nostalgic connection to *The Incredible Hulk* television series from the 1970s and early 1980s. While commentators were critical of certain aspects, they were still very excited about sequels and crossover with Avengers characters.

3.  *Watchmen*: General disappointment or torn commitment due to some nostalgic connection to the graphic novel.

4.  *X-Men Origins: Wolverine*: Dislike of the film on aesthetic grounds and aggressive disapproval of changes made to Wolverine's origin, especially the treatment of the character Wade Wilson/Deadpool.

5.  *Transformers: Revenge of the Fallen*: A split between general disdain and enjoyment of the film coupled with statements acknowledging its low calibre when compared to *TDK*.

**Creating a superhero film canon**
From books of the Bible to key works in academic disciplines, canonizing takes on various shapes. In the case of fandom, the process is always fluid. In place of differing perspectives on canonical texts at Nicene-scale events, locales like comic shops, comic conventions and digital forums become the breeding ground for countless debates that rarely end in the creation of concrete sets of guiding principles. Claiming The Beatles are the best musicians in the world is just as arguable as declaring the idiocy of the *Twilight* film series (2008–12). In the end, determining aesthetic worth is always a matter of opinion, even if major publications and institutions claim otherwise. But unlike music and film canonizing, fandom canons remain on the margins, buried in website comments or message boards, assumed more than confirmed.

Every social group, an 'interpretive community' as Stanley Fish describes them in 'Interpreting the Variorum', creates its own set of reading parameters, and the Super-

## Canonizing *The Dark Knight*: A digital fandom response
Tim Posada

HeroHype.com users clearly developed a culturally situated set of assumptions amidst spelling errors, occasional flame wars and tangents. In this interpretive community, users fell into several similar patterns, such as constantly referencing renowned comic creators like Frank Miller and Grant Morrison without context, discussing other superhero films (again without context) and creating usernames – like Avenger Hawkeye, Gambitx925, or NEON KNIGHT – that identified them as superhero fans. For French sociologist Pierre Bourdieu these are examples of earning 'cultural capital' – the creation and use of social currency.

SuperHeroHype.com fans partake in a reading process that does not always agree with the box office patterns or film critics' definition of a good film, but thrives on a new set of standards. Rather than seek the approval of critics and broader audiences, they stand by their film choices in quiet corners of the Internet hoping that those critics and audiences will begin thinking like them to ensure the continued production of superhero films. This is perhaps the most important characteristic of a superhero film canon: some level of mass appeal. As the ideal, *TDK* appealed to fans, critics and broad audiences. The forums, then, revealed various hints of a superhero film canon all found in *TDK*:

- Superhero films must align with general standards of film quality to some degree.

- Superhero films do not need to follow normal film conventions that require concrete conclusions. It can remain open ended – like the ambiguous ending of *TDK* – and even provide a bridge into another film property – again disregarding the often closed structure of conventional popular films – just as comic book series do.

- Changes can be made to comic characters on-screen as long as those changes 'work', though what 'works' remains in flux.

- Easter Eggs – aside references to the original comics, like a remark about the Batsuit's ability to protect against cats in *TDK* (a reference to Catwoman) – are treated like special gifts meant just for the fans.

Along with these standards, and many more aesthetic parameters organically addressed in forum conversations, films like *Iron Man*, *Spider-Man 2* (Raimi, 2004) and *X2* (Singer, 2003) were considered the best, while films like *Spider-Man 3*, *Superman Returns* (Singer, 2006) and *X-Men: The Last Stand* (Ratner, 2006) were the worst.

Largely, film critics agree with the quality of many films here, but such consistencies do not mean that critical taste is the same as fan taste. Fiske effectively discusses this in 'The Cultural Ecology of Fandom' through the term 'shadow cultural economy', which describes a fan community's role outside mainstream culture yet still '[sharing] features with them which more normal culture lacks'. Further complicating the differences between professional critics and fans, fan communities also vary in reception. In a study of comics culture during the 1990s, Pustz even discusses the negative con-

notation of the term 'fanboy' when describing 'immature' comic consumers – a unique cultural dynamic that complicates the often homogenous perception of fandom. While SuperHeroHype.com users might dislike the aforementioned superhero films, users of websites like ComicBookResources.com and io9.com might be more forgiving. But for SuperHeroHype.com a different standard exists. As a news service dedicated to film adaptations, users approach cinema with a dual commitment: popular film conventions (three-act structures, melodramatic conclusions, etc.) and superhero comic history. For example, many expressed great respect for *Watchmen* the graphic novel, but felt the film lacked entertainment value; love of source did not ensure love of the film. Similarly, while much of the *Wolverine* forum focused on the outrageous 'sins' of the film-makers when adapting the character's origin story, many others agreed with user Sad X-Fan: 'This was terrible. Not just because it strayed so far away from the comics, but because it was down-right terrible'. In each case, comics foreknowledge did not trump film quality, but *TDK* was something else altogether.

The *TDK* forum rarely addressed specific details from the comics. As for potential liberties with the source material, *TDK* is far from pure. First, beloved villain Two-Face's story is transformed into a symbolic counterpoint to Batman – the 'white knight' to Batman's 'dark knight' – appearing on-screen as Two-Face for very little time. Second, *TDK* even includes an original character, love interest Rachel Dawes, with no substantial backlash from fans. Lastly, at the 2008 Comic Con in San Diego, the Joker creator Jerry Robinson said he never imagined Batman's greatest nemesis as a sadistic terrorist, deeming the film's villain far darker than ever expected. Nonetheless Ledger's reimagining met with high praise. According to Roz Kaveney in *Superheroes!*, superhero film adaptations cannot be judged by its page-by-page adaptation of characters; rather, with multiple years of publication history, they must be gauged by the level of truth found in them. For the SuperHeroHype.com users, *TDK* found a balance between familiarity and originality. Clearly *TDK* draws upon recognizable Batman story elements as the film utilizes character ideas from *Batman: The Killing Joke*, marketing artwork from *Batman: Arkham Asylum*, and narrative elements from *Batman: The Long Halloween* and *Batman: The Dark Knight Returns*. The film carves out its own space in the Batman canon with a unique interpretation of the Joker and a depiction of Gotham City that more resembles Chicago (its filming location) than a gothic dystopia with sci-fi residual. Nolan's gritty Batman tale reaches truth by turning the Joker into a terrorist rather than a cartoony clown, and transforming the once camp crusader into something closer to reality, thereby creating a significant benchmark in canons for both superhero comics and superhero films. On screen, Tim Burton's *Batman* (1989) previously set the standard for a dark cinematic supervillain with Jack Nicholson's performance as the Joker, but these efforts were undercut by the camp sensibility of the third and fourth instalments, *Batman Forever* (Schumacher, 1995) and *Batman & Robin* (Schumacher, 1997). By drawing upon narrative elements of Frank Miller's *The Dark Knight Returns* (citizens-turned-

Canonizing *The Dark Knight*: A digital fandom response
Tim Posada

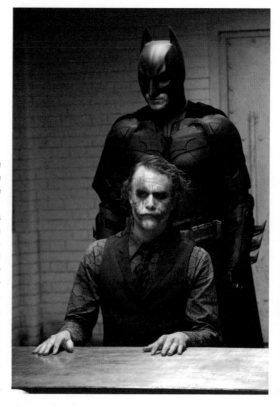

*Fig. 2: The Joker (Heath Ledger)
and Batman (Christian Bale)
participate in a battle of words
in The Dark Knight (2008).*

Batman copycats, the illegality of superheroism and the overall darker tone), *TDK* proved itself willing to venture into the territory that comics had been tapping into since the 1980s.

Linda M. Scott states that what unites readers of texts is a 'shared knowledge of cultural conventions', which lead to the creation of 'reading strategies'. For *Watchmen*, users employed a communal reading strategy based on how the film adapted the graphic novel. However, for *TDK* this shared knowledge was much broader. To further understand reading strategies, the concepts of 'intertextuality' and 'knowledge communities' become beneficial. For Fiske in *Television Culture*, intertextuality is found 'in the space between texts' where readers turn to external knowledge when interpreting a text. In *TDK* a rather humorous example of this occurs during the interrogation scene:

Batman: Then why do you want to kill me?
The Joker: I don't, I don't want to kill you! What would I do without you? Go back to ripping off mob dealers? No, no, No! No. You...you complete me.

This dialogue functions intertextually on two levels: (1) the Joker employs the phrase, 'You complete me', which was made famous by the film *Jerry Maguire* (Crowe, 1996); and (2) when the Joker asks, 'What would I do without you?' it is difficult not to nostalgically reflect on the years of narrative history these attracting-opposites have had together.

**'Why so serious?'**
The popularity of both *TDK* and *Transformers: Revenge of the Fallen* spurred some fascinating critical debate. In Peter Travers' *Transformers: Revenge of the Fallen* review for *Rolling Stone*, he compared the film to 'junk food' that 'poison[s] your insides and rot[s] your brain'. Elsewhere, former *Village Voice* writer Michael Atkinson critiqued *TDK* for metaphorically mirroring cultural anxiety, rhetorically asking, 'Does America need that badly a post-post-9/11 big Daddy to vanquish danger so we can slumber in our cradles?' Incidentally, Travers did not share Atkinson's pessimism, speaking highly of *TDK* and even claiming the film was robbed of a Best Picture nomination. Popular film has become an easy example of what Theodor Adorno and Max Horkheimer refer to as 'the culture industry' in their classic essay, 'The Culture Industry: Enlightenment as Mass Deception'. They claim media outlets (the primary force of the culture industry)

create a passive public unable to counter the power of dominant messages. While this view lingers, as Atkinson's attitude reflects, its universal application has lessened over the past seventy years with rising criticism of the possible elitism of such claims. This prompts the question: is the culture industry real or merely the intellectual elite's way of indiscriminately labelling the popular 'dangerous' or 'inferior'? While such a question is beyond the scope of this study, it appears clear that critical claims of inferiority are at least suspect considering ambiguous definitions of taste – something made clear by the perceived slighting of *The Dark Knight* by the Academy Awards.

However SuperHeroHype.com users care about more than critical acknowledge-ment, as the *Transformers: Revenge of the Fallen* posts showed. In the midst of divided reception, *Transformers: Revenge of the Fallen* supporters continually justified their enjoyment of the film despite its lack of critical worth. As user royal*** said, 'people should enjoy the movie for what it is; a huge dumb special effects laden action popcorn flick. It's a movie based on a toyline of transforming robots for ***s sake, wat do critics expect? *TDK*? god..'. (spelling and grammatical errors from the original post). The film's director, Michael Bay, echoed these sentiments when he countered criticism in a *Los Angeles Times* interview:

I think they reviewed the wrong movie. They just don't understand the movie and its audience. It's silly fun […] I am convinced that they are born with the anti-fun gene. The reviews are just so vicious. A lot of them are more personal than anything else.

Nonetheless, these few favourable comments were outnumbered by the 60-plus us-ers who asserted the film's insufficiency in light of *The Dark Knight*, which took the 'silly fun' out of the superhero genre.

What we find here is a distinction between silly fun and a question posed by the Jok-er in *TDK*: 'Why so serious?' Many users hoped for critical acknowledgment at the 2009 Academy Awards, resituating superheroes from the trash to a more respectable class of film. Unlike some elitist consumers who wish, according to Pustz, to retain 'ownership' of superhero stories in private sectors of a subculture, SuperHeroHype.com users cared more about the growth of superhero films and comics than remaining in the shadows. They desired to see *TDK* bridge the divide between popular art and high art, moving out of the 'shadow' of Fiske's 'popular cultural economy'. Now popular culture and fanboy subculture could finally align on a more permanent basis.

Tired of hiding, SuperHeroHype.com users saw *TDK* as an opportunity to be heard and set a new aesthetic standard – to turn critics into fanboys and fangirls. A heated media debate erupted surrounding the film's shunning at the Academy Awards for all but technical awards (save Ledger's nomination and win for his supporting role). This snub even garnered a humorous reference during the opening musical performance, wherein the telecast's host, Hugh Jackman, sang, 'How come comic book movies

**Canonizing *The Dark Knight*: A digital fandom response**
Tim Posada

*Fig. 3: Following the Joker's mayhem, Batman (Christian Bale) faces Gotham City's next major nemesis, Bane (Tom Hardy), in The Dark Knight Rises (Nolan, 2012).*

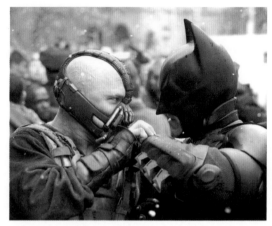

never get nominated? How can a billion dollars be unsophisticated?' However, *TDK* was eventually referenced by various representatives of the Academy of Motion Picture Arts and Sciences in its decision to switch from five to ten nominations in the Best Picture category for the 2010 ceremony. While not the intended victory, it becomes clear that differing perceptions of what constitutes an acclaimed film at the Oscars had to acknowledge *TDK*'s cinematic contribution.

Debates regarding canons remain to be continued, and with the release of films like *The Avengers* and *The Dark Knight Rises* (Nolan, 2012), the battle for the top dog won't have a victor anytime soon. Unlike official canons, such as the American Film Institute's top 100 list (which rarely adds new films), superhero film canons created by fans remain as open-ended as *The Dark Knight*'s conclusion. Fandom has long been considered an open-forum experience that provides multiple points of entry for participants; no one way of thinking reigns, just as no one superhero film speaks to everyone. As long as superhero films remain a Hollywood cornerstone, superheroes will battle for that top spot, hoping to prove that Batman doesn't have to fight injustice alone. ●

## GO FURTHER

**Books**

*Learning From YouTube*
Alex Juhasz  (Cambridge, MA: The MIT Press, 2011)

*Superheroes!: Caped Crusaders in Comics and Film*
Roz Kaveney (London: IB Taurus, 2008)

*Convergence Culture: Where Old and New Media Collide*
Henry Jenkins (New York: New York University Press, 2006)

*Comic Book Culture: Fanboys and True Believers*
Matthew Pustz (Jackson: University of Mississippi Press, 1999)

*Batman: The Long Halloween*
Jeph Loeb and Tim Sale (New York: DC Comics, 1999)

*Super Hero: A Modern Mythology*
Richard Reynolds (Jackson, MI: The University of Mississippi Press, 1992)

*Batman: Arkham Asylum*
Grant Morrison and Dave McKean (New York: DC Comics, 1989)

*Batman: The Dark Knight Returns*
Frank Miller, Klaus Janson and Lynn Varley (New York: DC Comics, 1987)

*Watchmen*
Alan Moore and Dave Gibbons (New York: DC Comics, 1987)

*Television Culture*
John Fiske (New York: Routledge, 1987)

*Distinction: A Social Critique on the Judgement of Taste*
Pierre Bourdieu, trans. Richard Nice
(Cambridge, MA: Harvard University Press, 1984)

*Image, Music, Text*
Roland Barthes, trans. Stephen Heath (New York: Hill and Wang, 1974) *Dialectic of Enlightenment* Theodore W. Adorno and Max Horkheimer
(London: Verso, 1972)

**Essays/Extracts/Articles**

'Beware the Comic-Con false positive' by Brian Lowry
In *Variety*, 14 July 2009,
Available at: http://bit.ly/13AyrN1

''Revenge of the Fallen' has turned off critics, but it reaped an estimated $201.2 million in domestic ticket sales in five days' by John Horn
In *Los Angeles Times*, 29 June 2009,
Available at: http://articles.latimes.com/2009/jun/29/ entertainment/et-bay29

'*Transformers 2*: It's the fanboys' fault' by JT
At *Giant Freakin Robot*, 26 June 2009,
Available at: http://www.giantfreakinrobot.com/film/transformers-2-fanboys-fault.html

'The fall of the revengers' by Roger Ebert
In *Chicago Sun-Times*, 24 June 2009,
Available at: http://blogs.suntimes.com/ebert/2009/ 06/the_fall_of_the_revengers.html

Canonizing *The Dark Knight*: A digital fandom response
Tim Posada

'Review: *Transformers: Revenge of the Fallen*' by Peter Travers
In *Rolling Stone*, 24 June 2009,
Available at: http://www.rollingstone.com/reviews/movie/25458013/ re-view/28840142/transformers_revenge_of_the_fallen

'Throwing down' by Michael Atkinson
At *Zero For Conduct*, 26 July 2008,
Available at: http://zeroforconduct.com/2008/07/26/throwing-down.aspx

'Comic book fandom and cultural capital' by Jeffrey A. Brown
In *Journal of Popular Culture* (vol. 30, no. 4), 2004, pp. 13-31.

'The bridge from text to mind: adapting reader-response theory in consumer research'
Linda M. ScottIn *The Journal of Consumer Research* (vol. 21, no. 3), 1994, pp. 461-80.

'The cultural ecology of fandom' by John Fiske
In Lisa A. Lewis (ed). *The Adoring Audience: Fan Culture and Popular Media* (New York: Routledge, 1992), pp. 30-49.

'Interpreting the variorum' by Stanley Fish
In *Critical Inquiry* (vol. 2, no. 3), 1976, pp. 465-85.

**Films**

*The Dark Knight*, Christopher Nolan, dir. (USA: Warner Bros. Pictures, 2008)

PEOPLE THINK IT'S
AN OBSESSION.
A COMPULSION.
AS IF THERE WERE
AN IRRESISTIBLE
IMPULSE TO ACT.
IT'S NEVER BEEN
LIKE THAT.
I CHOSE THIS LIFE.
I KNOW WHAT I'M DOING.
AND ON ANY GIVEN DAY,
I COULD STOP DOING IT.
TODAY, HOWEVER,
ISN'T THAT DAY.
AND TOMORROW
WON'T BE EITHER.

**BATMAN**
IDENTITY CRISIS (2004)

Chapter
7

# Mad, Bad, and Dangerous to Know: The Nolan/Ledger Joker, Morality and the Hetero-Fictional Fan Impulse

Leslie McMurtry

→ The Joker is:
'*Fascinating, repulsive, and contradictorily attractive*'. - Sorcha Ní Fhlainn
'*He's done unimaginably awful things*'. - Christopher Robichaud
'*The ideal postmodern cult figure*'. - Jim Collins

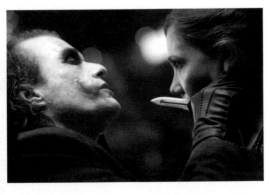

Fig. 1: *The Joker (Heath Ledger) tells Rachel Dawes (Maggie Gyllenhaal) how he got his scars in The Dark Knight (Nolan, 2008).*

As the chapter epigraphs show, the Joker means different things to different people. Fandom cannot come to a consensus about whether he is sane or insane. Mary E. Camp, writing with a group of medical professionals in *Academic Psychiatry* in 2010, determined that the Christopher Nolan-written and Heath Ledger-performed Joker, at least, was insane. More than that, he represented a 'fearless predator, unconstrained by social rules and expectations'. From a different quarter of the world came fandom's response. The release of *The Dark Knight* (Nolan) in 2008 resulted in an almost instantaneous effusion of fanfiction in archives such as FanFiction.net. Much of the fiction written about *The Dark Knight* analyzed, and, in many cases, eulogized, the Joker. Despite the acknowledged evil of the character, referred to by Camp et al. as 'stigmatizing' to the mentally ill, much of the fanfiction was of a romantic/sexual nature. Who are the authors of these stories, and why do they write them?

### Female fandom and archontic literature

Batman fandom of the 1990s, as many fan ethnographies have pointed out, was overwhelmingly male. Yet all this was about to change; Francesca Coppa, writing in *Fan Fiction and Fan Communities of the Internet Age* anticipated the spike in (female-authored) fanfiction upon the release of *Batman Begins* (Nolan, 2005), with 'groups of female media fans now shar[ing] space with male comics fans'. Fanfiction has traditionally been, in Abigail Derecho's words, the 'literature of the subordinate' and in that sense it has often been the domain of women writers, responding to an underrepresentation of women in media. With this criterion in mind, it is not difficult to see why female writers might want to reclaim *The Dark Knight* for their own; Rachel Dawes, Mrs Barbara Gordon, Detective Ramirez, and Judge Cerillo are the only females given any significant screen time.

But what, exactly, is fanfiction? M. Mackey and J. K. McKay summarize fanfiction as 'one relatively democratic version of that impetus to rework, to open up a previously finished story'. Batman is a perfect opportunity for such reworking. Some scholars (and fans) maintain that fanfiction has an ancient and illustrious history, while others believe it should be understood as a (recent) product of fan cultures. Derecho, in naming it 'archontic literature', from the word 'archive', suggests that when reading fanfiction, you are really reading two texts at once: the text that inspired the writing, and the 'spin-off' piece. Simply put, if someone writes a piece using the characters and settings of a cult text, its fanfiction. For a cult text to succeed in producing fanfiction, it must have hyperdiegesis - a sense of breadth and depth in the text's setting, a sense that any one

Mad, Bad, And Dangerous to Know: The Nolan/Ledger Joker,
Morality and the Hetero-Fictional Fan Impulse
Leslie McMurtry

story being told is only the tip of the iceberg in a larger universe – and what Matt Hills calls in *Fan Cultures* 'an endlessly deferred narrative'.

When fanfiction was first studied, it was seen as a highly subversive act; because of its frequent sexual content, and because it mimicked in some ways the precepts of chick lit and romance narrative, its consumption was framed, according to Catherine Driscoll, as 'private and purely for pleasure and thus something like a guilty secret'. In my analysis of the Joker fanfiction, I eschew an ethnography of the fan-authors themselves and instead focus on what their writing has to say about the way they view and craft a hyperdiegetic Batman universe. Critics like Deborah Kaplan have recognized that literary analysis of fanfiction rather than ethnography has been scarce. In archives like Fan-Fiction.net, the rules for posting fan fiction – essentially sharing it with the entire online world – are much less proscriptive than the commercial publishing or film-making industries; therefore the quality of much of fanfiction can be pretty poor. However, the most complex writing allows some insight into what Matt Hills calls 'just-in-time fandom', i.e. the immediate response allowed by online 'communities of the imagination'.

FanFiction.net, as of 27 May 2012, boasts 4,952 fanfics author-identified as belonging to the *Batman Begins/The Dark Knight* genre, and of these, 521 are categorized primarily as Joker-romance. A significant number of these works are 'slash' fiction, a term that originated with early, fanzine-based fiction describing a romantic/sexual relationship between Captain Kirk and Mr Spock of *Star Trek*; the term has come to identify any fiction that includes same-sex relations. The scope of this chapter is far too small to encompass the complex and much-studied genre of slash fiction, and we focus instead on heterosexual Joker-shipping (shipping is 'supporting certain pairings at the expense of others', such as Rachel/Bruce as opposed to Rachel/Harvey). Critics such as Alan Harris have characterized the Joker as asexual as well as amoral. Indeed, within the context of *The Dark Knight*, the only person for whom the Joker seems to espouse feelings is Batman. Yet, this has by no means prevented fan-writers.

### Sympathy for the devil

In *The Dark Knight*, DA Rachel Dawes is the love interest of both Batman/Bruce Wayne and Harvey Dent. A significant minority of fanfiction writers on FanFiction.net chose to link her in a 'ship' with the Joker. The pairing might, at first glance, seem unlikely given the fact that the Joker murders Rachel during the course of the movie. Nevertheless, fans of the Joker/Rachel (Jokachel) ship draw their inspiration (and their justification) from the party scene during which, crucially, the Joker makes Rachel privy to his second origin story in an intense and claustrophobic moment. Although given a heroic, mainly moral guidance-type role in the film, Rachel's appeal to most Joker fanfiction writers, who seem to prefer to make up their own original characters (OCs), is nominal. In this sense, perhaps, it is Rachel's own moral rectitude that hinders her. On the sliding scale of a pure and saintly ideal to an amoral nymphomaniac (a characterization which, in

Fig. 2 Harvey and Cleave
in 'Dark Side of the Moon'
(fanart).

Rachel's case, would be 'out of character' or OOC), fanfic writers have tended to present an OOC, more sexualized Rachel to complement the Joker.

Kendra Luehr's 'An Unhealthy Obsession' is a work that attempts to reconcile Rachel's moral character with traits of heightened sexuality. Loosely following the structure of *The Dark Knight*, the novella realistically portrays Rachel's relationships with Bruce and Harvey, while making her susceptible to the Joker, whose interest in her is partly as subject in his chaos experiments on Gothamites, and also a lust object: 'It's ok to want me, Miss Dawes, because all good women do – it's just in their nature to want the bad boys'. In 'An Unhealthy Obsession', romance conventions do not interest the Joker; Catherine Salmon and Donald Symons describe the Joker's sex aesthetic as 'sheer lust and physical gratification, devoid of courtship, commitment, durable relationships or mating effort'. Rachel, for her part, is *more* seduced by the notion that she can repair the psychologically damaged Joker. Borrowing fan canon ('fanon') elements from previous visions of Batman (such as the Tim Burton film), Luehr allows Rachel to discover a 'definitive' Joker origin as Jack Napier, whose father killed his mother and gave him his scars. Despite his continual spinning of 'Glasgow grin stories', she has brought meaning to, in Sudipto Sanyal's words, 'the meaninglessness of his mythmaking'.

This 'Beauty and the Beast'/reform motif in 'An Unhealthy Obsession' actually reverses the importance of lust in the narrative, and instead seems to reinforce romance conventions with the obviously flawed hero, a culmination in heterosexual fulfilment and suspense, depending at least partly on obstacles based on distinctions in social status. With part of the Joker's power in *The Dark Knight* hinging on the fact he has no one to lose, his murder of Rachel in the universe of the film would seem to negate any possibility of a romance narrative. However, in the final chapter of 'An Unhealthy Obsession', the author informs us that Rachel has not actually died and that she undergoes plastic surgery in a London clinic in the sequel. All along, the Joker has maintained that Rachel's demonstrable moral goodness has been merely overcompensation for dark deeds done in her past that threaten to make her as violent and unconventional as him. Rachel is at least as tempted by the Joker's ability to 'see beyond people and beyond masks as well,' as Stephanie Carmichael puts it, as she is by his sex appeal.

### Guy with the face

Original characters (OCs) paired with the Joker have included his ex-wife, a nurse, a French-Canadian seamstress, a college student, Bruce Wayne's daughter, a small-time crook, a stripper, a police officer and a journalist for *The Gotham Times*. 'So, is he the alter-ego of the author, or is he her ideal partner?' asks Victoria Somogyi in an examination of heterosexual fanfiction. She found that typically masculine traits of independ-

## Mad, Bad, And Dangerous to Know: The Nolan/Ledger Joker, Morality and the Hetero-Fictional Fan Impulse
Leslie McMurtry

ence, confidence and workaholism, as well as positions of authority, allowed a woman to be both, in Camille Bacon-Smith's words, the 'masculine cultural model of active agent' and subject of romantic, shipped fanfic. Such an unconventional (anti)heroine can be found in KatxValentine's Joker/OC fanfic, 'Dark Side of the Moon'. The heroine, Harvey Tinkle, never completely establishes herself as a reliable narrator. Nevertheless, she immediately appeals to the reader's sympathies as a highly modern, deeply flawed character with whom to identify, strikingly different from Rachel in her moral ambiguity, profuse swearing, and generally abrasive personality. KatxValentine achieves this partially through a highly original and humorous writing style, which quickly endears Harvey to the reader and to the Joker.

Significant motifs in Joker-ship fan fiction include:

- a weighing in on the sanity debate (see below)
- discussions – sometimes definitive, sometimes mysterious – of the Joker's origins, real identity, and where he acquired his scars
- careful prominence of moments when the Joker is without his make-up, as well as significance placed on his processes for applying and removing it.

It is this latter category, the make-up-less Joker, that is depicted with great originality in 'Dark Side of the Moon'. When Harvey Tinkle moves into a Gotham fleapit, she makes the immediate and unwilling acquaintance of Cleveland R. Punsworth, who is, as far as she is aware, an irritating social misfit with severe facial scarring.

Through a series of comic misadventures, which rely on Harvey's unexpected reactions to rote rituals of the Batman universe (she is outspoken and antagonistic towards Batman), Harvey and 'Cleave' become best friends – all within the space of a week. This perhaps unlikely manipulation of time/reason coincides with Rabowitz's Rules of Notice; with foreshadowing implied and rules of signification, time *can* be sped up believably within Harvey's universe, since the narrative roughly corresponds to that of *The Dark Knight*. Significantly, the writer makes her intellectual ownership clear, not only of her OC Harvey, but also of 'Cleave,' the Joker's alter-ego rather than his 'true' self. KatxValentine is able to subvert audience reactions in a number of ways; first by creating the loveable Cleave, and then by combining and brutally reconciling this aspect of his character with the murderous Joker.

How does the writer resolve the Joker, who mutilates and kills a child in front of Harvey Tinkle, with the comically bizarre Cleave, who spends most of his time prancing around in underwear, loudly singing along to Phil Collins and Cher? Away from the apartment and Cleave, Harvey also meets the Joker and is unable to make the connection: 'I push the thought away because I just don't want to think it'. To further complicate things, Cleave tells Harvey that the Glasgow grin is revenge from his jealous boyfriend, making Katx-

Valentine's Joker at least bisexual. A number of scenes from 'Dark Side of the Moon' are written from Cleave's perspective, announcing that Cleave is the façade, the Joker is the 'real' personality, and that Cleave's affection for Harvey is only really – again – the Joker's interest in her as another potential fellow agent of chaos. In this way, the Joker is proven correct, as Harvey is transformed by the end from a law-abiding citizen to a gun-wielding vigilante who rescues the Joker from Gotham MCU (Major Crimes Unit), all the while admitting but not confronting her love for him. KatxValentine's Cleave is another example of the way the Joker can be 'his own mystery' and still be accessible, even appealing.

### Without You, There Is No Me

J Horror Girl's novel-length *Can't Get You Out of My Head* posits an OC Joker-ship within the context of another fandom. Due to J Horror Girl's interest in, and familiarity with, the fandom of Asian horror films, her OC is as much a continual mystery (an 'endlessly deferred narrative') as the Joker is. This makes for gripping reading, which sustains the narrative across 100 chapters and almost 200,000 words; by Chapter 26, the story shifts to a detective story, a mystery never fully resolved. The OC, Grace, is introduced as a voice that seemingly exists only in the Joker's head. While initially dismissed by the Joker and Batman as an alter-ego, the voice gradually becomes more corporeal. At first, Grace and the Joker's relationship is one of mere physical symbiosis, each keeping the other alive, but Grace's personality is the one that interrogates Batman's motives and methods, as well as the Joker's. Moreover, her actions end up changing both the Joker and Batman for good.

In terms of conforming to the Joker-ship motifs identified earlier, Grace announces her existence by giving the Joker a Glasgow grin origin story involving dressmaker's shears, while at the same time acknowledging this as a 'shout out' to the film *Kuchisake-Onna/A Slit Mouthed Woman* (Kôji Shiraishi, 2007). In the words of Mackey and McKay, 'a shout-out hails the outside world from within the fiction, drawing on and speaking to fans' broader understanding of the story'. Once Grace manifests physically, though at first only visible in mirrors and on camera footage, the Joker betrays a physical attraction to her. Her identity is inherent in her diabolical pink shoes, another shout-out, this time to a Korean horror film, *Bunhongsin/The Red Shoes* (Yong-gyun, 2005). But she only becomes corporeal in Chapter 83, which is the first time her face is revealed; having died a horrific death, she 'haunts' the narrative in multiple ways. In terms of creating a romance narrative between Grace and the Joker, it is also in this chapter that the Joker reacts in the manner of a romantic hero – 'I couldn't wait any longer. I leaned in and kissed her' – despite later dismissing romance novels as 'AKA, Porn for Women' (what would he make of *Fifty Shades of Grey*?). Grace, neither dead nor alive, and a liminal figure in many other respects, completes the romantic narrative conventions: 'Nothing about this relationship was normal or usual; it was already much more intimate than sex, and that was the deciding factor. I felt married to him, as if I had always been married to him'.

Mad, Bad, And Dangerous to Know: The Nolan/Ledger Joker,
Morality and the Hetero-Fictional Fan Impulse
Leslie McMurtry

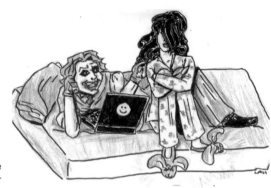

Fig. 3: The Joker and Grace in
Can't Get You Out of My Head
(fanart).

### Author anxiety and a question of sanity

As democratic and subversive as fanfiction may be, the fact remains that its authors crave reassurance from their readers, invest heavily in a community and value 'concrit' (constructive criticism). This is particularly interesting within the context of Joker-shipping, where many of the authors are self-identified as young, roughly in the same age bracket as most of their OCs (18–25 years old). In the Authors' Notes section, writers of the above three fics have communicated regarding real-life events, thanked their readerships, and apologised for self-declared poor writing. Given that fanfiction is often externally represented as a secret substitute for relationships, Kendra Luehr's declaration that 'An Unhealthy Obsession' 'will basically be a story your mother wouldn't want you to read. :-P' seems defiant in the face of criticism. Yet, in Chapter 9, after she has written a sexual scene too explicit for FanFiction.net, which has instead been posted on AdultFanFiction.net, Luehr writes, 'Omg, I feel SO effing DIRTY for writing this!'

Of great concern to the authors of OC fics is avoiding the label of 'Mary Sue'. Although critics such as Chander and Sunder have tried to celebrate the Mary Sue as an aspirational, democratic figure, being identified as one is still seen as highly pejorative by fanfiction writers. 'Mary Sue' has a long history of being a character who is the thinly disguised author pasted into the fandom of her choice; moreover, the Mary Sue is somehow 'better' than any other character so she can merit the love of her chosen ship-object. At their best 'Mary Sue litmus tests', auto-created by fanfic communities, acknowledge the primal desire for hetero-fictional writing, but also discourage mere fantasizing. In the case of the *Batman Begins/The Dark Knight* communities, countless fics have been identified by 'community policing' as Mary Sue transgressors; the Harley Who? and Mary Sue community claims over 400 fics that are found to bear the stigma of a Mary Sue OC.

The fanfiction writers of Joker-ships are perhaps also aware of external fears that fanfiction will lead girls into pornography, so they address this, either with defiance or embarrassment. Surprisingly, however, the writers do not seem compelled to morally justify sometimes-sexualized, sometimes-romantic writing about an undeniably evil character like the Joker. Bill Boichel and Sorcha Ní Fhlainn have considered, respectively, why criminals fascinate us, and why clowns might double for serial killers/paedophiles; the morality of the Joker for the shipping writers seems fundamentally tied up with the central debate regarding the character's insanity. Interestingly, the majority of critics consider the Joker insane, while, by inference, the majority of the shippers suggest he is 'super sane'. The Joker's 'super sanity' is a term Mike Collins applies in connection to the graphic novel *Arkham Asylum*. Daniel Moseley describes this viewpoint as 'a type of aesthetic perspective that attempts to bring non-moral and higher forms of goodness into the world via acts of cruelty or sadism'.

Among the critics who ultimately choose insanity, Camp et al. in *Academic Psychiatry* examined the settings, shot selections, music, lighting and editing in *The Dark Knight* to pick out representations of the Joker as other-than-human/a mad dog, concluding that not only was he violent, unpredictable and antisocial, he also displayed apparent suicidal behaviour. For these health-care professionals, not only was the Nolan/Ledger Joker insane, he reflected badly on the mentally ill. Mary K. Leigh and Daniel Moseley, both from philosophy backgrounds, came to similar conclusions. For Leigh, using Aristotelian categories, the Joker is 'vicious' and does wrong for wrong's sake. Moseley compared the Joker to Harvey Dent, the latter appearing 'morally ignorant', the former appearing not to be. For Moseley, the central debate was between two categories – that of the sociopath (with no conception of right or wrong) and that of the moral monster (chiming with Leigh's definition of 'vicious'). Moseley suggested that, while 'evil people find some positive value (that is, they do see some good) in their actions', this is not the same as moral goodness. When Christopher Robichaud asks, '[c]an we hold the Clown Prince morally responsible?', he asks, ultimately, whether the Joker's insanity (which he takes as a given) prevents him from being morally responsible. In his criteria for insanity, Robichaud cites the Joker's view of people as objects and his lack of self-preservation.

For the fanfiction authors, is the Nolan/Ledger Joker insane? Can we hold him morally accountable? And whatever the answers, does that mean it is morally acceptable to write sexual/romantic fanfiction about him? What are the moral obligations of the authors to their OCs, and ultimately, their readers? *Can't Get You Out of My Head*'s Grace goes so far as to wonder: 'When he hurt, I did, too. Emotionally, anyway. Damn it, why did I care about him at all? He was a mass murderer! Didn't that make me sick—or at least deeply pathetic?' When Robichaud describes one Joker origin story – that of the Red Hood – he suggests that if the Joker's transformation into evil wasn't originally his fault, he *can't* be held morally responsible. To a certain extent, 'An Unhealthy Obsession' takes this tack, at least in Rachel's mind. Grace stumbles over the Joker's memory of a group foster home, a hospital and (undefined) abuse: 'The problem is, every time you relate how you got your scars, every way you describe it, you're always sincere – or almost always. It's always the truth – but the truth is always different'.

This description begins to tie in with a view of the Joker often espoused by shippers, one that by virtue of its 'unique vision' seems to absolve them of any moral compunction in eulogizing such an evil character. This is Collins 'super sanity', or what Sorcha Ní Fhlainn describes as a state of 'simply being'. J Horror Girl has the Joker referring to himself as a god: 'Small "g", not big "G." Batsy, here, he's the god of fighting crime with hand and fist and really cool gadgets, and I'm the god of irony and banana peels over open manhole covers and the rictus grin'. The *Arkham Asylum* aesthetic of, in Collins' words, 'so insane he may be sane', includes a spirit of showmanship, along with rejecting society's conventional morality. In mimicking the Nolan/Ledger Joker as closely as

## Mad, Bad, And Dangerous to Know: The Nolan/Ledger Joker, Morality and the Hetero-Fictional Fan Impulse
Leslie McMurtry

possible, the fanfictional Joker believes that he embodies this aesthetic; whether he actually does is another matter. He likes to play around with other characters and the readers' perceptions of him. In *Can't Get You Out of My Head*, he tells the reader, '*I'm not* [insane]. They just don't know what else to label me' (emphasis original). By emphasizing the ethical decay of society and turning a critical eye to the moralities of Batman and other typically heroic characters, the authors make the Joker's chaos theory seem like a viable worldview. When Michael Smith describes the work of Lanzman, who holds that those who try to explain evil move toward justifying it, he chimes with Harvey Tinkle's experiences in 'Dark Side of the Moon', whose response to the evil the Joker has created in her by inspiring her love is denial.

Fred Botting suggests, 'Good depends on evil, light on dark, reason on irrationality, in order to define limits', but this is the world in which the Nolan/Ledger Joker operates and one that can be an ever-expanding universe thanks to writers of fanfiction. *Can't Get You Out of My Head*, for example, has stretched the limits of the hyperdiegetic universe of Batman; from the beginning, its length and breadth meant characters from *Batman Begins/The Dark Knight* (e.g. Gordon, Harvey, Rachel and Alfred) could exist alongside characters from other versions of Batman (e.g. Detective Montoya from *Batman: The Animated Series*). The story is riddled with shout-outs from sources as diverse as *The Aeneid* to the manga *Death Note*, and this almost anticipates its universe folding back on itself when Grace, having become corporeal and having consummated her relationship with the Joker in virtually the same moment, is transported to a meta-fictional world where Death tells her that Batman and the Joker's struggle has been going on since 1940. Where will the story go from there? As of July 2013, one year after the release of *The Dark Knight Rises* (Christopher Nolan), the *Batman Begins/Dark Knight* category on *FanFiction.net* is the eleventh most popular in the Movies genre – clearly, the storytelling tools of the future are in the hands of the fan fic writers. ●

## GO FURTHER

### Books

*Cyberspaces of Their Own: Female Fandom Online*,
Rhiannon Bury (Oxford: Peter Lang, 2005)

*Fan Cultures*
Matt Hills (London: Routledge, 2002)

*Warrior Lovers: Erotic Fiction, Evolution and Female Sexuality*
Catherine Salmon and Donald Symons (London: Weidenfeld & Nicholson, 2001)

*Batman Unmasked: Analysing a Cultural Icon*
Will Brooker (London: Continuum, 2000)

*Gothic*
Fred Botting (London: Routledge, 1996)

*Soap Fans: Pursuing Pleasure and Making Meaning in Everyday Life*
C. Lee Harrington and Denise D. Bielby (Philadelphia: Temple University Press, 1995)

*Enterprising Women: Television Fandom and the Creation of Popular Myth*
Camille Bacon-Smith (Philadelphia: University of Pennsylvania Press, 1992)

*Textual Poachers: Television Fans and Participatory Culture*
Henry Jenkins (London: Routledge, 1992)

### Essays/Extracts/Articles

'Dark knight, white knight, and the king of anarchy' by Stephanie Carmichael
In Kevin K. J. Durand and Mary K. Leigh (eds). *Riddle Me This, Batman! Essays on the Universe of the Dark Knight* (London: Eurospan Limited, 2011), pp. 54–69.

'"And doesn't all the world love a clown?": finding the Joker and the representation of his evil' by Michael Smith
In Kevin K. Durand and Mary K. Leigh (eds). *Riddle Me This, Batman! Essays on the Universe of the Dark Knight* (London: Eurospan Limited, 2011), pp. 187–200.

'The hero we read: *The Dark Knight*, popular allegoresis, and blockbuster ideology' by Andrea Comiskey
In Kevin K. Durand and Mary K. Leigh (eds). *Riddle Me This, Batman! Essays on the Universe of the Dark Knight* (London: Eurospan Limited, 2011), pp. 124–46.

'Introducing a little anarchy: *The Dark Knight* and power structures on the verge of nervous breakdown' by Sudipto Sanyal
In Kevin K. Durand and Mary K. Leigh (eds). *Riddle Me This, Batman! Essays on the Universe of the Dark Knight* (London: Eurospan Limited, 2011), pp. 70–80.

'Jane Austen fan fiction and the situated fan text: the example of Pamela Aidan's *Fitzwilliam Darcy, Gentleman*' by Veerle Van Steenhuyse
In *English Text Construction* (4: 2), 2011, pp. 165–85.

'*Lost in Austen*: adaptation and the feminist politics of nostalgia' by Alice Ridout
In *Adaptation* (4:1), 2011, pp. 14–27.

'Virtue in Gotham: Aristotle's *Batman*' by Mary K. Leigh
In Kevin K. Durand and Mary K. Leigh (eds). *Riddle Me This, Batman! Essays on the Universe of the Dark Knight* (London: Eurospan Limited, 2011), pp. 17–23.

Mad, Bad, And Dangerous to Know: The Nolan/Ledger Joker,
Morality and the Hetero-Fictional Fan Impulse
Leslie McMurtry

'"Wait til they get a load of me!": the Joker from modern to postmodern villainous
slaughter' by Sorcha Ní Fhlainn
In Anna Fahraeus and Dikmen Yakali Camoglu (eds). *Villains and Villainy: Embodiments
of Evil in Literature, Popular Culture, and Media* (Amsterdam: Rodopi, 2011), pp. 71–92.

'I am vengeance, I am the night, I am . . . the Doctor?'by Leslie McMurtry
In Anthony S. Burdge, Jessica Burke and Kristine Larsen (eds). *The Mythological Di-
mensions of Doctor Who* (Crawfordsville, FL: Kitsune Books, 2010), pp. 52–64.

'The Joker: a dark night for depictions of mental illness' by Mary E. Camp et al.
In *Academic Psychiatry* (34: 2), 2010, pp. 145–49.

'The Joker's comedy of existence' by Daniel Moseley
In Ben Dyer (ed.). *Supervillains and Philosophy: Sometimes Evil Is Its Own Reward*
(London: Perseus Running, 2009), pp. 127–36.

*Can't Get You Out of My Head* by J Horror Girl
At *FanFiction.net*, 27 July 2008,
Available at: http://www.FanFiction.net/s/4428854/1/Cant_Get_You_Out_Of_My_Head

'The Joker hypothesis' by BlueEyesUndertheFedora
At *FanFiction.net*, 23 July 2008,
Available at: http://www.FanFiction.net/s/4418377/1/The_bJoker_b_bHypothesis_b

'Dark Side of the Moon' by KatxValentine
At *FanFiction.net*, 21 July 2008,
Available at: http://www.FanFiction.net/s/4412287/1/Dark_Side_of_the_Moon

'An Unhealthy Obsession' by Kendra Luehr
At *FanFiction.net*, 21 July 2008,
Available at: http://www.FanFiction.net/s/4412296/1/An_Unhealthy_Obsession

'I have a name for my pain . . '. by Simon Guerrier
At *Nothing Tra La La? . . .*, 19 July 2008,
Available at: http://0tralala.blogspot.com/2008/07/i-have-name-for-my-pain.html

'The Joker's wild: can we hold the clown prince morally responsible?'
by Christopher Robichaud
In Mark D. White and Robert Arp (eds). *Batman and Philosophy: The Dark Knight of the
Soul* (Hoboken, NJ: John Wiley & Sons, 2008), pp. 70–84.

'Pirates and poachers: fan fiction and the conventions of reading and writing'
by M. Mackey and J. K. McKay
In *English In Education* (12: 2), 2008, pp. 131–47.

'Why doesn't Batman kill the Joker?' by Mark D. White
In Mark D. White and Robert Arp (eds). *Batman and Philosophy: The Dark Knight of the Soul* (Hoboken, NJ: John Wiley & Sons, 2008), pp. 5-16.

'Everyone's a superhero: a cultural theory of "Mary Sue" fan fiction as fair use'
by Anupam Chander and Madhari Sunder
In *California Law Review* (95: 2), 2007, pp. 597-626.

'Archontic literature: a definition, a history, and several theories of fan fiction'
by Abigail Derecho
In Karen Hellekson and Kristina Busse (eds). *Fan Fiction and Fan Communities in the Age of the Internet* (London: McFarland & Co., 2006), pp. 61-78.

'A brief history of media fandom' by Francesca Coppa
In Karen Hellekson and Kristina Busse (eds). *Fan Fiction and Fan Communities in the Age of the Internet* (London: McFarland & Co., 2006), pp. 41-60.

'Construction of fan fiction character through narrative' by Deborah Kaplan
In Karen Hellekson and Kristina Busse (eds). *Fan Fiction and Fan Communities in the Age of the Internet* (London: McFarland & Co., 2006), pp. 134-52.

'One true pairing: The romance of pornography and the pornography of romance'
by Catherine Driscoll
In Karen Hellekson and Kristina Busse (eds). *Fan Fiction and Fan Communities in the Age of the Internet* (London: McFarland & Co., 2006), pp. 79-96.

'Reimagining Rosie: portrayals of Tolkien's Rosie Cotton in twenty-first century fan fiction' by Amy H. Sturgis
In *Mythlore* (24: 3/4), 2006, pp. 165-87.

'Writing bodies in space: media fan fiction as theatrical performance' by Francesca Coppa
In Karen Hellekson and Kristina Busse (eds). *Fan Fiction and Fan Communities in the Age of the Internet* (London: McFarland & Co., 2006), pp. 225-44.

'Complexity of desire: Janeway/Chakotay fan fiction' by Victoria Somogyi
In *Journal of American and Comparative Studies* (24: 3/4), 2002, pp. 399-404.

'The concept of formula in the study of popular literature' by John G. Cawelti
In C. Lee Harrington and Denise D. Bielby (eds). *Popular Culture: Production and Consumption* (Malden, Mass: Blackwell Publishers, 2000).

'Trickster in American pop culture: a semio-discursive analysis of Batman and the Joker in the Hollywood Batman film' by Alan C. Harris
In *American Journal of Semiotics* (14: 1/4), 1998, pp. 57-78.

Mad, Bad, And Dangerous to Know: The Nolan/Ledger Joker,
Morality and the Hetero-Fictional Fan Impulse
Leslie McMurtry

'Batman: commodity as myth' by Bill Boichel
In Roberta E. Pearson and William Uricchio (eds), *The Many Lives of the Batman:
Critical Approaches to a Superhero and His Media* (London: BFI Publishing, 1991),
pp. 4–17.

'Batman: the ethnography' by Camille Bacon-Smith and Tyrone Yarbrough
In Roberta E. Pearson and William Uricchio (eds). *The Many Lives of the Batman:
Critical Approaches to a Superhero and His Media* (London: BFI Publishing, 1991),
pp. 90–116.

'Batman and his audience: the dialectic of culture' by Patrick Parsons
In Roberta E. Pearson and William Uricchio (eds). *The Many Lives of the Batman:
Critical Approaches to a Superhero and His Media* (London: BFI Publishing, 1991),
pp. 66–89.

'Batman: the movie, narrative – the hyperconscious' by Jim Collins
In Roberta E. Pearson and William Uricchio (eds). *The Many Lives of the Batman:
Critical Approaches to a Superhero and His Media* (London: BFI Publishing, 1991),
pp. 164–81.

**Films**

*The Dark Knight Rises*, Christopher Nolan, dir. (USA: Warner Brothers, 2012)
*The Dark Knight*, Christopher Nolan, dir. (USA: Warner Brothers, 2008)
*Kuchisake-Onna/A Slit Mouthed Woman*, Shion Sono, dir. (Japan: Tornado Film, 2007)
*Batman Begins*, Christopher Nolan, dir. (USA: Warner Brothers, 2005)
*Bunhongsin/The Red Shoes*, Yong-gyun Kim, dir. (South Korea: Sovik Venture Capital, 2005)
*Batman: The Animated Series*, Alan Burnett et al., prod. (USA: Warner Brothers Animation, 1992–95)
*Batman*, Tim Burton, dir. (USA: Warner Brothers, 1989).

# SOMETIMES IT'S ONLY MADNESS THAT MAKES US WHAT WE ARE.

**ARKHAM ASYLUM:
A SERIOUS HOUSE ON SERIOUS EARTH (1989)**

# Fan Appreciation no.4
# Dennis and Elijah Vasquez

In 2012, the traditionally San Francisco-based comic convention Wonder-Con was relocated to Anaheim. Undaunted, the convention still attracted thousands of fans from all over the United States and beyond. Many of these enthusiasts came dressed as their favourite comic book characters, including father and son Dennis and Elijah Vasquez, who attended the convention as Batman and Robin. The dynamic duo took time out of being photographed to talk about what Batman means to them.

**Liam Burke:** *What was your first experience or encounter with Batman?*
**Dennis/Batman:** The first biggest experience was probably the 1989 *Batman* film with Michael Keaton. It kind of blew me away when I was a kid. I was twelve, and it went on from there.
**Elijah/Robin:** When I played *Batman: Arkham Asylum.*

**LB:** *So the movies and the games, more than the comics?*
**D/B:** Well to start, and definitely going into comics after that.

**LB:** *Why do you think Batman compels such devotion among fans?*
**D/B:** I think he has the most interesting rogues gallery. The villains he gets pitted against are kind of a reflection of himself. It's a neat contrast every time he goes up against a different villain.

**LB:** *Is there a particular villain that jumps to mind when you think of that contrast?*
**D/B:** Probably the Joker. Ra's al Ghul is another villain that Batman could have been had he gone evil.

**LB:** *Who is your favourite Batman villain, Elijah?*
**E/R:** Bane.

**LB:** *Why Bane?*
**E/R:** He's the toughest.

**LB:** *So you are looking forward to the new Batman film then?*
**D/B:** For sure, yeah.

**LB:** *What kind of fan activities do you take part in?*
**D/B:** I collect comics. I actually turn G.I. Joe figures into Batman characters. I kept my old G.I. Joes as a kid and recreated them into the Batman characters for Elijah.

**Fan Appreciation no.4**
Dennis and Elijah Vasquez

**LB:** *What prompts you to dress up as Batman?*
**D/B:** I guess he's the most relatable character. Given a lot of circumstances it's possible that somebody could be him, but you know, that'd be a lot of circumstances.

**LB:** *There's a panel here about Becoming Batman [with E. Paul Zehr] that you might want to attend.*
**D/B:** I was reading that book actually [Becoming Batman], but there's a lot of biochemistry in it. I'll stick with the comics.

**LB:** *Apart from coming to WonderCon, do you go to other comic conventions? Are you part of any other fan groups?*
**D/B:** We did Comic-Con the year before last. We're kind of getting into it more. You know, Halloween cosplay and that kind of thing.

**LB:** *Across the decades there have been many different interpretations of Batman. Do you have a preferred version?*
**D/B:** I met Adam West when he got his star on the Walk of Fame in Palm Springs and I think that kind of solidified it. I just really love the comic nature of that show. It was not really in line with the comics, but it was great by itself. I like that one.

**LB:** *What do you consider the positives of Batman fandom?*
**D/B:** Integrity, I guess, is what I take from him. He cares for the people that are with him and he stands by what he's fighting for basically.

**LB:** *Do you think you can ever take Batman fandom too far? Are there any extremes?*
**D/B:** I think if I were to leave here and do something in costume, like if I drive home with my mask on!

# **Part 3**
# Representations
# of Fandom

# Fan Appreciation no.5
## Travis Langley

Dr. Travis Langley is a tenured professor of psychology at Henderson State University in Arkansas. His research includes studies of aggressive behaviour and mass media, particularly the psychology of media fans. Langley's recent book *Batman and Psychology: A Dark and Stormy Knight*, which combines his research expertise with his life-long interest in Batman, is garnering rave reviews and widespread interest. Langley was interviewed at the 2012 WonderCon, where he took part in the Comics Arts Conference panel, 'What's the Matter with Batman?'

**Liam Burke:** *Do you consider yourself a Batman fan?*
**Travis Langley:** Oh Yes, Batman's my hero.

**LB:** *What was your first experience or encounter with Batman?*
**TL:** I asked both of my sons that: 'What do you remember as the first Batman?' For my younger son he's very specific. It was seeing *Batman Returns* [Burton, 1992] edited for TV when the Batmobile throws off parts of itself to get through a narrow alley. That burned into his head, and so his early love of toy cars fixed on the Batmobile. My older son remembers it being *Batman: The Animated Series* [1992–95] even though he knows that's wrong. He was eight when that series came out so he would have to had known Batman already, but for him that cartoon retroactively burned itself into his memory. For me, Adam West was on TV when I was a little kid, there were also cartoons. He was always there – it's like asking me my earliest memory of the sky being blue.

**LB:** *In your research, you look at the psychology of media fans. From your studies, how has Batman affected people?*
**TL:** Heroes inspire people. Heroes give people hope. Heroes can model behaviour that other people might copy. My students and I have been doing studies and collecting data for the last few years. We are looking at personality inventories. Asking people to rate themselves and their heroes on different characteristics – such as the big five personality factors and other qualities – to see how their personalities relate to the heroes. Generally people rate Batman pretty well on many qualities. They tend to see him as being a bit on the neurotic side, but people do not tend to view him as crazy. They want to see him as being a strong person, the one who would be there to help you fight the bullies off.

**LB:** *What are the positive aspects of Batman fandom that you have encountered in your work?*

Fan Appreciation no.5
Travis Langley

**TL:** It is all a matter of which aspect you are looking at. Just in terms of reading, a fictional character can motivate you to take an interest. My younger son wanted to learn to read because he wanted to read stories. I was very motivated, specifically because of a Batman comic book that my mom had read to me, and I wanted to read it myself to have a better understanding of why Neal Adams' art made it look so much eerier than the Adam West TV show or cartoons had led me to expect. So your heroes are useful in encouraging literacy.

They also give people something to socialize about. You come to this environment [WonderCon] and you have people from all over the country and all over the world. There are plenty of experiences they don't have in common, but Batman being one of the three most famous superheroes on the planet, one of the most famous fictional characters of all, is automatically going to be a common bonding thing among the different people. We can have different views, but we have a common knowledge to discuss those views, such as the people who want to argue with me about whether he has PTSD [Posttraumatic stress disorder] or not.

**LB:** *Can this interest ever go too far?*
**TL:** It's a matter of degree. Are you so focused on this that you'll choose it over interacting with a person? If that's your choice and you're functioning in life, OK. But those that are choosing a specific interest over bonding with others, or they are so determined to be right about this detail or this story that they'll drive their friends away – there's a point where obsession is intruding. However, that could be the case with any topic in the world that someone has an interest in – somebody is a sports fanatic, somebody else is a My Little Pony fanatic, someone can be a Batman fanatic. So when you talk about the potential negative qualities, a lot of that will have to do with the negative of any obsession, any compulsive behaviour, anything that you prioritize to the point that it interferes with human functioning.

In terms of Batman himself, you could have somebody who is delusional, but somebody who is delusional about Batman would probably get delusional about something else. The first year my students were doing some research at a WonderCon, one of them met a woman who was talking about how excited she was because she was going to meet Noel Neill, who had played Lois Lane in the old *Adventures of Superman* TV show, and that she was very excited to meet Lois Lane. She explained how her parents were really Batman and Catwoman, and it was like she was getting to meet her Aunt Lois, and she was not kidding. Now if Batman weren't

there for her to think that's who had raised her, odds are this is somebody who would have been psychotic for something else.

**LB:** *Do you subscribe to the idea that the desire to become Batman fuels cosplay?*

**TL:** For some individuals, yes. For some of them they are giving a part of themselves for this other thing. Like you see somebody who where every single thing on their Facebook page is about the thing they are interested in, and there's nothing about them in there. Or every single Tweet is about their love of *Battlestar Galactica* [2004–09] and there's not one word about themselves. That love is getting in the way of us knowing anything else about them, getting in the way of getting to know them as people. Some of them don't want you to, some of them are so scared of you getting to know them as people they are afraid of being rejected for that, but if they talk about this other thing it's insulating. If you are not interested in *Battlestar Galactica*, they don't have to take that personally in the same way that you're not interested in their relationships. So they can feel freer. Although some will take it plenty personally if you rip into their *Battlestar Galactic* too; likewise Batman, or any such thing.

You see many people dressing up as Batman. They are not all out there thinking they are Batman. Some of them aren't fans. Some of them are dressing in that because it looks like the fun thing to be. I saw somebody talking about cosplaying as *Sucker Punch* [Snyder, 2011], a movie she didn't like, but she really loved the look of a particular character. Cosplay has many different functions, in an environment like this: it makes you part of the show, it makes you part of the fun, for some it lets them feel like celebrities – all these people taking pictures of them. For some, their normally shy self gets to come out in that circumstance where it wouldn't otherwise. For some people it lets them feel good in one place, where they can't elsewhere in their life. They get to set that crappy other stuff from their life aside, which they might have a little trouble doing if they were here as themselves.

Chapter
8

# Inspired, Obsessive and Nostalgic: The Facets of Fandom in 'Beware the Gray Ghost'

Joseph Darowski

→ 'Aficionado','enthusiast','fanatic','fanboy' and 'fangirl': there are many ways to describe an individual who becomes invested in a form of entertainment. That investment could be emotional, financial or creative, but individuals who develop an intense interaction of some form with popular culture are the lifeblood of the entertainment industry. While casual fans broaden the appeal of a popular culture product, those dedicated consumers who never miss an episode, buy every issue or purchase every album provide the consistent enthusiasm that is necessary for the long-term success of a television show, comic book or musical artist.

Popular entertainment is dependent on dedicated consumers. The higher the investment an individual has in the product, the more loyal they will be; such loyalty is essential to an entertainment company's bottom line. As Randy Duncan and Matthew J. Smith explain in their book, *The Power of Comics*, comic book fans 'make considerable investment in terms of their finances, time, and emotional involvement because of their love for the medium, its characters, and their creators. So much so, in fact, that to people outside of fandom, their behaviour may seem strange'. Comic book fans are not the only ones who are considered 'strange' to outsiders. For example, those who don't share the same interests have criticized dedicated followers of sports teams, fashion labels and specific works such as *Twilight*.

While it may be easy to generate a mental picture of a 'Lakers fan', a Trekkie or a comic book geek, loyal fans come in many varieties. Negative stereotypes abound of comic book fans who obsess about continuity, lack social skills and are perhaps too lax with their personal hygiene. The popular *The Simpsons* character Comic Book Guy embodies these stereotypes. However, no single caricature can embody all of fandom. 'Beware the Gray Ghost', a classic episode of *Batman: The Animated Series* (1992–95) explores several facets of fandom, simultaneously condemning some aspects while praising others. This complex interaction with fandom reflects many of the actual attitudes that exist between comic book creators and fans.

'Beware the Gray Ghost' is the seventeenth episode of *Batman: The Animated Series*. It was directed by Boyd Kirkland, who was responsible for many fan favourite episodes, including 'It's Never Too Late' and 'Harley and Ivy', as well as the spin-off feature *Batman & Mr Freeze: Sub Zero* (1998). The story was written by Dennis O'Flaherty and Tom Ruegger, with Garin Wolf collaborating with Ruegger on the teleplay. The episode introduces a new character, the Gray Ghost, to Batman's mythology. However, this is not one of Batman's fellow costumed adventurers or a member of his rogue's gallery. In the narrative universe of *Batman: The Animated Series* the Gray Ghost is a fictional character whose adventures Bruce Wayne enjoyed as a child, with the character's popularity spawning a television series, action figures, posters and toys.

The episode opens with flashbacks of a young Bruce Wayne watching the black-and-white *The Gray Ghost* television show, cross-cut with the present day, where crimes are committed that mirror the actions of the show. A ransom note is left in both the show and Gotham City signed 'The Mad Bomber'. An adult Bruce Wayne quickly makes the connection between the current bombing spree he is trying to solve and the television show he watched as a child, before the action shifts to Simon Trent, the aging actor who played the Gray Ghost. Trent is broke, unemployed and bitter that he has been typecast as the hero he played in his youth. In order to pay his rent, Trent goes to a nostalgia store, Yestertoys, to sell the Gray Ghost paraphernalia he retained, including his original costume. Later, the Gray Ghost costume and other memorabilia have been returned

Inspired, Obsessive and Nostalgic:
**The Facets of Fandom in 'Beware the Gray Ghost'**
Joseph Darowski

to Trent's apartment, with a note asking Trent for a meeting, at which Batman asks for Trent's help.

At first Trent refuses, but upon recognizing a buzzing sound from his time on the Gray Ghost show just before an explosion rips through a nearby building, he agrees to help Batman. The actor provides Batman with film reels of the old *Gray Ghost* shows, which were previously believed to have been lost in a studio fire. The collection includes 'The Mad Bomber' episode, which provides Batman with the villain's *modus operandi*: explosives strapped to remote control toys. While protecting the Gotham Library from the Mad Bomber, Batman is trapped by the explosive-carrying toys when Simon Trent, now wearing his Gray Ghost costume, lowers a rope. Batman and his childhood icon, the Gray Ghost, team up to solve the case. This dynamic duo quickly realizes the Mad Bomber must be the owner of Yestertoys, and defeat the copycat criminal. The episode's coda reveals the Gray Ghost has enjoyed a resurgence in popularity: a new video collection of the old show is released using Trent's copies, and Trent himself enjoys financial security and new-found respect.

This episode highlights three different facets of fandom that are worth exploring: the inspired fan, the obsessive fan and the nostalgic fan. There certainly are other areas of fandom that could be explored, and that are worthy of analysis, but these areas align nicely with this classic episode of *Batman: The Animated Series*.

### Inspired

There are two layers of inspiration that can be found in this episode. First, within the narrative, Bruce Wayne is at least partly inspired to become Batman due to his enjoyment of Gray Ghost stories. Second, there is a meta-narrative around the real world inspiration for Batman.

Immediately following the opening credits for *Batman: The Animated Series* this episode switches to the opening credits for the fictional series, *The Gray Ghost*. A young Bruce Wayne is enamoured with the show, even wearing a homemade version of the Gray Ghost's costume. The inspiration is made even more explicit when Batman's actions, such as leaping off the roof, are cross cut with footage of the Gray Ghost performing the exact same manoeuvre in the old television show.

Batman makes it clear to Simon Trent that his old role helped to inspire him to become the hero of Gotham City. When Simon Trent is brought to the Batcave, Trent remarks that it is almost an exact replica of the Gray Ghost's lair. Batman then shows Trent a display of Gray Ghost toys in the Batcave, and explains, 'As a kid, I used to watch you with my father. The Gray Ghost was my hero'. To which Trent replies, 'So it wasn't all for nothing'. This, in all likelihood, is one of the great hopes for creators of superhero tales – that their stories can serve as inspiration for someone, somewhere to become better. It has been argued that superhero stories help to define morality for young children who encounter them. There are clear lines of right and wrong, and children are meant to root

for and identify with the hero. Bruce Wayne was explicitly inspired by the Gray Ghost stories to become a particular kind of hero: the costumed adventurer.

There is also a real world aspect in this episode's nod to the inspiration for Batman. It is no secret that the creators of Batman, Bob Kane and Bill Finger, were inspired by other elements of popular culture around them. While popular culture historians have identified a myriad of potential inspirations, the most obvious is the pulp magazine and radio drama character The Shadow. This episode acknowledges that debt: the Gray Ghost's outfit is reminiscent of The Shadow's pseudo-costume, with a fedora and cape. Additionally, in the introduction to The Shadow radio drama a voice would ask, 'Who knows what evil lurks in the hearts of men? The Shadow knows!' Similarly, in the opening credits for the *Gray Ghost* television series, a narrator asks, 'Those with evil hearts beware, for out of the darkness comes the Gray Ghost!' The episode even contains a poster for the Gray Ghost that *Batman: The Animated Series* producer Bruce Timm identified as 'a direct swipe from a George Rozen *Shadow* cover'. While most young viewers of the show were unlikely to catch this nod to the real world inspiration for Batman, fans of Batman and his history would recognize this homage. In a further metatextual reference, the design of the Mad Bomber was based on producer Bruce Timm, who also provides the character's voice.

### Obsessive

Interestingly, the fans who were most likely to recognize the implied references to The Shadow are the same type of fans who are criticized in 'Beware the Gray Ghost'. The villain of the piece is an obsessed fan, just the sort who would know all the ins and outs of Batman's real world creation. The Mad Bomber not only runs the store called Yestertoys, but he is completely obsessed with toys to the point that he cannot function in society. When Batman tells him it is time to put away his toys, referring to the bomb-laden remote control cars he has been using to commit crimes, he replies:

I'm afraid I can't. You see, I need the money to buy more toys. I love toys. They can play songs, they can dance, they can even eat money. Oh boy, can they eat money. All my money. And then, I remembered an episode of the Gray Ghost, and I knew what else a toy can do. It can carry a bomb. It can hold a city for ransom. Oh the power of the toy. It can earn millions. Millions for a little old toy collector. Me!

When a bomb goes off and destroys Yestertoys, nearly killing the Mad Bomber, Batman and Simon Trent, the Mad Bomber does not express any concern for the people around him. Instead, he weeps, 'NO! My toys, my toys, my beautiful toys!'

The Mad Bomber also represents another aspect of fandom that is sometimes looked down upon: the investor or speculator. While the Mad Bomber is obsessed with toys, he is also obsessed with using the toys to make him money. There is a subset of

### Inspired, Obsessive and Nostalgic:
### The Facets of Fandom in 'Beware the Gray Ghost'
Joseph Darowski

many fandoms that is invested in the acquisition of products and memorabilia for potential financial gain rather than emotional investment in the properties.

Clearly, the Mad Bomber's priorities in life had been skewed heavily by his obsession with toys. Any fandom that goes too far – be it for sports, comic books or, in this case, toys – can adversely affect an individual's social skills, perspective on life or even their perceptions of right and wrong.

In an interview with Uricchio and Pearson Batman writer and editor Denny O'Neil describes the trepidation he felt when meeting fans following the comic book death of the second Robin, Jason Todd:

There was a nasty backlash and I came to be very grateful that people could not associate my face with the guy who killed Robin. I also forgot that there are John Hinkleys out there. A lot of us [comic creators] have gotten death threats [...] Every once in awhile, I run into guys at signings that I think might be a potential danger [...] They often ask about violence. 'Why doesn't Batman kill him? I just want him to kill him'. I say 'Come on, it's just a story'. And they just keep on saying, 'I would kill all the criminals if I were Batman'. Keep an eye on that guy!

Death threats, like the ones Denny O'Neil describes, are an extreme fan activity, but it demonstrates the, for lack of a better term, 'creepiness' that can be an unfortunate by-product of obsessive fandom. Josh Flanagan, a comic book commentator on iFanboy. com, felt the need to provide the following counsel to the many comic book fans who frequent his site:

'Don't be creepy'. I want to extend that to all fans today. If you're the guy at the DC panel with the really old comic book T-shirt and you're getting angry about their Green Arrow answer, you're probably the creepy guy. If you're hanging out on message boards under an anonymous name, just waiting to prove to people that they don't know how right you are about some arcane thing, you're probably the creepy guy. If you're on Twitter, and all of your interaction is with comics and pop culture celebrities and you don't know any of them... little creepy. Of course, this isn't most fans. But then most fans, myself included, do it a little bit. That's OK. It's when you go overboard. These are the kinds of things that happen when you make your hobby, in this case comics, your entire world. Comics are great. They are the most under appreciated art form and storytelling device in popular culture, and the community is made up of some of the smartest, funniest, more talented professionals and fans out there. But comics should not be the only thing you've got going on.

The advice offered by Flanagan and one of the messages of 'Beware the Gray Ghost' is that fandom is fine, but obsession is not. Fandom helped inspire Bruce Wayne to be-

come Batman, but obsession turned a store owner into a supervillain.

## Nostalgia

Just as there are dual layers in how 'Beware the Gray Ghost' addressed inspirational aspects of fandom, the episode includes multiple interpretations of nostalgic fandom. The finale of the episode reveals that a nostalgia-driven resurgence in popularity for the Gray Ghost has taken place. As a news reporter explains, 'Gothamites have turned out in record numbers to celebrate the video release of the long lost *Gray Ghost* television series. And on hand for the festivities is the toast of the town, the Gray Ghost himself, Simon Trent'.

The line of people waiting for Trent's autograph includes parents and children. Undoubtedly, with the television series considered lost, most of these children would never have seen an episode. Parents who were familiar with the show are introducing their children to it and to the actor who played the lead character. This nostalgia cycle is present in the real world as well. Parents will often introduce children to the entertainment they enjoyed in their youth, whether it be Disney princesses, the Teenage Mutant Ninja Turtles, superheroes or sports teams. This desire to have their children enjoy the same entertainment they did is, at least partially, fuelled by nostalgia for their own youth.

An added layer of nostalgia in this episode comes from the voice casting of Adam West as Simon Trent/the Gray Ghost. Adam West portrayed Bruce Wayne/Batman in the popular 1960s' live action *Batman* television series. His voice and line delivery were distinctive enough that any fan of that series is likely to recognize him in the role of the Gray Ghost. Series' producer Bruce Timm revealed in an interview in *Comics Above Ground* that his 'first hardcore exposure to superheroes as a genre was the Adam West show'. For Timm, there may have been some personal nostalgia in having the first actor he remembers playing Batman voice a character in the series that he was producing. Such references may not necessarily be noticed by casual viewers, but are enjoyed by hardcore fans of Batman.

## The many facets of fandom

The relationship between producers, distributors and consumers has always been complex and multi-layered. The creators of popular culture rely on fans for the business to function, but at the same time there is a tension between fans and creators. 'Beware the Gray Ghost' navigates several facets of dedicated fandom and demonstrates a nuanced understanding of the relationship between a popular product and the consumers who enjoy it. Fandom is not simply a uni-dimensional experience. Within a single individual there can be many different reactions to a product, but within a large fan community there is certain to be even greater variation. Inspiration, obsession and nostalgia are but three of the aspects of fandom. ●

**Inspired, Obsessive and Nostalgic:**
**The Facets of Fandom in 'Beware the Gray Ghost'**
Joseph Darowski

~~~~~~~~~~~~~~~~

GO FURTHER

Books

The Power of Comics: History, Form, and Culture
Randy Duncan and Matthew J. Smith (New York: Continuum. 2009)

Comics Above Ground: How Sequential Art Affects Mainstream Media
Darwin Talon (Raleigh, NC: TwoMorrows Publishing. 2004)

Modern Masters: Bruce Timm
Eric Nolen-Weathington (ed.) (Raleigh, NC: TwoMorrows Publishing. 2004)

Batman Animated
Paul Dini and Chip Kidd (New York: It Book., 1998)

Websites

'Comic Book Resources', comicbookresources.com
'iFanboy', ifanboy.com

CRIMINALS,
BY NATURE,
ARE A COWARDLY
AND SUPERSTITIOUS LOT.
TO INSTILL FEAR INTO
THEIR HEARTS,
I BECAME A BAT.
A MONSTER
IN THE NIGHT.
AND IN DOING SO,
HAVE I BECOME
THE VERY THING THAT
ALL MONSTERS BECOME -
ALONE?

BATMAN
HUSH (2002-2003)

Chapter
9

Villainous Adoration: The Role of Foe as Fan in Batman Narratives

Tony W. Garland

→ If you asked Bruce Wayne why he chose a bat, assuming he was happy with you knowing his secret, he would probably tell you an origin story that has appeared in many comics and graphic novels. He sits alone in the dark of Wayne Manor. 'Criminals are a superstitious cowardly lot,' he thinks, 'so my disguise must be able to strike terror into their hearts'. And then a bat flies through the window (or, if Frank Miller is telling the story, after being shot, stabbed and crashing a police car Wayne asks a bust of his dead father, 'What do I use...to make them afraid' and 'crashing through the window' appears a giant bat) and Wayne says, 'I must be a creature of the night, black, terrible...a...a...a bat!'

The dark, imposing and disorientating arrival of Batman swooping down on you as you try to break into a jewellery store is pretty terrifying. Add Batman's martial arts training, deductive skills and endless array of equipment shadowed by the ominous Bat-Signal lighting up the dark and dreary Gotham skyline, suddenly you no longer have to see Batman to be scared of him, and any self-respecting petty criminal is going to look for a new line of work or move to a different city.

Having scared off the cowardly and superstitious criminals, those who remain are attracted to Batman as a distinctive idea (and probably a little afraid as well). If you asked Bane why he came to Gotham, the Riddler why he leaves clues or the Joker why he does anything, they would probably cite Batman. For these villains, and many more disturbed criminals who inhabit Gotham City, Wayne's decision to become Batman creates a fearsome yet attractive image that evokes an emotional reaction and garners an obsessive dedication. The unhinged hordes of the Gotham underworld become Batman fans.

The academic definition of a fan is as unstable as a recently escaped inmate of Arkham Asylum, and frequently viewed with as much disapproval. Batman villains, who seem to be defined by mental instability, could have fixated on anything, but the dark, brooding and obsessive Batman is almost irresistible. Academics like Janet Staiger and Henry Jenkins discuss the morality of fandom, but unsurprisingly they are not immediately engaged with death traps, poison gas or larceny. Staiger describes how the status of fans has moved from 'pathological spectators' to active and yet ambiguous roles that 'cannot be easily bifurcated into good and bad'. The subject of fandom does not limit fan activities. For instance, Batman can encompass everything from wearing a branded T-shirt to the time-consuming recreation of a working Batmobile. Whether fictional or real, fan activities attract a broad spectrum of responses from celebration to ridicule, depending on who is observing.

Jenkins' appropriation of Michel de Certeau's concept of textual poaching suggests that the fan 'is drawn not into the preconstituted world of the fiction but rather into a world she has created'. Jenkins later observes in *Convergence Culture* that the fan becomes the creative force whose 'pre-established values' negotiate with the inspiring object of their fan adoration – whether it is a TV programme, comic book or actual person – to create a 'personal mythology' and produce their distinctive fan activities, such as fanfiction, cosplaying or, in this case, bizarre criminal activities.

A convergence between the everyday actions of the fan and the object of their adoration is, according to Jenkins in *Fans, Bloggers and Gamers*, 'central to how culture operates'. To negotiate the world of insane criminals, Batman needs his superhero persona or he loses the advantage of being distinguished above the everyday policeman. In response to Batman, some characters are inspired to become Robin, Batgirl, Batwoman, Huntress or part of the Batman Inc. franchise. Other characters, possibly influenced by

Villainous Adoration: The Role of Foe as Fan in Batman Narratives
Tony W. Garland

the antagonistic attitude of extreme fans, become Batman villains, and their fan actions incorporate criminal activities because of their 'pre-established values' and mental instability. John Fiske suggests fandom 'typically lacks [...] deference' and creates a 'sense of possession, the idea that stars are constructed by their fans and owe their stardom entirely to them'. The fan dynamic between Batman and the insane villains of Gotham is paradoxically interdependent. Batman's existence as a character depends on the antagonistic relationship with his fanatic villains, who wish to kill him yet owe their actions to him.

The second instalment of Christopher Nolan's Batman trilogy, *The Dark Knight* (2008) raises this issue of escalation and perpetuation by addressing how the presence of Batman would affect a world devoid of costumed heroes. In the interrogation room scene, the Joker tells Batman that he has 'changed things forever'. The Joker is clearly a fan of Batman, asking Batman, 'What would I do without you?' and telling him, 'you complete me'. The Joker makes clear his intention to teach Batman about himself while illustrating his dependence on Batman. Other fan reactions are presented at the beginning of the film. An unstable mob thug views Batman as a challenge, rejecting profit and safety in favour of a desire for violence and aggression, and the Scarecrow is presented as seeking attention and validation from the appearance of the Batman, quickly recognizing an imposter and rejoicing when the authentic Batman arrives. A system of negotiation and convergence occurs between the pre-existing lives of Batman villains and their inspiration that motivates them into participating in the creation of culture; they commit crazy crimes because of Batman. The discussion of Bane, the Riddler and the Joker will illustrate differing fan dynamics in Batman comics and graphic novels, and present the dynamic as a reason for the continued popularity of Batman and his villains.

The Bane of Batman's life
In 1984, the villain Wrath was introduced in the first issue of *Batman Special* as an anti-Batman. Rather than having philanthropist parents killed by a criminal, Wrath's criminal parents are killed by a policeman, prompting him to become a professional assassin and wage a war on law enforcement. Bane is a similar anti-Batman, created in the early 1990s as a central villain for the year-long story *Knightfall*, which involves Bane literally and metaphorically breaking the Batman. The difference between Wrath and Bane is Batman's role in Bane's negotiation between his everyday reality, and his aspiration to conquer and master himself and others. Bane recognizes the dominance of Batman, uses him as a reason to escape from prison, and poaches a purpose from Batman; except it is a purpose focused on superiority rather than justice.

As an unborn child, Bane is sentenced to life imprisonment for his father's attempted coup of the Caribbean republic of Santa Prisca. At the age of six, Bane's mother dies and he is released into the general population. An accidental fall provides Bane with a vision of his future self who tells him he will become '[a] physical and mental paragon.

The living embodiment of human superiority', and that '[t]he world is yours and will be yours one day', except '[t]he fear that lies at the heart. Only this can keep you from what is yours'. In his vision, Bane experiences fear as a bat. At this point, Bane, who does not even have a name, has established the values that will dictate his personal response to the Batman. The cold-blooded murder of a bully by the 6-year-old Bane provides him with a name and a ten year stint in solitary confinement where he achieves mental and physical mastery.

On his release from solitary, Bane 'had become a legend' and a master of his world. Having been told about Batman and Gotham City, 'the greatest city on the planet' where '[a]nything a guy could want is for sale', Bane establishes Batman as an opponent as well as a role model for success. Bane vows, 'I will meet this Batman some day. I will destroy him'. The very mention of Batman causes a change in Bane: 'It enflamed his imagination. It fueled [sic] his dreams. The creature became his obsession and his purpose'. All that remains to complete the conflict is a highly addictive 'super steroid' called venom injected directly into Bane's brain to provide him with the enhanced strength and intelligence to manipulate Batman into physical and mental vulnerability, learn his secret identity and break him.

The third Christopher Nolan film, *The Dark Knight Rises* (2012), effectively exploits elements of Bane's origin story to benefit the film's narrative twists. The fan dynamic between Bane and Batman is not as developed as it was in the comics, but Bane's actions are motivated by Batman's presence and he does provide Batman with a physical and mental challenge. Bane's defeat of Batman and conquest of Gotham in *The Dark Knight Rises* and the *Knightfall* comics breaks the fan dynamic. In the comics, when Bane is beaten by a replacement Batman and forced off the drugs, he fights alongside Batman and claims to be innocent due to his unfortunate origin and venom addiction. Bane's defeat and rehabilitation ends the fan relationship, and when he appears in subsequent comics, the absence of a strong fan relationship means he is more often a henchman than a supervillain.

Riddle me this...
The Riddler originated in the golden age of Batman comics and was quickly established as a criminal with a distinctive *modus operandi*, often presented as a psychological compulsion. After only three previous appearances, Batman concludes: 'The Riddler has a strange conditioned reflex! He can never make an important move in his life without leaving a riddle to explain it!' Bane claims to be innocent because the venom drug made him apparently unaware of his obsessive fan activities. The Riddler is aware of this compulsion to compete with Batman making the compulsion a derivative of his fan adoration.

The first appearance of the Riddler in 1948 provides an origin story that introduces Edward Nigma as 'a puzzle expert' who compulsively cheated as a child. A desire to

Villainous Adoration: The Role of Foe as Fan in Batman Narratives
Tony W. Garland

cheat and outwit others is established as more important than solving puzzles, and exists before the appearance of Batman. Nigma becomes a successful sideshow conman, but 'the small pickings of a carnival attraction do not satisfy the crooked puzzle master!' Consequently, while standing in a luxurious apartment, Nigma decides to become a criminal. He states, 'I'll make each crime a duel of wits between myself and the law – and fix the puzzles so I'll always win!' and then decides 'The Riddler! That's what I'll call myself for that's what I'll be to the Batman'. Nigma's personal desire to cheat and the exaggerated theatrical recognition of being a Batman villain converge to create the Riddler, who is defined in relation to Batman. Without the green suit and clues, the Riddler would be a very successful conman. However, he wants people to know he has cheated them and he wants to cheat a worthy opponent. The pre-existing values of the Riddler are formed into a psychological compulsion in relation to Batman.

After Batman has defeated the villain Hush at the end of a twelve-issue story, the Riddler reveals himself to be the secret mastermind behind the manipulation of villains from Killer Croc to Poison Ivy, and heroes from Superman to Catwoman. Resentful because he 'used to be a somebody in this town', the Riddler freely discloses his role in the conspiracy and that he has solved the riddle of Batman's identity because he is attempting to 'show them all'. Unfortunately for the Riddler, he is aspiring beyond his own limits; cheating psychopathic villains like the Joker and Hush is dangerous, and solving riddles is not the same as cheating. Batman illustrates the Riddler's impotence in relation to Batman's secret identity by telling him 'a riddle that everyone knows the answer to is...worthless'.

The Riddler's recognition of his own inferiority in relation to Batman and other villains motivates him into criminal activities within narrow limits. After a year in a coma, the Riddler, who 'barely remembered his own name, let alone the small fact that I'm Batman', became a legitimate detective. During his time as a detective (2006 to 2011), the Riddler's dynamic with the Batman continued, and the two competed to solve cases. In his first legitimate job, 'the glory hungry Riddler' willingly accepts the confession of a 'patsy'. Leaving the Riddler to accept media attention and a pay cheque, Batman secretly leads the murderer to Commissioner Gordon, who makes the arrest and undermines the Riddler. The Riddler later realizes, 'It was him [Batman] all along'. Batman's secret role in the apprehension of the murderer demonstrates the continuing competitive dynamic based on the Riddler's desire to cheat Batman – in this instance, by beating Batman at his own game.

Despite being an unbalanced, attention-seeking criminal who ends up in Arkham Asylum, the Riddler is more ordinary than other Batman villains and, as Poison Ivy tells him when he asks for protection from Hush, he isn't the same calibre as Two-Face and the Joker. Against the exaggerated threat of other villains (while the Riddler robs a bank in one comic, Scarecrow scares four men to death and Poison Ivy threatens to release a fatal airborne fungal toxin), the Riddler is a nuisance to Batman, but provides a recip-

rocating relationship. The Riddler's challenge is cerebral rather than physical like Bane. While Superman first appeared in *Action Comics*, Batman first appeared in *Detective Comics*, and is often referred to as 'the world's greatest detective'. Detection in the context of Gotham is not necessarily about figuring out who committed a crime. A jewel-encrusted cat has been stolen, a murderer has left a huge grin on his victim, or twins are being ransomed for two million dollars. There is a long list of usual suspects with unusual compulsions. The Riddler's compulsion to leave clues flatters and challenges Batman while participating in his identity as detective.

The Riddler may not be the most sensational criminal, but he has survived over six decades of Batman stories and appeared in comics, novels, cartoons, TV shows, computer games and films. The Riddler's continued success as a villain is ensured by his involvement in a fan dynamic with Batman.

Batman's biggest fan

The Joker is Batman's greatest enemy and arguably Batman's biggest fan. Many of the characters who aid Batman's quest against crime actively discourage him from crimefighting. Alfred Pennyworth, the ever-faithful Wayne family butler, is constantly reminding Bruce Wayne to sleep, eat and generally stop being Batman. The Joker, on the other hand, cannot exist without Batman, and in several stories actively provokes Batman into action or stops being the Joker because he thinks Batman is dead. There is, of course, an obviously contradictive self-destructive motive in the Joker's desire to kill Batman, but he is insane after all.

As a character, the Joker appeared in the first issue of *Batman*. However, his appearances became less regular in the late 1950s and 1960s, when he was reduced to a simple prankster. He was reinvented in 1973 after the successful Batman TV show. On his return, the Joker had a symbiotic relationship with Batman. When threatening a crooked official who wants to uncover Batman's secret, the Joker describes Batman as 'my perfect opponent' and says, 'The Joker must have the Batman! Nay, The Joker deserves the Batman...And for anyone else to destroy the Batman would be unworthy of me!' In *The Dark Knight Returns*, Frank Miller's 1986 graphic novel set after Batman retires, Batman's reappearance puts a smile back on the Joker's face and causes him to return to mass homicide. The Joker's admiration of Batman is balanced against his desire to destroy Batman.

A story called 'Going Sane' provides a more detailed exploration of the Joker's dependence on Batman. Having seen Batman die, the Joker completely forgets about his life as the Joker, becomes Joseph Kerr and finds love. The Joker observes, 'If there's no Batman to drive crazy, then what's the point of being crazy?' However, Joseph cannot escape terrifying dreams of being chased by a bat and 'clown-face', who Joseph describes as 'the real monster'. The eventual re-emergence of the Joker is a combination of being unable to resist 'clown-face', who feels like 'someone inside of me with

Villainous Adoration: The Role of Foe as Fan in Batman Narratives
Tony W. Garland

a knife trying to hack his way out', and the reappearance of the Batman (we knew he wasn't really dead). Batman is central to the existence of the Joker, but Jenkins' idea of 'pre-existing [psychotic] values' converge with fandom for Batman to create the Joker's 'personal mythology'.

In comic book terms, a character's 'personal mythology', or what Jenkins considers the 'resources through which we make sense of our everyday lives', is an origin story and the Joker's is a little confused, as evident by the villain's contradictory monologues in *The Dark Knight*. In Alan Moore's seminal graphic novel, *The Killing Joke*, the Joker was a failed comedian who turns to crime, suffers personal tragedy (his pregnant wife is killed) and a horrible accident (his plunge into a chemical plant's toxic waste). Paul Dini's 'Case Study', a potentially apocryphal backstory by Harley Quinn, envisions the Joker as a vicious criminal whose horrible accident causes him to approach crime like Batman approaches crime-fighting. 'Just as Batman adopted a fearsome image to wage war on crime,' Harley states, 'The Joker would hide behind a mask of madness to carry out a very calculated campaign of revenge'. The Joker is inspired to action by Batman and participates in the theatrical crime instigated by Batman's arrival, while subverting the possibility of Batman achieving justice through senseless crime that will only end if Batman stops.

The Riddler allows the Batman to flex his detective muscles, but he is also focused, like Bane, on defeating Batman. The Joker's symbiotic relationship with Batman, no doubt affected by insanity, casts him as antagonist, teacher, sage and accomplice. In a prologue to Grant Morrison's *Batman R.I.P.*, the Joker provides Batman with clues to the conspiracy against him by dealing him a dead man's hand and telling him, 'Some very, very bad people have decided to hurt you. Hurt you so bad you'll never recover'. Beyond several symbolic interpretations of the cards and their colours, the villain conspiring against Batman is named Hurt. The Joker is involved in Hurt's plan to destroy Batman, except the Joker's objective, as it has been in previous stories, is to change Batman's perceptions.

Batman may frequently wrestle with how many lives might have been saved by the Joker's death, but generally he does not attempt to actively teach or rehabilitate the Joker. In Alan Moore's *The Killing Joke*, Batman reasons with the Joker and invites him to accept help so 'We don't have to kill each other'. However, the Joker does not seek Batman's permission to provoke a reaction from him, and is instead driven by a desire to rewrite Batman's character in the manner of an emotionally committed fan who be-lieves in the superiority of his understanding. In the 2001 crossover *Last Laugh*, the Jok-er enacts an anarchic crime spree, infecting supervillains with Joker venom, causing chaos across the DC universe, which he says, 'has always been about Batman'. The Joker planned to have 'Batman kill me...suicide by super hero' to undermine Batman's belief in justice. The climactic confrontation between Batman and the Joker in *Batman R.I.P.* depicts a similar situation when the Joker tells Batman: 'the real joke is your stubborn,

bone deep conviction that somehow, somewhere, all of this makes sense!'

Against the certainty of Batman, the depiction and reception of the Joker is morally ambiguous. He is a homicidal maniac with no compulsion about taking human life, and a desire to inflict senseless pain and suffering, yet he is as entertaining as Batman is admirable. He is a force of constant chaos, whose existence is dependent on Batman as a force of constant control. More than just the antithesis of Batman, the Joker has endured because of his fan dynamic with Batman.

Batman villains and us

Not all villains are created equal. Some are more powerful than others, some are more intelligent, some are crazier and some just want to rob, steal and murder without forming a relationship with Batman. In fact, quite a few villains just want to kill him; they don't want to compete with him or defeat him or teach him. However, the villains who combine adoration and hatred of Batman have an enduring quality that often makes for better stories. When Bane escaped from prison and went in search of his father, he changed the fan dynamic and has had limited success as a Batman villain. A resonance is created between Batman, the villains who are motivated to crime by his presence, and the insanity of Gotham City. It is a resonance that begins within the limits of the narrative and extends into the real lives of Batman fans.

In the *Detective Comics* story 'Batman: Imposters', a former victim of the Joker creates a psychologically addictive recreational drug from Joker venom, which gives rise to 'mad mobs' of Joker imposters. Combining drugs, revenge and Joker venom is a recipe for disaster, and a force of Batman imposters rise to oppose the Joker imposters. That Gotham citizens can be inspired to extreme action by justice or chaos suggests a susceptibility to insane escalation, but this dimension of fandom does not end there. A cooperative online video game inspired by the story was released in 2012, which allows a community of Batman fans to adopt the role of insane, murdering Batmen and Jokerz. The game, *Gotham City Imposters*, validates a violent engagement with fandom by allowing players to become Batman and Joker fans fighting against one another, and consequently creates an uncomfortable proximity between stories about the violent creation of Batman villains and the reaction of fans.

In the insane world of Batman's Gotham City being a fan takes on potentially sinister connotations, producing stories and situations far removed from the average Batman fan even in the wake the Aurora tragedy. We might not have costumed villains and vigilantes who inspire fear and motivate ordinary people into acts of extraordinary devotion, but we definitely feel the impact of those stories. The unsettling tales of Batman and his villains contribute to our 'personal mythology', and as fans of the Batman stories – whether comics, films, cartoons or computer games – we are often inspired through the enduring interest created by our own fan relationships. ●

Villainous Adoration: The Role of Foe as Fan in Batman Narratives
Tony W. Garland

~~~~~~~~~~

**GO FURTHER**

**Books**

*Batman - Batman Versus Bane*
Chuck Dixon (London: Titan, 2012)

*Batman – Imposters*
David Hine (London: Titan, 2011)

*Batman R.I.P.*
Grant Morrison and Tony Daniel (London: Titan, 2010)

*Batman: Hush*
Jeph Loeb (New York: DC Comics' 2009)

*Batman: Going Sane*
J.M. DeMatteis (London: Titan, 2008)

*The Joker: The Greatest Stories Ever Told*
Bill Finger et al. (New York: DC Comics' 2008)

*Convergence Culture: Where Old and New Media Collide*
Henry Jenkins (London: New York University Press, 2006)

*Fans, Bloggers and Gamers, Exploring Participatory Culture*
Henry Jenkins (New York: New York University Press, 2006)

*Perverse Spectators: The Practices of Film Reception*
Janet Staiger (New York: New York University Press, 2000)

*Batman: featuring Two-face and The Riddler*
Mark Hamill et al. (London: Titan, 1995)

*Textual Poachers: Television Fans and Participatory Culture*
Henry Jenkins (New York: Routledge, 1992)

*Batman: Year One*
Frank Miller (London: Titan, 1988)

*The Killing Joke*
Alan Moore (London: Titan, 1988)

*The Dark Knight Returns*
Frank Miller (New York: DC Comics, 1986)

*Batman Special*
Mike W. Barr (New York: DC Comics, 1984)

**Extracts/Essays/Articles**

'The cultural economy of fandom' by John Fiske In Lisa A. Lewis (ed).
*The Adoring Audience: Fan Culture and Popular Media* (London: Routledge, 1992),
pp. 30–49.

**Films**

*The Dark Knight Rises*, Christopher Nolan, dir. (USA: Warner Bros., 2012)
*The Dark Knight*, Christopher Nolan, dir. (USA: Warner Bros., 2008)

# Fan Appreciation no.6
## Seamus Keane

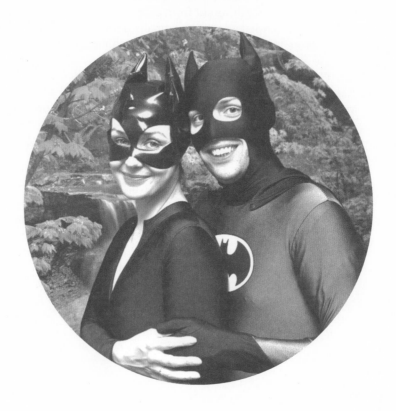

Seamus Keane is an artist and life-long Batman fan based in Galway, Ireland. Seamus has managed to balance his two interests by teaching art and working in the local comic store, *Sub City*. He describes his art style as stemming from his love of comics and sketching pictures from Batman comics. Even though his work is very different from comic art, Seamus believes he wouldn't be an artist today if it wasn't for Batman comics. Seamus was interviewed shortly before his Batman-themed Vegas wedding [pictured].

**Liam Burke:** *Why do you think Batman endures and has such a rich legacy?*
**Seamus Keane:** I think it's because he doesn't have powers. I think if you put the work in, you could be Batman; or there's at least the possibility that you could be Batman. He's identifiable in the fact that he lost his parents to violence, struggled, put the work in and he became the guy to stop other people losing what he lost. I think everybody can identify with him.

**LB:** *Across the decades there have been many different interpretations of Batman. Do you have a preferred version?*
**SK:** No, I think Batman more than anybody else can change and endure over the years. I love the 1960s' Batman – the Adam West one – although I'm not sure I'd love it now if I saw it for the first time, but I grew up with it so I love it for that. But then I also love the animated Batman, the Bruce Timm stuff, which is fantastic. Then you have the movie versions. I think the Tim Burton [*Batman*, 1989] one is probably my favourite of the movies because of how they could skip over the origin. I enjoyed the origin of *Batman Begins* [Nolan, 2005], but Tim Burton gets right in there doing it with the flashbacks and the newspapers, it works really well. My favourite Batman is the 1970s' one with the blue and grey suit, the yellow belt – less of a superhero and more of an actual detective.

**LB:** *Do you have a favourite Batman villain?*
**SK:** Ra's al Ghul, I just love him. I think he's fantastic. I love that kind of, you know, megalomaniac Bond villain. He's also a man on a mission, and he's not altogether that bad of a guy. He wants to clear the world so it can start over. Now, he wants to put himself as the leader at the end of it, and that's where your problem is.

**LB:** *As a Batman fan, can you recall any extreme moments in your own fandom?*
**SK:** I have a Batman tattoo. A lot of people draw the line at that one. They think, 'OK, that's it', but I'm having a Batman wedding in Vegas, which

Fan Appreciation no.6
Seamus Keane

was my fiancée's Alison's idea [pictured]. She's going to dress as Cat-woman and I'm going to be Batman. My brother is going to be Superman, although he's bald, so he might be the Nicholas Cage Superman. We're going to have another one that will be the serious white wedding, so this is just going to be a fun wedding for us.

**LB:** *What's the Batman tattoo?*
**SK:** It's the logo and it's on my arm. It's in the classic black. I love the black and yellow symbol, but they only put the oval around it because they couldn't trademark a black bat. I thought the yellow on a tattoo would look tacky, so it's the black from the yellow oval, just without the oval.

**LB:** *You've a lot of Batman fans coming into Sub City. Is there anything that sets them apart or are they just comic book fans?*
**SK:** No, I think fans of this stuff are just fans. You get more Batman fans because the movies are generally better received. And again, he's more identifiable than say Superman, who's a guy from another planet and has all these fantastic powers. Batman's got the gadgets. He's like a super-hero James Bond.

**LB:** *The interest in Batman tends to go up and down relative to films, but is there anything else that peaks interest?*
**SK:** Not with Batman, but it's funny because we were told by [comic dis-tributor] Diamond that Batman sells better in Ireland and England than any place else in the world.

**LB:** *Did they give you a reason why?*
**SK:** No, they don't understand it. Just that they sell more Batman graphic novels in Ireland and the UK, which is amazing because you'd think they'd sell more of them in America. So it's obviously something that appeals over this side of the world more so than other places.

**LB:** *Have you encountered any strange behaviour from Batman fans?*
**SK:** We have an awful lot of guys in here with Joker tattoos, especially now, which is weird – guys getting sleeves of loads of different Batman characters and stuff. You have a lot more female fans of Batman than fe-male fans of anybody else. I think a lot of that has got to do with Harley Quinn – women love Harley Quinn.

**LB:** *Are they fans of the Batman comics or just Batman generally?*

**SK:** I think it's the Batman idea. I think he's bigger than the comics. I remember reading years ago that his logo was one of the top five most recognizable symbols in the world. I think Coca-Cola is another one and the Superman 'S' because even though Coca-Cola changes languages, it still keeps the font and the way it's written is the same. It's instantly recognizable and so are Superman and Batman: they don't change no matter the language. It's interesting that you can wear a Batman T-shirt in Saudi Arabia and they'd still know who it was. There's something cool about that.

**LB:** *Why do you think Batman compels such devotion among fans?*
**SK:** That I don't know. My mother has pictures of me as a kid: I'm about five, with black plastic bags tied around my neck because I'm Batman. I don't remember it, but she took photos. There's not really an explanation for it. If you could see my room, it's like a museum. It's wall to wall; you name it, I have it. And I thought I had everything until last Christmas when my girlfriend gave me tissues, Batman tissues, and I'm like, 'I don't have these!' which is the mission. You have to try and find things that you don't have.

# Part 4
## Being Batman

# Fan Appreciation no.7
## Kim Newman

Award-winning novelist and short story writer Kim Newman has been writing film criticisms for celebrated UK magazines *Empire* and *Sight & Sound* for over two decades. In that time he has seen Batman reach cinematic heights, as well as crushing lows. Here Newman discusses Batman, adaptations and his own fandom.

**Liam Burke:** *What was your first experience or encounter with Batman?*
**Kim Newman:** I'm exactly the right age to have been brought into comics by the Adam West series, which is now sort of despised, but actually I'm the same age as [comic book writers] Grant Morrison, Neil Gaiman, a bit older than Mark Millar, but they all came in the same way. Adam West's *Batman* was the thing that made us aware of American comics as opposed to *The Beano*, or *Commando* or other British comics. It was a craze in a way that I don't think a TV show could be a craze anymore in a multi-channel environment. This is a country where we had three channels, and if you were a kid you watched *Batman* in the same way you watched *Thunderbirds* or *Doctor Who* – interestingly both those franchises resonate throughout the rest of our lives as well.

So, yeah, I would say I went through an intense period as a child of being a Batman fan, going from the TV show to reading the comics, which then come over into Britain as ballast – so we had no sense of what was new or old. I remember reading what I now know were the contemporary Batman comics, which were before Neal Adams and Dick Giordano tried to make it serious, when it was sort of reflecting what the TV show was doing. However, because the show was so popular they also reprinted a lot of old stuff. I remember reading a lot of Dick Sprang-era Batman, as well as what I now know are like 1940s/1950s stuff – I hate to say Bob Kane because I know he drew almost none of it – so Jerry Robinson/Bill Finger Batman, that period. All that stuff was around and being republished.

So, as a character and as a medium, Batman comics became a big thing for like two or three years, and like everybody else I came back through *The Dark Knight Returns*, which was probably the thing that made me read comics again having grown out of comics as everybody did back then.

**LB:** *Across the decades there have been many different interpretations of Batman. Do you have a preferred version?*
**KN:** I don't know what I think of as the *real* Batman, and I think that's the strength of Batman as a character. It used to be said that every generation had its Hamlet, and now I think every generation has its Batman. I find it quite funny that people now put down Adam West; without Adam West's

*Batman*, Batman [the comic] might well have been cancelled. Batman could be as famous now as Hawkman. It was not a comic that was doing particularly well. It was just because it became this weird TV show, which did something with it. The reaction afterwards was to go grim and gritty and dark and to say that these were the origins of Batman, and that's true there's a nightmare aspect to it that's always been fascinating, but the Penguin has always been a camp character. He was camp before there was even a notion of camp; the same is true of the Mad Hatter, Tweedledum and Tweedledee and all those crazy 1950s' comics. It was knowing, and it was also fun in a way that I think that quite a lot of modern comics sadly aren't. I think comics now seem to be aimed at alienated 15 year-olds as opposed to the 'gosh wow' 9 year-olds. And in my fifties, I now find myself more in sympathy with 9 year-olds than 15 year-olds. I don't know if this is a correct, but it's certainly the way I feel.

**LB:** *As a Batman fan, can you recall any extreme moments in your own fandom?*
**KN:** By the time the big budget Batman movies came out I was already a critic so I got the tickets, but I remember being desperate to get an extra ticket for the press screening of the first *Batman* movie in 1989 [Tim Burton] because a girl I was keen on really wanted to see it. It didn't work out, but I got the ticket. I remember the crushing disappointment of *Batman Forever* [Schumacher, 1995] and *Batman & Robin* [Schumacher, 1997]. Actually the girl I'm seeing now said she would kill herself if I didn't get her in to see the new *Dark Knight* movie, so this is something that's never going away in my life. As like a 7, 8-year-old I remember going to the first *Batman* movie, the Adam West one, and thinking that was like the best movie ever made, maybe not as good as *The Dalek Invasion of Earth* [Felmyng, 1966], but for an 8-year-old the best movie made that year.

I've not been a collector, but I have done that terrible thing you can do now as a grown-up with a disposable income, buying back all the comics I had as a kid that disappeared for one reason or another. I suppose the sad thing is, the £20 I pay for an issue now means less to me than the six pence pocket money that would buy the plastic bags with the three comics. I do remember that period of Batmania.

**LB:** *Why do you think Batman compels such devotion among fans?*
**KN:** Superman is the archetype. Superman is the ideal of the hero, and Batman is the shadow, the one you need as well. It's why the World's Finest team-up always worked better when they were friends than when they

tried to make them antagonists. They need each other, they need the yin and the yang. All superheroes define themselves by how alike they are, or how different they are from Superman. They've tried to say in subsequent years that Batman's generic ancestors are Zorro, or The Shadow, or The Bat – the silent film character – to say there's this other tradition, the dark avenger tradition. That didn't really happen in Batman comics until the 1970s, there was a whole lot of Batman as a fun character before then when his cowl was blue, and the art was kind of goofy and even when it was scary it was sort of charming scary; and also Batman had Robin, so Batman had a light sidekick.

They have recently tried the idea that Batman is more gritty and cynical, which I also don't think is quite comfortable for the character. I think if he was really gritty and cynical he'd be the Punisher, and that's interesting because Marvel always define themselves by not being Superman. Marvel, because they came along later, they have this thing that Spider-Man is tougher than you and me, but if you put him in a room with Thor, the Hulk and Iron Man he's a loser, he's a lightweight, so when he triumphs that's actually a triumph, and I suppose they try that with Batman. They try to put him up against crazier and bigger obstacles.

There's the other thing about Batman that people aren't too happy discussing: Batman does have a superpower, he's unimaginably wealthy. Clark Kent works for a living, hammering away at the typewriter, meeting deadlines and all that. OK, he can squeeze coal into diamonds, but he doesn't do it that much, and you know if he did he'd pay the taxes on it. Whereas there's a playboy fantasy to Batman. In the very first Batman strip, you don't find out that Bruce Wayne is Batman until the last couple of frames. Commissioner Gordon calls on his friend Bruce Wayne, and tells him a story about meeting Batman, and in the end Commissioner Gordon leaves and thinks 'you know Batman is a really interesting guy, but Bruce Wayne is probably the most useless man in Gotham City'. One of the things I really like about *Batman Begins* [2005] is that it brought back a character we hadn't seen since the 1940s: Bruce Wayne the asshole, and Christian Bale plays that 'drunken Billionaire burns down house' really well.

One of the problems I have is where they made Clark Kent and Bruce Wayne more conventionally heroic, where you started wondering why they even needed to put on the cloak to do good stuff. I mean Clark Kent started out as the guy who always lost the scoop to Lois, and suddenly he's winning Pulitzer Prizes, he's breaking big stories, and everyone in the newsroom says he's great. He worked when he was a fumbling idiot, and

**Fan Appreciation no.7**
Kim Newman

the same with Bruce Wayne: when he became super confident as himself you start wondering why he needs Batman, and in fact that's kind of what the [Grant Morrison comic arc] Batman Inc. is addressing: What use is Batman to Bruce Wayne, why doesn't he just give up?

**LB:** *Do you have a favourite Batman villain?*
**KN:** As a deep down Adam West fan, it's the Riddler, who has not been particularly well-used lately. Obviously I thought Jim Carrey [in *Batman Forever*] was very weak. Frank Gorshin's performance in the Adam West series though is one of the great examples of extreme over-acting ever committed to film; his insane laugh is so demented that Cesar Romero had nothing to do as the Joker – the Joker seemed like an imitation of The Riddler. He also brought back the fact that Batman comes from a comic called 'detective', and I really liked those stories – I think it's a Bill Finger thing – where Batman has to solve puzzles. Also, I think the Frank Gorshin bowler hat with a question mark is kind of cool.

The other one that really works for me is Catwoman, but I'm not sure if she's really a villain anymore – she was slightly more fun when she was. Because morality in comics has shifted to the point where you can be a kleptomaniac and a hero she now seems almost demure in that all she does is steal. It may also be that she has had great design work. No one deals with this anymore, but comics are still a visual medium. How successful a character is is often to do with the look, the basic design and this is mostly to do with Jerry Robinson on characters like the Joker, Scarecrow, Catwoman, the Riddler and Penguin. It's so brilliant that they have escaped from just being comic characters. For instance, in *The Avengers* [Whedon, 2012] there's that moment at the end where you find out Loki is working for somebody else, and this character turns around and everybody in the audience who doesn't read comics goes, 'Who the fuck is that?' *Batman Begins* can have that moment at the end where Commissioner Gordon goes 'this guy left a playing card', and everybody in the audience knows who he is. Those characters have escaped from just being comic book characters to being general popular culture.

# DID I FINALLY REACH THE LIMITS OF REASON? AND FIND THE DEVIL WAITING? AND WAS THAT FEAR IN HIS EYE?

**BATMAN**
BATMAN RIP

Chapter
10

# 'Elementary, My Dear Robin!': Batman, Sherlock Holmes and Detective Fiction Fandom

Marc Napolitano

→ In March of 1987, DC Comics published *Detective Comics #572* to mark the golden anniversary of the title. The issue's cover featured every fanboy's dream: a team-up of superheroes from widely different eras. Here, Batman and Sherlock Holmes pour over an indistinct text; mounted on the wall behind them is a framed copy of *Detective Comics #27*, the 1939 issue that marked the Batman's (then the Bat-Man's) debut. It is ironic that an iconic hero like Batman made his first appearance in a comic book that did not bear his name (as did his most immediate and important predecessor, Superman).

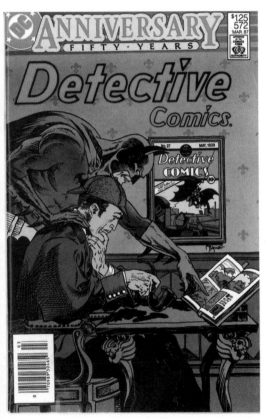

*Fig. 1: The greatest detective in the DC Universe meets the greatest detective in any universe – Detective Comics #572 (March 1987)*

Nevertheless, it is understandable that *Detective Comics #27* would precede *Batman #1* given the infancy of both the character and his medium: why would anyone purchase a comic book entitled *Batman* when no one had any idea who Batman was? Similarly, the Victorian readers who snapped up *Beeton's Christmas Annual* in 1887 had no conception of Sherlock Holmes, nor any way of knowing that, by reading *A Study in Scarlet*, they were witnessing the introduction of a character who would go on to become the most popular literary figure of all time. Holmes and Batman occupy such a prominent place in popular culture that it is difficult to conceive of a time when they were unknown. In the 'Detective Comments' section of #572, the issue's lead writer, Mike W. Barr, reflects that:

To me, Superman is an 'always' character. I remember asking my mother, when I learned Superman had first appeared in 1938, how she could have avoided buying a copy of *Action Comics* #1. Didn't she *know*? How could she *not* know? But she didn't [...]. Yet to my mother, Sherlock Holmes is an 'always' character. Created in 1887, Holmes has thrilled generations of readers, and has become synonymous with the word 'detective,' as Superman has become the embodiment of the term 'super-hero'.... The main feature of *Detective [Comics]* for all these years, *The Batman*, is himself an 'always' character [Barr's emphases].

Barr seems to be speaking for all contemporary fans of the above-mentioned characters: they have *always* been with us, so it is impossible to imagine the world without them.

Though Batman plays a prominent role in #572, the issue's primary purpose is to commemorate the legacy of *Detective Comics*; as Barr writes, 'Before there was *Batman*, there was *Detective Comics* [...] *Detective* was the first comic book to group stories around a central theme'. Batman was a product of that theme: crime and detection. Though he is frequently called a superhero, he is, first and foremost, a detective; for all of his remarkable talents and physical prowess, his greatest attribute is his analytical mind. Les Daniels astutely points out that when Bob Kane and Bill Finger began their partnership, they met in Edgar Allan Poe Park 'unconsciously pay-

'Elementary, My Dear Robin!':
**Batman, Sherlock Holmes and Detective Fiction Fandom**
Marc Napolitano

ing tribute to the classic American writer who is credited with inventing the detective story'. *Detective Comics #572* thus provided Batman with an opportunity to celebrate the title's 'central theme' by working alongside other detectives from different epochs in the history of detective fiction. Batman stands for the detective as superhero, while Slam Bradley, a gruff yet heroic investigator who debuted in *Detective Comics #1*, embodies the hardboiled private eye of the Depression era. Finally, there is Holmes, representing not only the nineteenth century sleuth, but likewise, his inimitable self: literature's greatest detective hero who, that very same year, would celebrate his centenary.

Though the juxtaposition of these three very different detectives – and these three very different conceptions of detective fiction – is awkward at times, the end result is a captivating exploration of the perpetual popularity and intertextuality of the detective story. Barr embraces the latter quality throughout the issue; the middle chapter features a 'lost' Sherlock Holmes adventure that bears the hallmarks of a traditional Holmes narrative. Similarly, Bradley's mannerisms are evocative of Sam Spade, and he paraphrases several lines from *The Maltese Falcon*. This intertextuality is appropriate given that Batman, the character, was a 'composite text' from the start: Robin Hood, the Lone Ranger, The Shadow, Zorro, Douglas Fairbanks, the Green Hornet, and of course, Sherlock Holmes himself, have all been cited as inspirations for the Batman. Similarly, comic historian Rick Marschall identifies the intertextual slant of Batman's early adventures, asserting that:

The mixture of genres Kane and Finger loved resulted in the Batman living in the best of both worlds [...] a traditional detective mystery could be combined with an exotic costumed-hero tale; the protagonist could be cerebral as well as an action-figure; plotting could be sophisticated (to a comic-book point) but also could have – should have – some violence and visual verve.

In pairing Batman with iconic detectives and placing him in a story that embraces the traditions of detective fiction, Barr simultaneously drew readers' attention to the ways in which these traditions had shaped the 'dark knight'.

Like the famed characters from the hardboiled private eye sub-genre – Race Williams, Sam Spade and Philip Marlowe – Batman was a product of the 1930s' pulp magazine fad, and the grittiness of the earliest Batman adventures vividly suggest these roots; Kane would later reflect that the pulps 'helped establish the heroes and formulas which were the forerunners of comic books'. But what of the Holmesian influence? Finger frequently cited Holmes as a model for Batman, eventually attributing the creation of Robin to the necessity of giving the Dark Knight detective a 'Watson' with whom he could interact with whilst solving cases. Nevertheless, the world of the pulps (and later, the world of comic books) seems antithetical to the world of *The Strand Magazine* given the gritty Americanness of the former and the Victorian Englishness of the latter.

Mike Ashley asserts that:

Britain failed to develop a distinct 'field' of pulp magazines in the way that America did. In the US 'pulp fiction', meaning primarily popular and generic fiction published originally in pulp-paper magazines, has gained an almost mythological status; but not so in Britain, except by contagion from the US (the average British reader today, questioned about pulp magazines, would probably reply that they were an American phenomenon and be quite unaware that there were any UK pulps). We have speculated above that this may have been partly because of the strength of the juvenile story-paper tradition in the UK; but there may have been other reasons [...] indeed, it may have been due in part to the very prestige, persistence, and unchangingness of *The Strand* until World War II.

Still, it is important to consider that George Newnes' conception for *The Strand* was partially inspired by the success of American magazines like *Harper's Weekly*. Newnes' belief that short fiction was the ideal genre for the literary component of his periodical reinforces this 'American' approach, particularly in light of the fact that the short story had never achieved the same resonance in nineteenth century Britain that it had attained in America and France; the success and enduring power of *The Strand* opened up this new medium for late Victorian and Edwardian authors. Conan Doyle took Newnes' vision one step further by promoting the notion that:

A single character running through a series, if it only engaged the attention of the reader, would bind the reader to that particular magazine. On the other hand, it had long seemed to me that the ordinary serial might be an impediment rather than a help to a magazine, since, sooner or later, one missed one number and afterwards it had lost all interest. Clearly the ideal compromise was a character which carried through, and yet installments which were each complete in themselves, so that the purchaser was always sure that he could relish the whole contents of the magazine.

Sherlock Holmes – like Batman and the other comic book characters of the golden age – thus found his niche in the episodic, short fiction format, which achieved a loose continuity by the consistent presence of the central character. Nevertheless, each issue could exist independently as an individual episode in the life (or, more accurately, as an individual adventure in the career) of that character. Though there is a basic sense of chronology, the concept of an overarching narrative is far less significant than the idea of a successful formula that can be repeated to produce an endless series of stories. Consequently, perhaps the most significant connection between these two detectives is not the methodology employed by their creators/publishers, but rather the chief by-product of this methodology regarding the stories' readership: the construction of a fan-base whose enthusiasm defined the enduring power of the character. In regard to

'Elementary, My Dear Robin!':
Batman, Sherlock Holmes and Detective Fiction Fandom
Marc Napolitano

Holmes, it is useful to turn to Kate Jackson's definition of *The Strand*'s readership as a reading community: '[a category] of readers linked together by a common experience or expectation of objective or bond rather than by physical proximity'. Jackson's description of *The Strand*'s attempt at building a community based in shared expectation is at once evocative of Cornel Sandvoss' observation that fandom 'constitutes a particular form of engagement with the text that presupposes familiarity'. As in the case of *The Strand*, comic book fandom is a community with specific presuppositions that have been shaped by the readership's dedication to the material, though that community must simultaneously be flexible and dynamic. Even as actor and playwright William Gillette reshaped Holmes in his own image for the stage, he was able to frame his version of the detective in such a way as to reflect the ideals and expectations of the fan-base whilst forever leaving his own mark upon the character. Similarly, Will Brooker observes that:

[Batman's] position as a cultural icon is, then, due to the extent to which he can adapt within key parameters. He must remain familiar while incorporating an edge of novelty; he must keep the loyalty of an older generation who remembers their childhood [...] while constantly pulling in the younger audience who constitute his primary market.

Although prominent comic book writers and graphic novelists have taken Batman in bold new directions, the success of their endeavours has largely depended on the extent to which they understood the character's fan community. As Tony Bennett observes, the power and popularity of Frank Miller's *The Dark Knight Returns* can be traced back to the fact that 'Miller's Batman bears the impress of all the previous guises in which the character – and his allies and opponents – have been incarnated. The early Gothic Batman, the Cold War Batman of the 1950s and his 1960s parodic successor: these are all there [...] activating the reader's latent knowledge of these matters and, thereby, registering the significance of the remodelling of Batman which the text undertakes'.

Though Miller was revolutionizing the Batman mythos, the full breadth of his achievement can only be understood within the context of Batman fandom, and by the very community that had developed over the character's nearly fifty-year history.

The building of any community is a gradual process, and the growth of a Holmes and Batman fandom was no exception; in the case of Holmes and *The Strand*, Christopher Pittard links this development to the sociological theories of Richard Sennett, who views the movement towards community as stemming from 'a certain purifying instinct [...] which gives precedence to the ordered over the disordered and painful'. Obviously, Holmes' (and Batman's) status as an agent of order coincides with this sort of community, though the darkness, violence and chaos that define the first two Holmes adventures belies this fact. Nevertheless, as Holmes found a permanent home in *The Strand*, Pittard notes that the brutality and sensationalism that characterized *A Study in Scarlet* and *The Sign of the Four* were rejected 'in order to provide healthy reading

and to purify the crime narrative [...]. Such a change was necessary for the short stories to be included in *The Strand*'. Tellingly, *Detective Comics* followed a similar trajectory upon the introduction of Batman; the starkness and cruelty of the first string of Batman adventures is somewhat jarring, as is Batman's willingness to murder criminals. Nevertheless, the 'purifying instinct' described above soon exerted an influence on the stories; the introduction of Robin in *Detective Comics #38* served to brighten the world of Batman in numerous respects, and Batman instantly became a less violent vigilante. Reflecting on the introduction of Robin, Kane later stated, 'I thought it would make the strip more successful by appealing to two audiences. I felt that children wanted a lighter hero and a lighter mood and would identify with a younger character like Robin'. Much as Conan Doyle tailored the Holmes stories to fit the ethos of the middle-class *Strand* readership, Kane and Finger sought to build a youthful yet diverse fan community for their superhero, who had already proved popular enough to warrant his own title. Nevertheless, the emergence of this community, like the growth of *The Strand*'s 'fandom', depended on the development described by Pittard.

Of course, detective fiction, as a genre, is fundamentally conducive to this form of purification, not only because of its central focus on punishing deviance, but likewise because of its essential conservatism. George N. Dove views the conservatism of the genre as 'structural' and not 'thematic', 'that of the organized game, preserving custom and convention as essential to its own continuation. Detective fiction adapts easily to thematic, but not to structural, invention'. In a virtual duplication of this sentiment, Robert A. Rushing claims that:

Of the principal types of modern genre fiction [...] detective fiction, especially in its classic formulation, is by far the most formulaic, the most conservative. It has many subgenres (the cozy, the police procedural, the hard-boiled, the forensic), but what is remarkable is that most of these subgenres manifest a set of generic tics that [...] are no less compulsive.

Much as the detective genre that shaped them was defined by its strict adherence to formulaic conventions and its unwavering emphasis on logic and control, Holmes and Batman became adherents to a strict methodology when enacting their investigations, providing their fan communities with a clear sense of what a Sherlock Holmes mystery or a Batman adventure should be. In the case of the former, fans could count on a casual conversation between Holmes and Watson at 221b Baker Street, the arrival of a client, a deductive inference based on the client's appearance, the outlining of a problem, an investigation into that problem, and a denouement. Rushing describes this consistency as 'an attractive feature of Conan Doyle's fiction: the stories are familiar, and make use of a narrative structure that obviously works', thus giving fans a sense of comforting consistency in an inconsistent world; Kane and Finger adopted a similar strategy when

'Elementary, My Dear Robin!':
**Batman, Sherlock Holmes and Detective Fiction Fandom**
Marc Napolitano

creating the narrative formula for Batman. Indeed, in spite of the diversity of Batman's initial adventures, the early issues are striking for their structural redundancies – the redundancies of detective fiction. In between the set-up and the denouement, Daniels describes Finger's formula as consisting of three separate confrontations between the hero and villain (sometimes a disposable 'villain of the month', other times a 'super-villain' such as the Joker or the Riddler): 'Batman would encounter his opponent three times: losing the first fight, earning a draw in the second, and finally triumphing in the third'. Although the notion of Batman having multiple confrontations with the villain seems antithetical to the conventions of detective fiction, where the villain is not revealed until the final chapters, the formula worked remarkably well in the context of Batman's action-oriented/visual medium, and provided the same reassuring stability as the Holmesian detective narrative.

The palpable conservatism of the two heroes relates not only to their roots in detective fiction, but likewise to their target demographics. Holmes, for all of his bohemian quirks, represented the triumph of middle-class urban professionalism, and thus served as a reassuring presence to the readers of *The Strand* regarding what Ernest Mandel calls 'the stability of bourgeois society and the self-confidence of the ruling class [which] assumed that this stability was a fact of life'. Similarly, Bennett describes comic books as '[I]nherently conservative in view of their conception as a juvenile medium', and the dependability of superheroes (and their narratives) has traditionally been a source of relief for young readers. Batman, like Holmes before him, is a preserver of the *status quo*: both men focus on restoring the social order – they do not reform that order. Nevertheless, they clearly apply their own subjectivity when determining what that 'order' should ultimately look like; as Batman memorably asserted in *The Dark Knight Returns*, 'The world only makes sense when you force it to'. The potential danger in this approach, and the discomforting tendency of fans to excuse it based on their admiration of the characters, alludes to the potentially fascistic elements of the detectives' personalities: Batman has repeatedly been scrutinized from this standpoint, while Holmes has faced similar criticism as a representative of imperial chauvinism.

The obsessive, controlling behaviour of both characters is likewise discomforting even as that same behaviour assures the stability of the social structure. Jacqueline Jaffe states that 'to be capable of bringing order to the chaos of modern life, Holmes must subordinate all emotion to the service of the intellect', while William Uricchio and Roberta E. Pearson perceive Batman's obsession with order as stemming from the chaos of the primal scene of his parents' murder: 'The obsession causes him to engage in his Sisyphean reenactment of that original encounter'. Ironically, this obsessive conduct is essential to the preservation of the fan-base, for Batman's 'Sisyphean' war on crime and Holmes' fixation on the 'scarlet thread [...] running through the colourless skein of life' are what allow for the development of the formulaic approach to their adventures. Essentially, the compulsiveness of the heroes facilitates the fidelity of the fandom in two

distinct ways: by reassuring readers of the firmness of the social order, and by providing a strong sense of stability through the repetition of a narrative style.

Of course, for Batman and Holmes, any such gain (much like the societal benefits within their respective canons) is subsidiary to the personal satisfaction that they derive. Famed DC Comics artist and editor Dick Giordano once reflected 'the origin of the Batman is grounded [...] in emotion. An emotion that is primal and timeless and dark. The Batman does what he does for himself, for *his* needs. That society gains from his actions is incidental' [Giordano's emphases]. Though Holmes' ultra-rationalism is antithetical to the raw emotion that drives Batman, he too 'does what he does for himself, for his needs'; without cases to solve, he would self-destruct.

In light of this selfish dimension to the detectives' quests, it is somewhat ironic that they became role models for their readerships and icons of core values for their fanbases. Lord Robert Baden-Powell, founder of the British Scout movement, encouraged Scoutmasters to turn to Holmes as a model for rationality, camaraderie and masculinity, and he likewise believed in the value of Holmes-inspired projects. Similarly former-Batman writer and editor Denny O'Neil notes that in spite of the character's dark roots, 'Batman became a sort of ebullient scout master [sic] for a while'. Though O'Neil cites the 1950s as the decade in which Batman adopted this persona, the seeds were sown for this transition as early as 1940 with the introduction of Robin. Notably, in *Batman #3*, the title character breaks the 'fourth wall' and directly addresses his fans, claiming that the central goal of his exploits is to promote citizenship:

We'd like to feel that our efforts may help every youngster to grow up into an honest, useful citizen.
It depends on YOU and YOU and YOU. You've got to govern your own lives so that they can be worthwhile, fruitful lives – not lives wasted in prison, or even thrown away altogether before the ready guns of the law enforcement agents who [sic] duty it is to guard those of us who are honest from those of us who are not. And not only must you guide your OWN life in the proper channels – you must also strive to be a good influence on the lives of others.

However dated this message may seem over seventy years later, it is a prime indication of the aforementioned 'purifying tendency' that defined the building of the character's fanbase, and like Holmes before him, Batman came to represent a model of civic duty to his readership. While the conservatism of these values may seem hokey, outmoded and perhaps even distasteful to some contemporary readers, it is in keeping with the roles of the two characters as detectives. As Ronald R. Thomas notes, 'the detective story imposes restrictions on the autonomy of the self by identifying certain kinds of violent behaviour as criminal'. The existence of detective fiction – like the existence of Holmes and Batman – is dependent upon criminality, or, more specifically, the detec-

'Elementary, My Dear Robin!':
Batman, Sherlock Holmes and Detective Fiction Fandom
Marc Napolitano

tion and punishment of criminality, and the preservation of the social structure.

Batman's face-to-face encounter with Holmes in the concluding panels of *Detective Comics #572* is a genuine 'geek out' moment for any true genre fan, as the greatest detective in the DC Universe meets the greatest detective in *any* universe. Though the aged Holmes attributes his survival into the late twentieth century to 'a distillation of royal jelly, developed in my beekeeping days' and his residency in Tibet, it is obvious that Holmes' ostensible immortality is actually the result of his mythic status; it is the same immortality that has been conferred upon his greatest successor in the realm of detective fiction, the Batman. As Barr notes, Holmes and Batman are 'always' characters, but not simply in the sense that they have always been *with* us. Perhaps more importantly, they have always been there *for* us, and just as the citizens of Victorian London and Gotham City can rest easier knowing that Holmes and Batman are on the case, the detectives' fanbases can likewise attain a certain peace of mind from the order and familiarity that defines the characters' canons. ●

## GO FURTHER

### Books

*Resisting Arrest: Detective Fiction and Popular Culture*,
Robert A. Rushing (New York: Other Press, 2007)

*The Age of Storytellers: British Popular Fiction Magazines, 1880–1950*,
Mike Ashley (London: British Library, 2006)

*A Study in Scarlet*,
Arthur Conan Doyle (London: Electric Book Co., 2001)

*George Newnes and the New Journalism in Britain 1880–1910: Culture and Profit*,
Kate Jackson (Aldershot: Ashgate, 2001)

*Batman Unmasked: Analyzing A Cultural Icon*
Will Brooker (London: Continuum, 2000)

*Batman: The Complete History*,
Les Daniels (San Francisco: Chronicle Books, 1999).

*The Reader and the Detective Story*,
George N. Dove (Ohio: Bowling Green State University Popular Press, 1997)

*Batman and Me: An Autobiography*,
Bob Kane (California: Eclipse Books, 1989).

*Arthur Conan Doyle*,
Jacqueline A. Jaffe (Boston: Twayne, 1987)

*Detective Comics* no.572,
Mike Barr, AdrienneRoy, and Denny O'Neil (New York: DC Comics, 1987)

*The Dark Knight Returns*,
Frank Miller (New York: DC Comics, 1986).

*Delightful Murder: A Social History of the Crime Story*,
Ernest Mandel (Minneapolis: University of Minnesota Press, 1984).

## Extracts/Essays/Articles

'"Cheap, healthful literature": *The Strand Magazine*, fictions of crime, and purified reading communities' by Christopher Pittard
In Victorian Periodicals Review (40.1), 2007, pp. 1–23.

'The death of the reader? Literary theory and the study of texts in popular culture' by Cornel Sandvoss
In Jonathan Gray, Cornel Sandvoss and C. Lee Harrington (eds). *Fandom* (New York: New York University Press, 2007), pp. 19–32.

'The Batman says' by Whitney Ellsworth and Jerry Robinson
In Bob Kane and Bill Finger. *The Dark Knight Archives: Volume 1* (New York: DC Comics, 1992), p. 169.

'Memories and adventures' by Arthur Conan Doyle
In Harold Orel (ed.). *Sir Arthur Conan Doyle: Interviews and Recollections* (New York: St. Martin's Press, 1991), pp. 17–35.

'Foreword: holy shifting signifiers' by Tony Bennett
In Roberta E. Pearson and William Uricchio (eds). *The Many Lives of the Batman: Critical Approaches to a Superhero and his Media* (London: Routledge, 1991), pp. vii–ix.

'Elementary, My Dear Robin!':
Batman, Sherlock Holmes and Detective Fiction Fandom
Marc Napolitano

'I'm not fooled by that cheap disguise'by William Uricchio and Roberta E. Pearson
In Roberta E. Pearson and William Uricchio (eds). *The Many Lives of the Batman: Critical Approaches to a Superhero and his Media* (London: Routledge, 1991), pp.185–203.

'Notes from the Batcave: an interview with Dennis O'Neil'
by Denny O'Neil, Roberta E. Pearson and William Uricchio
In Roberta E. Pearson and William Uricchio (eds). *The Many Lives of the Batman: Critical Approaches to a Superhero and his Media* (London: Routledge, 1991), pp. 18–32.

'Foreword'by Rick Marschall
In Bob Kane (au). *Batman Archives: Volume 1* (New York: DC Comics, 1990), pp. 1–6.

*Detective Comics #27* by Bob Kane and Bill Finger
In Bob Kane (au). *Batman Archives: Volume 1* (New York: DC Comics, 1990), pp. 7–13.

'Growing up with the greatest'by Dick Giordano
In *The Greatest Batman Stories Ever Told* (New York: Warner Bros, 1988), pp. 7–13.

'Detective comments'by Mike Barr
In *Detective Comics #572* (New York: DC Comics, 1987), p. 1.

# BOTH OF US TRYING TO FIND MEANING IN A MEANINGLESS WORLD! WHY BE A DISFIGURED OUTCAST WHEN I CAN BE A NOTORIOUS CRIME GOD? WHY BE AN ORPHANED BOY WHEN YOU CAN BE A SUPERHERO?

**THE JOKER**
BATMAN #663

Chapter
11

# Dark Knight Triumphant: Fandom, Hegemony and the Rebirth of Batman on Film

William Proctor

→ **INTRODUCTION**

Fan activity is often celebrated as a triumph for agency at the expense of structural factors, which risks dislocating the industrial forces at play from a complex interaction and intersection of producer, text and audience. It would be erroneous to suggest that fandom is an 'island', floating in a sea of tranquil optimism without regard for the economic dictates of the Hollywood entertainment machine. As Dudley Andrews claims, 'film art and the cultural economy are invariably tied up with one another' and cannot be analyzed as distinct and detached entities. Rather, by drawing upon Antonio Gramsci's theory of hegemony, I will argue that fandom illustrates a dialogical struggle, a tug of war if you will, between the forces of incorporation (structure), and the voices of fan cultures (agency). As John Storey puts it:

> Hegemony is never simply power imposed from above: it is always the result of 'negotiations' between dominant and subordinate groups, a process marked by both 'resistance' and 'incorporation'. There are of course limits to such negotiations and concessions [...] they can never be allowed to challenge the economic fundamentals of class power.

As this quotation points out, the dialogue between media conglomerates and fandom is not an equal balance, as some commentators argue. The means of production are firmly wielded in the hands of Hollywood conglomerates, and, as Marxist scholar Mike Wayne points out, they have 'awesomely more resources at their disposal to shape the agenda'. Douglas Gomery argues that, Hollywood is a 'textbook example of monopoly capitalism' and remains a 'collection of businesses seeking power and profit'.

Yet fandom clearly has a voice and, at times, the volume is turned up so loud that the stability of the Hollywood hegemony can be loosened from its axis. In short, the 'powers that be' at the top of the spectrum take note of the cacophony of voices bellowing from beneath. In the 1960s, for example, fans joined forces to protest against NBC's decision to remove *Star Trek* (1966–69) from its broadcasting schedules by picketing studios, participating in protest demonstrations and partaking in a now-legendary letter-writing campaign that featured the vocal indignations of over 100,000 fans. At the time, this was unprecedented, and NBC paid heed to the voices of ardent fans: *Star Trek* was saved.

This victory for agency has a barbed edge, however: NBC did indeed re-commission the show for a third season, but placed it in the Friday night 'death-slot' of 10pm and cancelled the programme after the third season. *Star Trek* did, however, go into syndication and the rest, as they say, is history: four spin-off TV series, twelve feature films and an entire universe of novels, books and merchandising extras. This is hegemony in action.

From this position, this article provides an analysis of Warner Bros.' *Batman* film franchise through the lens of fan cultures. In *The Films of Tim Burton*, Alison McMahan argues that the 1989 *Batman* film inaugurated a new era of 'vertical integration, synergy and ancillary markets'; in other words, 'total merchandising'. The film franchise continued along this economic trajectory with the second Burton film in 1992 – *Batman Returns* – until Joel Schumacher replaced Tim Burton as director with 1995's *Batman Forever* and 1997's *Batman & Robin*. For many critics, commentators and, most importantly, fans, *Batman & Robin* was a turgid, squalid affair. In *Supergods*, comic book writer Grant Morrison declares with characteristic hyperbole that the film 'transformed a money-

**Dark Knight Triumphant:**
**Fandom, Hegemony and the Rebirth of Batman on Film**
William Proctor

spinning film franchise into a radioactive turkey cat dinner [that is] widely regarded as the worst Batman film ever made and indeed reviled by some commentators as the most indefensible artefact ever created by a so-called civilization'. Julian Darius, author of *Improving the Foundations: Batman Begins from Comic to Screen*, argues that 'Schumacher's [Batman films] were singled out for almost religious disdain – so much so, that in comic circles, Schumacher was never mentioned without disparagement'. The Legions of Gotham website states that the film 'effectively destroyed Batman movies and caused an eight year drought'. This catastrophic failure, across multiple discourses forced the Batman film brand into cinematic purgatory for the best part of a decade. But it is important to point out that, contrary to popular thought, *Batman & Robin* did not suffer the ignominious fate of lost profit. Box office receipts for the film totalled $238,207,122 worldwide with merchandising tie-ins amassing in excess of $160m. Combining these figures together and the total revenue comes close to $400m, which far exceeds the film's reported budget of $125m (which excludes home video/DVD sales: *Batman & Robin* is included as part of a 'first wave' box set which incorporates the four films of the Burton/Schumacher tenures, and is still sold on internet shopping sites and in high street stores).

In *Show Sold Separately*, Jonathan Gray argues that one should not study the film text as an isolated, textual utterance external to other activities that are an integral feature of its media architecture. Drawing upon Gerard Genette's notion of the 'paratext', Gray extends the scope of a text to all its peripherals including toys and spin-offs. *Batman & Robin*'s merchandising blitz was gargantuan: a novelization by Michael Jan Friedman; a comic book adaptation; a computer game for the Sony Playstation; a vast range of tie-in toys by Kenner which includes over fifty variations on the Batman character – Wing-Blast Batman, Laser-Cape Batman, Neon Armour Batman to name a select few – and large iconographic toys such as The Wayne Manor Batcave and Mr. Freeze's ice fortress; alongside multiple theme park rides connected to the film franchise. Taking these paratexual activities into account, Schumacher's – or, rather, Warner Bros.' – *Batman & Robin* made a substantial windfall, rather more than *Batman Begins* (Nolan, 2005) in fact.

So, given that Batman was still an economically robust film franchise in spite of almost universal castigation, what was the rationale for Warner Bros.' abandonment of Batman films for eight years? If the profit principal is the only determining factor of success, why not simply continue unabated? Enter the Bat-fan.

### Legends of the Dark Knight (fan)

The Internet has opened up a democratic space for fans to express their thoughts, opinions and frustrations on forums and social networking sites. Today's multimedia marketplace, as argued by Henry Jenkins, is 'where old and new media collide, where grassroots and corporate media intersect, where the power of the media producer and

157

the power of the media consumer interact in unpredictable ways'. Although this cultural 'convergence' is more far-reaching and ubiquitous in this post-millennial digital land-scape, in 1997, the year of *Batman & Robin*, fans were beginning to stretch their limbs online and make vocal their vitriol.

Will Brooker's *Batman Unmasked: Analyzing a Cultural Icon* contains a snapshot of fan discontent at the time of *Batman & Robin*, and is valuable for situating the argument in its temporal context. By investigating comments on the Mantle of the Bat: Bat Board Internet forum, Brooker records the indignation fans felt towards Schumacher and *Batman & Robin*. The Bat Board, as Brooker points out, 'is usually characterized by mild language out of respect to younger visitors [yet] the movie drove these fans to full-on cursing both in the theatre and on the Internet forum'.

For example, Bat-fan 'Nightwing' comments that:

This is without doubt one of the worst movies I have ever seen! When the film ended the audience all shouted obscenities at the screen. I didn't pay a dime to see it and I feel cheated! Everybody was horrible! Uma was the absolute worst of anyone. Clooney was nowhere near as good as Keaton or Kilmer. This was the worst I've seen Chris O'Donnell, Arnold was awful as well [...] this is the worst of the series, it made *Batman Forever* look as good as the first film. Commissioner Gordon was reduced to a role very similar to O'Hara from the 60's [sic] TV show. It's that bad. *Batman & Robin* is pure shit!

Mike Higgins is no less caustic in his views:

You have got to be fucking kidding me. This movie was the absolute worst of the series. I hope they crucify Schumacher and hang him from the tallest building in Hollywood. Uma's performance was so over the top it was like watching the campy 60s show [...] I can't write anymore, I'm just too damn disappointed.

Jeff Shain's colourful, rhythmic rant is 'an example of the sheer impotent rage that can boil up within a fandom denied any real power to influence the way its treasured icons are represented to the mass public:

Schumacher, you little piss ant! Who the fuck gave you the right to direct anything re-motely as cool as Batman? I'm a film major in my freshman year, and I can tell you right now I can direct a better film on crack with my mouth stitched closed and my eyeballs plucked out! I don't know what the fuck you were thinking [...] pick up a Batman comic you asinine fool? Does Gotham City look like Club Expo to you? Do you see any neon? What the fuck? And NIPPLES? This isn't a fucking joke! Batman isn't some two-bit cir-cus freak like your bearded lady of a mother! He is the essence of gothic darkness, a man ripped between reality and fantasy, teetering on the brink of insanity with only his

**Dark Knight Triumphant:**
**Fandom, Hegemony and the Rebirth of Batman on Film**
William Proctor

partner and his butler and his mission to keep from going crazy! Did you capture any of these elements? Of course not, because obviously you must have gone to the Ronald McDonald School of Film? Who's the next villain, Schumacher, you schmuck, you prick… the Hamburglar? FUCK YOU!

The general consensus among fans, like Jeff, 'Nightwing' and Mike, is that Batman should be dark and serious. From this perspective, Schumacher's major offence can be located in the aesthetic shift from 'Dark Knight of Gotham' back to the 'Caped Crusader' of the 1960s television show. Putting aside many of the comments from fans that border on homophobia, the message to executives at Time Warner was clear and simple: this will not do. The success of grim, bleak Batman narratives such as Frank Miller's seminal 1980s' comic books (*The Dark Knight Returns* and *Year One*), pessimistic, dystopian stories like Alan Moore's *Watchmen* and even the neo-gothic expressionism of Burton's *Batman* and *Batman Returns* indicated a blueprint for future Batman adventures. But, instead, Schumacher introduced cod-pieces, bat-nipples and George Clooney. Arnold Schwarzenegger as Mr. Freeze and the questionable punning ('Let's kick some ice'; 'You're not sending me to the cooler!') was just the figurative icing on the cake.

It would be easy to dismiss fan antagonism as a minority cluster, but the quotes cited above are not individual, isolated incidents. Websites began to spring up online with names like 'The Anti-Schumacher Site', 'The Anti-Schumacher Society' and 'Bring me the Head of Joel Schumacher'. Bat-fans Aaron Koscielniak and Adam Rosen set up 'Bring me the Head..'. to give fans a platform to vent their frustrations at Time Warner for exploiting the Batman brand through the corporate, merchandising bonanza of toys and spin-offs mentioned above. Moreover, they claimed that *Batman & Robin*:

[W]as absolutely worthless, and what's worse, it defames the good name of Burton and what he represents […] Joel Schumacher has truly trashed the Dark Knight. The traditional dark, gothic atmosphere of Gotham City is replaced with a neon circus, and he tries to sell the heroes off as clowns, with Schumacher the ringmaster. This site is dedicated to getting off our chests […] all the things that made us really PISSED OFF about this movie.

In 'Batman, Time Warner and Franchise Filmmaking in the Conglomerate Era', Kim Owczarski illustrates that time has not diluted consumer displeasure. In 2007, ten years after *Batman & Robin*, Joel Schumacher's latest film, *The Number 23*, was due for release and one extremely disgruntled Bat-fan indicated that he still hated Schumacher:

I still haven't got through that film to the end. And I'm a Batman nut. I'd rather have Burt Ward paper-cut my eyeballs and then pour lemon juice on them than try and watch *Batman & Robin* again.

While it is incredibly difficult to pinpoint what Time Warner actually paid attention to and the effect these discourses had on their response, it can be suggested that fandom played a crucial part in forcing Time Warner to rethink their approach to the Batman brand. Back in 1999, Brooker stated that:

[t]he relationship between fan pressure and institutional response is hard to call at present. The anti-Schumacher webmasters may have some justification in claiming that campaigns like theirs have halted the progress of the Warners juggernaut; on the other hand, the multinational may roll on with another day-glo spectacular of a Batman sequel, oblivious to the protests of idealists like Jeff Shain.

However, given the benefit of hindsight, I would argue that the 'death' of the film franchise and its twenty-first century resurrection indicates that fan reaction played, at the very least, *some* part, especially if we take into account the fact that the text – and all its multitudinous merchandising interconnectivity – still struck gold for Time Warner. The eight year gap between films and the decision to narratively disconnect the next film completely from *Batman & Robin* indicates that Warner Bros. has used fan commentary as an aesthetic blueprint to create the next iteration of the Batman. As Owczarski puts it: 'As fans express discontent over casting rumours over the direction of the franchise, representatives at Time Warner can react to these criticisms quickly and efficiently'. In 1999, Brooker pointed out that that 'the future of the movie franchise [...] hangs very much in the balance'. Enter Christopher Nolan.

### Christopher Nolan and the Dark Knight effect

According to DiPaolo, *Batman Begins* 'won the support of comic book aficionados across cyberspace as a "traditional" and pitch-perfect portrayal of *Batman*'. In *Regeneration and Rebirth: Anatomy of the Franchise Reboot*, I define what a reboot is and how it operates. Simply put, a reboot wipes the slate clean, at least from a narrative position, and strives to disconnect the new text from its predecessor in a quest for autonomy. *Batman Begins* is not a prequel or sequel to the Burton/Schumacher quartet of Batman films, but is what screenwriter David Goyer describes as 'a cinematic equivalent of a reboot'.

The concept of rebooting draws from the comic book tradition which seeks to collapse existing continuities and begin again from a narrative 'ground zero' in order to streamline the story-world, erase incongruities and contradictions, and invite new readers through a 'jumping on' point. As Goyer explains, 'One of the reasons they do that is after ten years of telling the same story, it gets stale and times change [...] by doing that, setting it at the beginning, you're instantly distancing yourself from anything that's come before'. This was the strategy adopted for the rebirth of the Batman film franchise.

**Dark Knight Triumphant:**
**Fandom, Hegemony and the Rebirth of Batman on Film**
William Proctor

First and foremost, *Batman Begins* had to repair the damage done to the franchise by Joel Schumacher. As Jonathan Gray puts it:

The tale of *Batman Begins* is one of how to escape a dark shadow. Audience and critical reception of *Batman & Robin* had been so near-universally caustic that it had set up a strong paratexual perimeter and a flaming hoop through which any subsequent Batman text would need to pass. *Batman Begins* and Time Warner needed to apologise for *Batman & Robin* and to erase any semblance of an intertextual connection: only Batman himself could remain, albeit radically configured.

As I argue in *Beginning Again: the Reboot Phenomenon in Comic Books and Film*, *Batman Begins* does not continue along the same narrative trajectory as the Burton/Schumacher films, but strived to 'wipe the slate clean' and begin again from 'year one'. The strategy here is to disconnect the new iteration from the 'other' Batman, the camp crusader, the 'day-glo' Knight; although it is incredibly important to point out that a 'new' text can never truly wipe the slate clean: rather, it re-activates the other texts within what Brooker, in his most recent work, *Hunting the Dark Knight: Twenty-First Century Batman*, calls the 'Batman Matrix', which comprises 'a vast archive' of intertextual enunciations. *Batman Begins* quotes and cites sources such as *Year One*, *The Dark Knight Returns*, *The Long Halloween*, *The Man Who Falls*, and Denny O'Neil's Ra's al Ghul stories from the 1970s – not to mention the wealth of texts operating across what Jim Collins calls 'the intertextual array'. The plurality and abundance of texts oscillating within and across the cultural circuit make it difficult, if not impossible, to accurately identify any one source as signifier and that 'the works of previous and surrounding cultures [are] always present'. Concurrently, Brooker writes that 19 out of 27 reviews of *Batman Begins* compared Nolan's film with Schumacher's and Burton's films, therefore 'in the process of cutting ties with the previous versions, these protestations of difference tend to make the earlier text visible'.

Furthermore, the notion that Batman is a site of binarism between light, campy caped crusader and grim, Dark Knight is one that is too reductive. Rather, the history of Batman is a 'spectrum' with varying shades of colour and tonal differences rather than a simple yin and yang of polarities. Even in Nolan's trilogy, we have humour and lightness set against the pitch-black night. In *Batman Begins*, Bruce Wayne gives a homeless vagabond a coat as he departs Gotham before returning as Batman. This comedic 'plant' is returned to later in the film when Bruce Wayne, now operating as the fully-fledged guardian of Gotham, comments wryly: 'Nice coat'. In *The Dark Knight*, a novice vigilante dressed in a homemade Batman outfit questions the hero's treatment of him: 'We're trying to help you...What gives you the right? What's the difference between you and me?' to which Batman responds: 'I'm not wearing hockey pads'; and in the final instalment, *The Dark Knight Rises*, Selina Kyle/ Catwoman states, while climbing into what she per-

ceives to be the Batmobile, 'My mother warned me about getting into cars with strange men' to which Batman replies: 'This is not a car' before a winged Batplane takes off. One could argue that these 'bat-jokes' lighten up the obsidian atmosphere.

In addition, Grant Morrison's critically applauded six-year run on the Batman mythos in DC Comics drew heavily on earlier, campier traditions. In *Batman & Robin: Reborn*, he draws:

[i]nspiration from some of the most neglected areas of Batman's long publishing and screen history – like the 1950s 'sci-fi' Batman and the 1960s TV show [...]. Looking at the 1950s covers in particular, there's an obvious vogue for intense, clashing colours in the logos, so we were able to do something ostensibly un-Batman-like while quoting Batman's graphic past – the vibrating contrast of purple and green, or blue and yellow, and the big flat expanses of background colour that were popular during that era of design all seemed ripe for a comeback. [*Batman & Robin: Reborn* is] as garish, sensational and flippant as we could make it.

## Conclusion

*Batman Begins* was a massive success, in both the critical and economic spheres, but it was the follow-up, *The Dark Knight*, that really propelled Nolan's name into the cultural stratosphere due to its billion dollar box office receipts and exceptional critical kudos. Finally, the Bat-fans got what they wanted: a Batman as dark as the night and as 'real' as plausibility will allow. Additionally, Nolan's films inaugurated a 'new' cycle of films that continue to this day – the reboot – which strives to 'begin again' from a narrative 'ground zero'. I have argued elsewhere that film industry professionals – directors, writers, producers and actors– have been quick to align their products with Christopher Nolan's Batman texts using the reboot label for promotional purposes. Samuel Bayer, director of the *A Nightmare on Elm Street* (2010) remake conjures Nolan's name and activities as a linchpin to connect their respective films:

I like what Christopher Nolan did with Batman. I think Tim Burton is an amazing director, but I think that Christopher Nolan reinvented, to a degree, the superhero genre. Heath Ledger's portrayal made people forget about Jack Nicolson. The new Batmobile made me forget about the old Batmobile [...] that's the way we're approaching *Nightmare* [*on Elm Street*].

Rupert Wyatt, director of *Rise of the Planet of the Apes* (2011), also draws comparison with Nolan's Bat-texts:

This is part of the mythology and it should be seen as that. It's not a continuation of the other films; it's an original story. It does satisfy the people who enjoy those films. The

**Dark Knight Triumphant:**
**Fandom, Hegemony and the Rebirth of Batman on Film**
William Proctor

point of this film is to achieve that and to bring that fanbase into the film exactly like
*Batman* [*Begins*].

Following the critical and financial failure of *Superman Returns* (Singer, 2006),
Christopher Nolan was brought on board to act as 'mentor' and producer of the *Super-
man* reboot, *Man of Steel* (2013). Director Zack Snyder speaks about the connection
between the *Batman* and *Superman* cinematic regenerations:

If you look at *Batman Begins*, there's that structure, there's the canon that we know about
and respect, but on the other hand there's this approach that pre-supposes that there
haven't been any other movies [...] in every aspect, the whole thing is from that perspective.

For Kevin Feige, the president of production at Marvel Studios, the current cycle of
reboots owes a debt, not to Nolan, but to Schumacher: 'I tell people the seminal film
that's responsible for everything that has happened was *Batman & Robin* [...] If it hadn't
been so bad, things wouldn't have gotten so good'.
So, then, the cycle of reboots which includes critical and financial triumphs such as
*Casino Royale* (Campbell, 2006), J.J. Abrams' *Star Trek* (2009), the *Planet of the Apes*
reboot all owe fealty to Schumacher's risible film text that forced the Dark Knight into
hibernation for an eight year interregnum period. As this chapter has argued, fandom has
played a part in this zeitgeist, perhaps more than any executive at Time Warner would
care to admit, and illustrates a battle for hegemony taking place within the media-sphere.
From this perspective, fan's voices, protestations and recommendations have offered the
culture industry an aesthetic model on which to draw from to give the audience what they
desire, which, in turn, creates profit and economic stability. Nolan's *Batman* trilogy pro-
vides a blueprint which is then incorporated into the 'Hollywood Entertainment Machine'
and used to recycle popular culture until, once again, the cycle fails and the need for re-
newal and rebirth is initiated once more. This is how the struggle for hegemony operates.
At the time of writing, Nolan's final instalment of what is now called *The Dark Knight
Trilogy* – which, interestingly, removes the Batman prefix altogether, perhaps to fur-
ther erase any connections to the Schumacher films and the 1960s TV show – *The
Dark Knight Rises* has received overwhelming critical kudos with reports of audiences
weeping and participating in standing ovations (although there have been some com-
mentators who complained about the lack of a cohesive plot and muffled vocal per-
formances). Moreover, by analysing seventeen international and national reviews, Joel
Schumacher's *Batman & Robin* is only cursorily mentioned on one occasion. Compared
to Brooker's analysis of *Batman Begins*' reviews that discussed *Batman & Robin* over
sixty per cent of the time, there has been a discernible shift in critical discourse. Is it too
much to suggest that Christopher Nolan and his collaborators have rescued the Batman
from cinematic purgatory? And, furthermore, can we claim that this change of strategy

is down to the audience, the vocal and passionate Bat-fan, who demanded a Dark Knight rather than a Camp Crusader?

For the moment, at least, the Dark Knight fan remains triumphant. What happens now? One thing is certain: the Batman *will* return. ●

~~~~~~~~~~

GO FURTHER

Books

Hunting the Dark Knight: Twenty-First Century Batman
Will Brooker (London: IB Taurus, 2012)

Cultural Theory and Popular Culture: An Introduction (6th edition)
John Storey (Essex: Pearson, 2012)

Improving the Foundations: Batman Begins from Comics to Screen
Julian Darius (US: Sequart Research, 2011)

War, Politics and Superheroes
Marc DiPaolo (North Carolina: McFarland, 2011)

Supergods: Our World in the Age of Superheroes
Grant Morrison (London: Jonathan Cape, 2011)

Batman & Robin: Reborn
Grant Morrison, Frank Quitely and Phillip Tan (New York: DC Comics, 2011)

Show Sold Separately: Promos, Spoilers and Other Media Paratexts
Jonathan Gray (London: New York University Press, 2010)

Convergence Culture: Where New and Old Media Collide
Henry Jenkins (New York: New York University Press, 2006)

The Films of Tim Burton: Animating Live Action in Contemporary Hollywood
Alison McMahan (London: Continuum, 2005)

Batman Unmasked: Analyzing a Cultural Icon
Will Brooker
(London: Continuum, 2002)

Dark Knight Triumphant:
Fandom, Hegemony and the Rebirth of Batman on Film
William Proctor

Extracts/Essays/Articles

'Beginning again: the reboot phenomenon in film and comic books' by William Proctor
In *Scan: Journal of Media Arts Culture*, July 2012,
Available at:
http://www.scan.net.au/scan/journal/display.php?journal_id=163

'Regeneration and rebirth: anatomy of the franchise reboot' by William Proctor
In *Scan: Journal of Media Arts Culture*, 22 February 2012,
Available from:
http://www.scope.nottingham.ac.uk/February_2012/proctor.pdf

'Economies of adaptation' by Dudley Andrew
In Colin MacCabe, Kathleen Murray and Rick Warner (eds). *True to the Spirit: Film
Adaptation and Questions of Fidelity* (New York: Oxford University Press, 2011)

'Economic and institutional analysis: Hollywood as monopoly capitalism' by Douglas Gomery
In Toby Miller (ed.). *The Hollywood Contemporary Reader* (London: Routledge, 2008)

'Batman, Time Warner and Franchise Filmmaking in the Conglomerate Era' by Kim Owczarski
(unpublished Ph.D. dissertation: University of Austin, Texas, 2008)

Film/TV

Man of Steel, Zack Snyder, dir (USA: Warner Bros., 2013)
The Amazing Spider-Man, Marc Webb, dir (USA: Columbia Pictures, 2012)
The Dark Knight Rises, Christopher Nolan, dir (USA: Warner Bros., 2012)
The Dark Knight, Christopher Nolan, dir (USA: Warner Bros., 2012)
Rise of the Planet of the Apes, Rupert Wyatt, dir (USA: 20th Century Fox, 2011)
A Nightmare on Elm Street, Samuel Bayer, dir (USA: New Line Cinemas, 2010)
Casino Royale, Martin Campbell, dir (USA: Metro-Golden Mayer, 2006)
Batman Begins, Christopher Nolan, dir (USA: Warner Bros., 2005)
Batman & Robin, Joel Schumacher, dir (USA: Warner Bros., 1997)
Batman Forever, Joel Scumacher, dir (USA: Warner Bros., 1995)
Batman Returns, Tim Burton, dir (USA: Warner Bros., 1992)
Batman, Tim Burton, dir (USA: Warner Bros., 1989)
Star Trek: The Original Series, Gene Roddenberry, creator (USA: NBC, 1966–69)

THE
FUTURE
IS A
RIDDLE
ONLY
TIME
CAN
SOLVE.

THE RIDDLER
JOKER'S ASYLUM II #1: 'THE HOUSE THE CARDS BUILT'

Fan Appreciation no.8
Michael E. Uslan

In the 1970s and 1980s the camp hangover from the Adam West television series meant that no one in Hollywood recognized what every fan knew: Batman would be the perfect protagonist for a dark and gritty feature-length film. In order to change perceptions, a single-minded fan would need to scale the walls of Hollywood and change the system from within. That fan was Michael E. Uslan.

In his autobiography, *The Boy Who Loved Batman*, Uslan warmly recounts his journey from early childhood comic book collecting, through teaching the first university-accredited comic book course to executive producing every big screen adaptation of Batman since Tim Burton's film in 1989. Here he discusses his vow to bring the Dark Knight to the screen.

Liam Burke: *Why do you think Batman compels such devotion among fans?*
Michael E. Uslan: Batman is unique. Batman is a superhero who has no superpowers, and as I have contended since day one his greatest superpower is his humanity. When I was a kid, Batman was a character I could identify with because he was human, and in my heart of hearts, I truly believed that if I worked out real hard, and studied real hard and if my dad bought me a cool car, I could become this guy, and there is that huge identification with this character for that specific reason.

The next thing that makes Batman so appealing is that he has the greatest supervillains in the history of comics, and inarguably the greatest supervillan ever created in the Joker. I am a subscriber to Stan Lee's theory of supervillains: the greatest superheroes in history, the ones with the longest of longevity, have been the ones with the greatest supervillians, because, ultimately, it is the supervillains who define the superhero.

That still doesn't specifically address how come Batman seems to be able to traverse not only borders internationally but cultures as well, and I think there's two points to that. One is his origin story. It is such an emotional, resonating and primal story of a child who sees his parents murdered before his eyes and makes a commitment in the belief that one person can make a difference. That is an intensely primal story that does cross cultures. Lastly, more than any other character, Batman's essence has been defined as no guns and no killing, and I think that generations of young people who grew up with Batman have responded to and embraced that. He had that kind of an impact on young people in the process of growing up, and I think all of these aspects add up to the reason why Batman is so uniquely popular, identified with and works worldwide.

Fan Appreciation no.8
Michael E. Uslan

LB: *Across the decades there have been many different interpretations of Batman. Do you have a preferred version?*
MU: Absolutely, and the best way to explain that is to take you back to a cold night in January 1966. I was in the eighth grade, a true comic book geek. I was excited because that night the Batman television series was about to appear on TV. As it started I was excited because it opened with an animated sequence that resembled Bob Kane and Jerry Robinson's artwork; the Batmobile looked really, really cool; the series was in colour; the sets were extravagant – somebody was spending a lot of money on this show. And then I was simultaneously thrilled and horrified by what I then saw. I quickly realised that with what they were doing the whole world was laughing at Batman and that just killed me.

That moment was to have a tremendous impact on my career because I had my own Bruce Wayne vow. I vowed that someday, some way, I would show the world what the true Batman was: the Batman created in 1939 by Bob Kane and Bill Finger as a creature of night, stalking criminals in the shadow. That, to me, was the true Batman. A lot of times if you ask people what is the true version of any particular comic book or movie, it always tends to be the version that they first were exposed to when they were about 12 years old. So I recognize and appreciate that all over the world fans have vastly different interpretations of Batman that remain their personal true version of Batman, but what's most important is that the integrity of the character has to be respected.

LB: *When you first announced Batman: The Movie it was at the 1980 New York Comic Con. This strategy has now become commonplace. Why did you think it was an important step?*
MU: It had never happened before. That was the first time a major motion picture was announced at a Comic Con. As a complete comic book fan-boy growing up in an era before the Internet, comic book collecting was one of the most insulating hobbies you could ever have. It wasn't until I was in fifth grade that I discovered one other boy in my class who was as into comic books and superheroes as I was. We thought we were alone until the birth and emergence of a thing called 'comic book fandom', when fans began to communicate amongst themselves based on letters being sent to editors that were published in comic books that had full addresses in them. On the back of that, the first fanzines were created, and I became an early member of comic book fandom soon after its birth. From there, a couple of guys got this great idea that with all the comic book companies based in New York City that there should be a meeting of comic book fans

so we could meet face-to-face, or as I say, pimple-to-pimple, and have a chance to discuss comics, trade comics, talk to some professionals and have a fun weekend together. That became the first Comic Con. It was in July 1964 in a fleabag hotel off the Bowery in New York and 200 of us met.

So that was the beginning of it all for me. Then to be able to announce my lifelong dream project of a dark and serious Batman movie, a major motion picture, at a comic book convention to the fans, and be able to communicate to them, with Bob Kane and the president of DC Comics, that we're doing this for you because we're doing it for me and I'm one of you was important. When I said this movie is not going to be about Batman it's going to be about 'The' Batman, they understood the coded language and they went crazy. We then had a press cocktail party afterwards and the ones invited were the initial growing fan press and some people from outside. But that was our focal point – to do this for the fans and to get the fans behind the project initially. So it was utterly groundbreaking, and again it set the pace for what would become the norm many years later.

LB: *Do you think the wider status of fans changed over the years?*
MU: Totally. I can summarize that very easily. Dr Fredric Wertham wrote a book, *Seduction of the Innocent*, in the 1950s successfully attacking comic books. He was a psychiatrist who had his own clinic in Brooklyn, and Dr Wertham interviewed 100 youth male delinquents because there was this national scare due to the post-World War II rise in juvenile delinquency. He asked them if they had ever read a comic book, they all did. Therefore, Dr Wertham concluded comic books cause juvenile delinquency. He went out on a lecture circuit, he spoke to PTAs, garden clubs and churches and the word spread. Comic books were accused of not only creating a generation of juvenile delinquents and young criminals, they were accused of being communists; one of the points was even, 'Well if boys read Batman and Robin and girls read Wonder Woman, the boys could become homosexual and the girls could become lesbians'. And this was a nation that bought that hook, line and sinker. I contend had it not been for the advent of rock 'n roll music and Elvis Presley, which took the spotlight off comics, the whole comic book industry could have been put out of business.

So that was the aura under which people read comic books; where they had to put their collars up or their sunglasses on when they'd try to buy a comic book under the piercing glance of society. When I was a kid growing up, by the time that you passed the age of twelve, if you were still seen going into your drug store or candy store and buying comic books, people looked at you like there was seriously something radically wrong

Fan Appreciation no.5
Travis Langley

with you, including the people who were selling you the stuff.

Today, comic books and superheroes are the basis for blockbuster movies, hit television series, video games, major animated series and movies. They're impacting the culture, they're impacting our fashion, they're impacting choices about what we're studying, and so what I say to all of my fellow fanboys and comic book geeks is 'We win!'

LB: *As a film-maker, have you found your background in fandom benefiting you professionally?*
MU: Completely. Ultimately, the reason that DC Comics sold me the rights to Batman when I was in my twenties – I mean who in their right mind would sell the rights to Batman to a kid in his twenties – was because they trusted me. They knew the fan and comic book historian I was, and that I would do all I could do in my power to protect Batman and restore the dignity I felt he lost in the TV series when everybody was laughing at him. My commitment was to make dark and serious Batman films and show the world what my true Batman was like.

LB: *Where do you think Robin fits into the mythos?*
MU: I liked Robin when I was growing up. I didn't identify with Robin, I always identified with Batman. In fact, in our neighbourhood whenever we played Batman and Robin, the oldest boy got to play Batman, the next oldest boys got to play the villains and the youngest one, which was often me, got stuck playing Robin. That's the hierarchy; the way we looked at it all.

As we move further on the comics were becoming more sophisticated. When I was going off to college, Robin (Dick Grayson) was also being sent away to college, forcing Bruce Wayne to rely on Alfred, close up the Batcave and move to the city. It was a drastic change in direction and a big step forward for the return of the Dark Knight persona, but in order to do that, Robin had to go.

LB: *How do you feel about the late 1980s' reader poll to decide if Robin should die?*
MU: When a guy I'm very close to [former Batman editor] Denny O'Neil was in the midst of letting the readers decide if Robin was going to live or die by a poll, it wasn't Dick Grayson anymore, it was a new kid [Jason Todd] who was Robin and he was a little bit of a jerk as far as I was concerned. There were no tears shed by me when he was killed off. The greatest impact that story had was that it broke through to the mainstream press and it brought worldwide attention back to comic books – a lot of people

didn't even know that comic books were still being published.

Going into the movies, putting on a different hat now, I am a subscriber to the Stan Lee theory of sidekicks. Stan Lee hated sidekicks. He tried to inject a sense of reality into his comic book superheroes and as Stan said, 'what adult is going to spend his time running around with a 12-year-old kid on a daily basis?' He said it doesn't work on any level, not if you're trying to be serious about your comic book superhero, and certainly not if you're going to try and make the transition into movies and try to convince people to take them seriously and to appreciate superheroes on that level.

LB: *As a Batman fan, can you recall any seminal moments in your own fandom?*
MU: There are so many moments of importance, such as when my partner Benjamin Melniker and I were about to walk in to see the final cut of our first Batman movie in 1989 – the brilliant movie by Tim Burton – and as we were about to go in Ben pulls me aside and said 'two hours from now you're going to walk out and your life is going to be different', and he was absolutely right. And I think seeing the finished product on the screen for the first time, realizing the long hard road I had been through to make this dream come true, was an incredibly intense moment, but it was a moment that incorporated the heart of the fanboy as much as it did the heart of a film-maker.

When I saw *The Dark Knight Rises* completed for the first time I cried like a baby and I turned to my wife who was sitting next to me and said, 'This is the culmination of everything I have ever hoped and dreamed to see with Batman on the silver screen since I was 14 years old that night I watched the Batman TV show premiere'. So, in terms of intensity and moments that tie the fan and producer together, those were two incredible moments.

As an example of the true comic book geek that I am, at the star-studded world premiere of our first movie in June 1989, where am I? I am hanging out with Bob Kane and Stan Lee. I couldn't care less about all the actors and paparazzi and everything like that. I was at the premiere of my first Batman movie with Stan Lee and Bob Kane and it just didn't get any better than that.

Contributor Details

EDITOR

Liam Burke is a media studies lecturer at Swinburne University of Technology in Melbourne, Australia. He is currently finishing a book length-study on comic book film adaptations, which will be published by the University Press of Mississippi in 2014. Liam's academic publications include articles in the journals *Participations: International Journal of Audience Research*; *SCAN: Journal of Media Arts Culture* and *Estudios Irlandeses*. His first book, *The Pocket Essential: Superhero Movies*, was published in 2008, and he regularly contributes to *The Irish Times* and *Film Ireland*. Liam has been a fan of Batman since the Batmania of 1989.

CONTRIBUTORS

Will Brooker is the foremost academic expert on Batman. His Ph.D was on Batman's cultural history from 1939-99 – published as *Batman Unmasked* (2000) and his most recent monograph is *Hunting the Dark Knight: 21*st *Century Batman*. He has written on Batman for various publications including *The Guardian*, *The Independent*, *Times Higher Education* and *Newsweek*, and been interviewed on television with 1960s Batman icon Adam West. Brooker is currently Director of Research in Film and Television at Kingston University, London.

Anna-Maria Covich recently completed a master's thesis – *Alter/ego: Superhero comic book readers, gender and identity* – at the University of Canterbury in the gender studies programme. Her most recent research focus has been on New Zealand-based adult fans and readers of superhero comic books. Previous research has included queer/Crip readings of Frank Miller's *Daredevil Visionaries*, issues of sustainability in the University of Canterbury curriculum, and the ways in which science and innovation are socially mediated. Covich is currently reconsidering her claims of sanity, as she hopes to continue her research with a Ph.D. in the areas of gender, the media and embodiment.

Joseph Darowski is a member of the English faculty at Brigham Young University-Idaho. He received his Ph.D. in American Studies from Michigan State University, where he studied popular culture, comic books and American literature. He has published research on comic book characters, popular television shows and popular culture theory, and serves on the editorial review board of *The Journal of Popular Culture*. He edited *The Ages of Superman: Essays on the Man of Steel in Changing Times* and the forthcoming collection *The Ages of Wonder Woman*.

Robert Dean is a lecturer at the University of Glamorgan in Wales. He received his Ph.D. from Aberystwyth University in 2010. His thesis was entitled 'Musical Dramaturgy in Late Nineteenth and Early Twentieth-Century Theatre on the British Stage'. Dean has published work on Ibsen, Chekhov, Wagner and Chris Morris. At the age of fourteen he cut class and travelled 75 miles on public transport to watch Tim Burton's *Batman*.

Jennifer Dondero is an adjunct instructor in the forensic psychology department at The Chicago School of Professional Psychology. She began teaching at The Chicago School after graduating with her master's in forensic psychology in 2008. Her professional training includes work in both courtroom and correctional settings. Dondero's professional career outside of teaching includes recently serving as a media expert for Warner Bros. Distribution Studios, assisting with research regarding cinematic serial killers, and editing a forthcoming text on the *Saw* movie franchise. She has also presented research related to pop culture and serial killers at several conferences including the annual American Psychological Association and Pop Culture Association national conferences. Dondero owns more than 100 Batman graphic novels, collects five current Batman titles put out by DC Comics, and is an active contributor to various online social networking sites dedicated to discussing Batman comics and film.

Tony W. Garland has a Ph.D. in decadent literature and the *femme fatale*. He has published work on the poetry of Algernon Swinburne and Charles Baudelaire, and the drama of Oscar Wilde. He is currently working on an anthology of essays on the critical writing of Oscar Wilde. In addition to reading nineteenth century literature, he enjoys classic and contemporary popular culture. He has published an article on the Bond girl villain in the James Bond films and always liked Batman as a good guy who looked like a bad guy and had villains you almost hoped would win.

Leslie McMurtry obtained a BA in English/French from the University of New Mexico and an MA in creative writing from Swansea University in Wales, where she is currently a doctoral candidate in English (radio drama). Her published academic work has been included in *The Unsilent Library: Essays on the Russell T. Davies Era of the New Doctor Who* (Science Fiction Foundation, 2011) and 'I Am Vengeance, I Am the Night, I Am . . . The Doctor?' in *The Mythological Dimensions of Doctor Who* (Kitsune Books, 2010). She has been a reader and writer of fanfiction since 1997.

Marc Napolitano is an assistant professor of English at the United States Military Academy, West Point, New York. He attained his Ph.D. in English from the University of North Carolina at Chapel Hill in 2009; his primary areas of interest include the Victorian novel, Dickensian literature and detective fiction. He has been an avid follower of the Dark Knight's adventures since the age of eight when he first experienced Tim Burton's *Bat-*

man on VHS. However, his favourite incarnation of the character will always be *Batman: The Animated Series.*

Tim Posada (MA, Claremont Graduate University; MAT, Fuller Theological Seminary) is a Ph.D. candidate in cultural studies at Claremont Graduate University in California, where he studies visual culture and new media genres. He has a part-time position at the Faculty of Communication Studies at Azusa Pacific University where he serves as story and design adviser for student publications. He is also the film columnist for the Beverly Press.

William Proctor is a Ph.D. candidate at the Centre for Media and Cultural Studies Research, University of Sunderland where he is researching and writing his thesis on reboots in film, TV and comic books, as well as teaching on film, media and cultural studies courses. He has published articles on the reboot phenomenon in *Scope: The Journal of Film and Television*; *SCAN: Journal of Media Arts Culture* and has a chapter in the forthcoming edited collection, *Marxism Matters*, which he is co-editing with Professor John Storey (titled *Marx at the Multiplex: Batman, Bond and the Dialectics of Entertainment*). He has delivered a number of international conference papers on the reboot and has acted as curator for a special themed edition of the online scholarship forum, *In Media Res*, which investigates reboots in film and TV. Batman has been his favourite superhero since childhood.

Margaret Rossman is a fourth year Ph.D. student in the Department of Communication and Culture at Indiana University. She received her MFA in film studies from Boston University in 2009 and her BA in English from Harvard University in 2006. Her work centres on teen and tween culture, female audiences and fans, viral marketing and new media.

I AM VENGEANCE!
I AM THE NIGHT!
I AM BATMAN!

BATMAN
BATMAN: THE ANIMATED SERIES 'NOTHING TO FEAR'

Image Credits

Additional Images

Inside cover image © Liam Burke with the permission of Dennis and Elijah Vasquez
Inside back cover image courtesy of Seamus Keane

Chapter 1: Fig. 1 p. 12 © DC Comics

 Fig. 2 p. 13 © DC Comics

 Fig. 3 p. 13 http://cbldf.org/

 Fig. 4 p. 14 © DC Comics

 Fig. 5 p. 15 http://www.fanpop.com/

 Fig. 6 p. 16 © DC Comics

 Fig. 7 p. 17 © Warner Bros

 Fig. 8 p. 18 © DC Comics and Warner Bros

Fan Appreciation no. 1 p. 24 http://mspub.blogs.pace.edu

Chapter 2: Fig. 1 p. 32 http://www.gigaventure.com/

 Fig. 2 p. 34 http://4thletter.net/

 Fig. 3 p. 34 http://www.flickr.com/

 Fig. 4 p. 36 http://zubko.com/

 Fig. 5 p. 37 © DC Comics

Chapter 4: Figs. 1-2 p.49 from Batman Swoops Down (Spear's Games)

 Fig. 3 p.50 from Batman: Shoot 'n' Score Springboard (New World Toys)

 Fig. 4 p.50 from Batman: Rapid Fire (New World Toys, circa 2008)

 Figs. 5-7 p. 51 from Batman Forever (Parker Brothers)

 Fig. 8 p.52 from Batman (Ocean)

 Figs. 9-11 p.52-3 from Batman: The Caped Crusader (Ocean)

 Figs. 12-14 p. 54 from Batman: The Movie (Ocean)

 Figs. 15-16, p. 55-6 from Arkham Asylum (Rocksteady)

Fan Appreciation no. 2 p. 58 Courtesy of E. Paul Zehr

Fan Appreciation no. 3 p. 64 © Liam Burke with the permission of Josh Hook and Kendal Coombs

Chapter 5: Fig. 1 p. 70 www.ibelieveinharveydent.com

 Fig. 2 p. 70 www.ibelieveinharveydenttoo.com

 Fig. 3 p. 71 http://asmith50.wordpress.com/

 Fig. 4 p. 72 http://www.firstshowing.net/

 Fig. 5 p. 73 http://www.moviechronicles.com/

 Fig. 6 p. 73 http://www.moviechronicles.com/

 Fig. 7 p. 75 www.rorysdeathkiss.com

Chapter 6: Fig. 1 p. 79 © Warner Bros

 Fig. 2 p. 84 © Warner Bros

 Fig. 3 p. 86 © Warner Bros

Chapter 7: Fig. 1 p. 91 © Warner Bros

 Fig. 2 p. 93 © Leslie McMurtry

 Fig. 3 p. 96 © Leslie McMurtry

AND UNTIL
WE MEET AGAIN,
BOYS AND GIRLS,
KNOW THAT
WHEREVER EVIL LURKS,
IN ALL ITS
MYRIAD FORMS,
I'LL BE THERE,
WITH THE
HAMMERS OF JUSTICE,
TO FIGHT FOR
DECENCY AND
DEFEND THE INNOCENT.
GOOD NIGHT.

BATMAN
BATMAN: THE BRAVE AND THE BOLD 'MITEFALL!'

FAN PHENOMENA

OTHER TITLES AVAILABLE IN THE SERIES

Star Trek
Edited by Bruce E. Drushel
ISBN: 978-1-78320-023-8
£14.95 / $20

Star Wars
Edited by Mika Elovaara
ISBN: 978-1-78320-022-1
£14.95 / $20

Doctor Who
Edited by Paul Booth
ISBN: 978-1-78320-020-7
£14.95 / $20

Buffy the Vampire Slayer
Edited by Jennifer K. Stuller
ISBN: 978-1-78320-019-1
£14.95 / $20

Twin Peaks
Edited by Marisa C. Hayes
and Franck Boulegue
ISBN: 978-1-78320-024-5
£14.95 / $20

For further information about the series
and news of forthcoming titles visit **www.intellectbooks.com**